1,000 Ideas by 100 Manga Artists

chartwell
books

1,000 Ideas by 100 Manga Artists

Cristian Campos

Brimming with creative inspiration, how-to projects, and useful information to enrich your everyday life, quarto.com is a favorite destination for those pursuing their interests and passions.

Inspiring | Educating | Creating | Entertaining

This edition published in 2021 by Chartwell Books,
an imprint of The Quarto Group
142 West 36th Street, 4th Floor
New York, NY 10018 USA
T (212) 779-4972 F (212) 779-6058
www.Quarto.com

First published in 2011 by Rockport Publishers,
an imprint of The Quarto Group
100 Cummings Center, Suite 265D
Beverly, MA 01915

ISBN: 978-0-7858-4067-1

Library of Congress Control Number: 2021950370

10 9 8 7 6 5 4 3 2 1

Chartwell titles are also available at discount for retail, wholesale, promotional, and bulk purchase.
For details, contact the Special Sales Manager by email at specialsales@quarto.com or by mail at The Quarto Group,
Attn: Special Sales Manager, 100 Cummings Center Suite 265D, Beverly, MA 01915, USA.

Publisher: Paco Asensio
Editorial coordination: Cristian Campos
Editor: Cristian Campos
Art director: Emma Termes Parera
Layout: Esperanza Escudero
English translation: Cillero & de Motta

Editorial project:
maomao publications
Via Laietana, 32, 4th fl, of. 104
08003 Barcelona, Spain
Tel.: +34 93 268 80 88
Fax: +34 93 317 42 08
www.maomaopublications.com

Printed in China

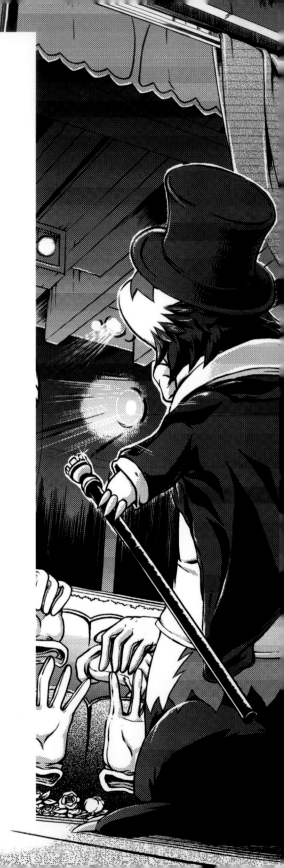

Contents

Introduction ..8

1,000 Ideas ...18

Aileen Strauch ..20
Akiko Matsuo ..23
Angela Wraight & Gwen Kortsen26
Anna Fitzpatrick ...29
Anne Pötzke ...32
Atsushi Ikeda ...35
Audra Ann Furuichi ..38
Ayako Okubo ..41
Bettina M. Kurkoski ...44
C. Lijewski ..47
Chie Kutsuwada ...50
David 'Def' Füleki ..53
Eito Yoshikawa ..56
Emiko Goto ...59
Fantasista Utamaro ...62
Faye Yong ...65
Haruka Shinji ...68
Hayden Scott-Baron ...71
Heisuke Kitazawa (PCP) ..74
Hirochi Maki ...77
Hiroshi Fujii ...80
Holly Segarra ...83
Imaitoonz ...86
Irene Flores ..89
Joanna Estep ...92
Joanna Zhou ...95
Junko Kawakami ..98
Kana Nagano ..101

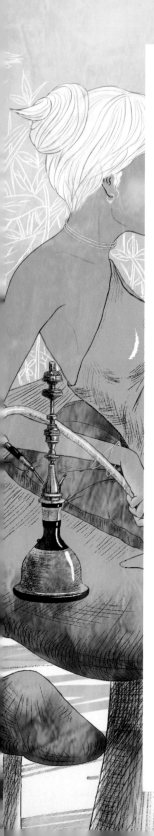

Kaoru Hironaka .. 104

Karen Rubins ... 107

Karen Yumi Lusted ... 110

Kate Holden .. 113

Kato Ai / ai☆madonna .. 116

Kayo Tamaishi ... 119

Kazuko Tsuji ... 122

Keiko Enobi (Atoron) .. 125

Kenji Urata ... 128

Kentaro Hisa ... 131

Kevin Bolk .. 134

Kimiaki Yaegashi .. 137

Kina de Grasse Forney ... 140

Kira Imai .. 143

Komtena ... 146

Koya Okada ... 149

Kurumi Aoyama .. 152

Kyle Hoyt ... 155

Kyotaro .. 158

Laura Watton ... 161

Lindsay Cibos and Jared Hodges 164

Mari Mitsumi ... 167

Marie Sann ... 170

Marumiyan .. 173

Masayoshi Mizuho .. 176

Maximo V. Lorenzo ... 179

Megumi Terada .. 182

Melanie Schober ... 185

Minako Saitoh Botsford .. 188

Mississippi (Takashi Horiguchi) 191

Miya Nakajima ... 194

Mizki Yuasa ... 197

Mizna Wada .. 200

Naoshi ... 203

Neill Cameron .. 206

Noriko Meguro ... 209

Noritomo Shimizu ..212

Ponto Ponta ..215

Queenie Chan ..218

Robert Deas ...221

Romi Watanabe ...224

Rose Besch ..227

Ruben de Vela ...230

Ryuji Shishido ...233

Sachlich ...236

Sai Tamiya ...239

Saki Asada ...242

Sally Jane Thompson ...245

Sayuri Maeda (SMO) ..248

Shoko Shimizu ...251

Shuhei Tabuchi ..254

Sonia Leong ...257

Stephen 'Teben' Hetrick ...260

Steven Cummings (SC) ..263

Syujyutu Karasuba ...266

T. Birdman ...269

Takeuma ..272

Taruto Aoyama ...275

Tent ..278

Tsubasa ..281

Tsukasa Tomoyose (Atoron) ..284

Viviane ...287

Yishan Li ..290

Yiso ..293

Yoshida Yoshitsugi ..296

Yu Kagei ..299

Yukihiro Tada ..302

Yunico Uchiyama ...306

Yurie Sekiya ..308

Yusaku Maeda ..311

Zarina Liew ..314

+cruz ..317

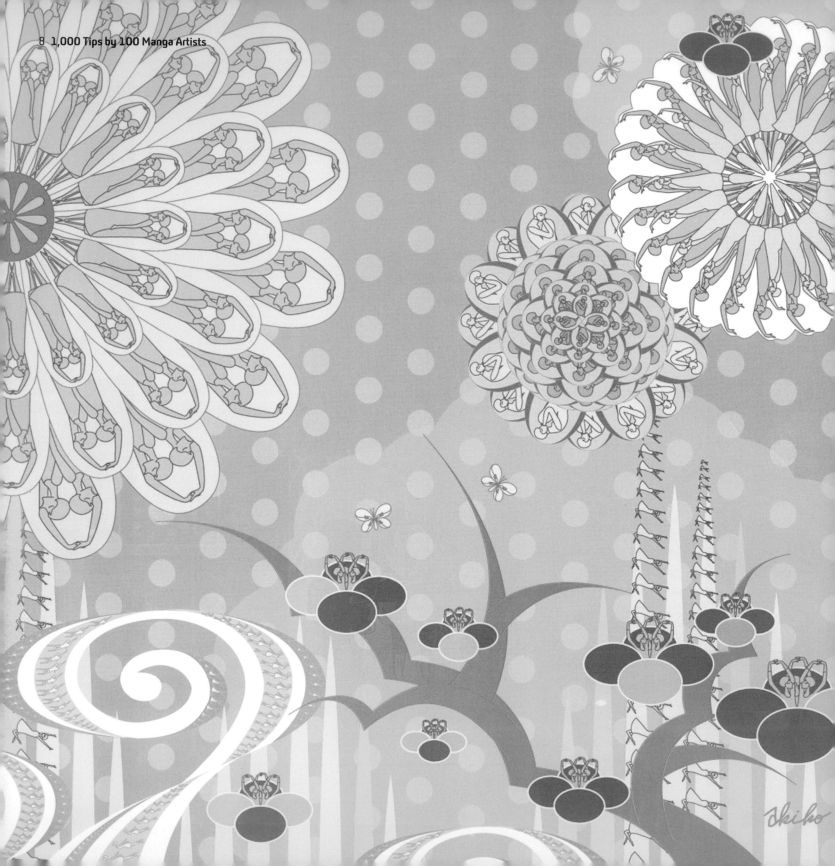

Is manga really so different from the Western style of comic? After all, if the West has the traditional 4-panel comic strip running horizontally across the page, Japan has the *yonkoma*, a 4-panel comic strip running... vertically down the page. If the West has comics full of superheroes, Japan has the *shonen* manga, a whole genre dedicated to male adolescents with an overdose of testosterone. If the West has the graphic novel, Japan has the *seinen* manga, with adult themes and a graphic style that is far more complex than the one used in cartoons targeting a younger readership. And let's not forget the ninjas, who are nothing more than the Delta Force equivalent of the Japanese feudal past, or the mechs—gigantic robots that to me (dare I say it) have always looked like aircraft carriers from the U.S. navy, capable of standing up, walking in a funny way and inadvertently crushing terrified young deer and lashing out left, right and center.

But make no mistake: manga *is* different from the Western comic strip. Very different, in fact. For starters, manga is not a genre, but a bit of a hodgepodge where anything goes. There is no human on Earth that is weird enough to be left without a manga devoted to their own private whims and obsessions. There are action manga; manga for boys, for girls, for teenage lesbians, for mature lesbians; with a sports theme, with a culinary theme; on basketball, on ping-pong; gore manga, apocalyptic manga, horror manga; surrealist, pornographic, educational, minimalist, contemplative manga; Baroque, offensive, epic manga... Manga is, in this respect, larger than life. Manga can contain reality plus anything that smacks of fantasy that can be conjured up by human imagination. Neither the European cartoon, nor the U.S. graphic novel, nor the comics featuring superheroes, nor the "alternative" comics can evoke even a hundredth part of what is meant by the

word *manga*. In the West, we don't even have an equivalent word in our languages for the Japanese mono no aware, something akin to the awareness of the transient nature of things and the feeling of repentance that accompanies their loss. In fact, I am not even sure whether we Westerners have the slightest awareness of the transient nature of things, and I'm even less sure whether we have felt even the teeniest nanobyte of repentance over its loss. We might just conceivably feel a bit of "pity." And that's the end of it. This thing about mono no aware is s-o-o-o abstract...

So of all the countries on Earth, Japan is without a doubt the one that is most unlike all the rest. There are more similarities between the Dominican Republic and Saudi Arabia, or between Vanuatu and Switzerland, or between North Korea and the US, than between Japan and any other country in the world. And that includes any one you care to mention.

And that is reflected in manga.

And it is this feeling of strangeness that has given rise to this book. There are dozens of books on the market that teach you how to draw manga. Although in fact what those books really do is teach you how to imitate manga. And there's no denying that they are very good at it. A few kinetic lines, a few foreshortened limbs, and one or two grossly exaggerated facial expressions are sufficient to do the trick: if you can master these techniques, no one will say you were born in Boston rather than Kyoto. There are also dozens of books that "talk" about manga. These books explain who Osamu Tezuka is, and Kinomoto Sakura; they tell you why the Gonzo studio is famous or what the origin of Totoro is. Some books even include an interview with a famous mangaka—one of those characters that sometimes also appear in the Sunday supplement of a newspaper that has just discovered manga: "Hey, just look at the funny characters

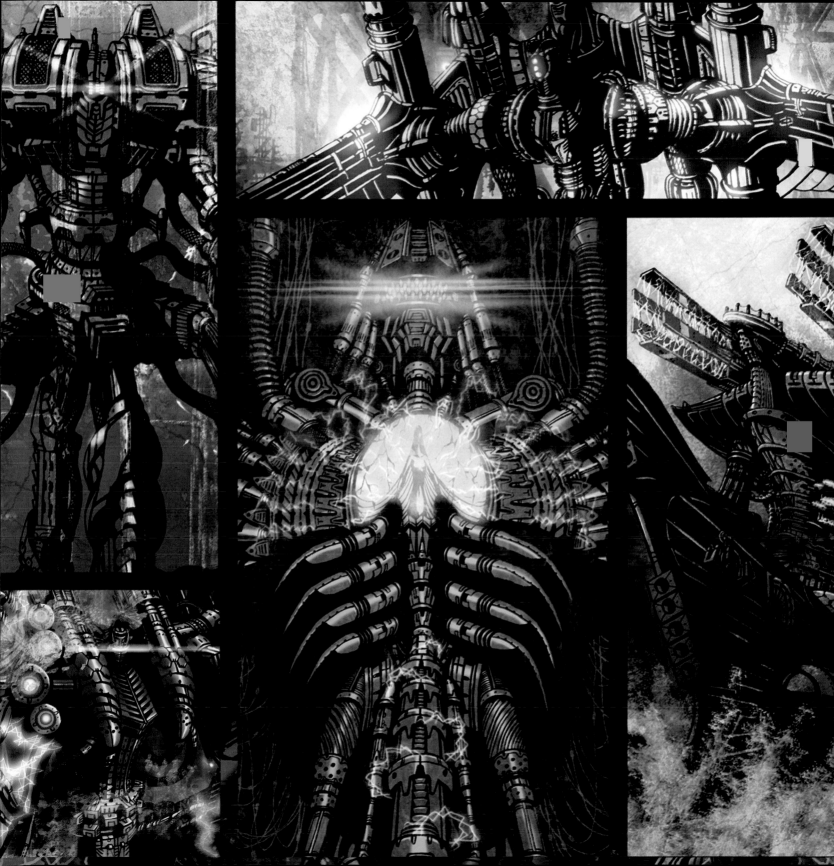

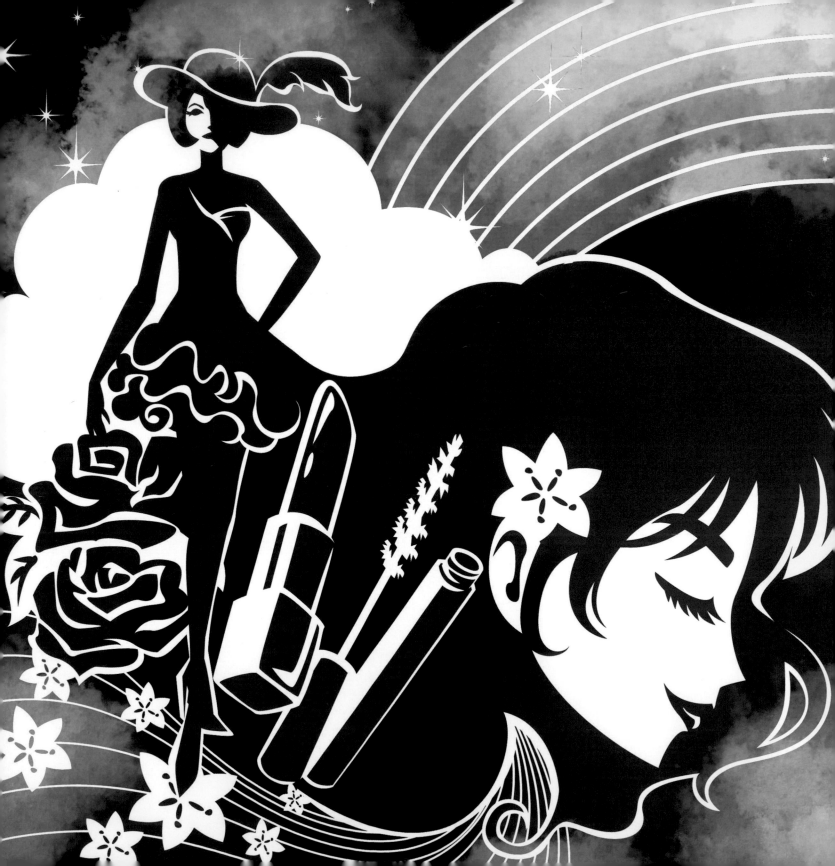

they've drawn here! And they're really obsessed with panties!"

In other words, all the books on manga treat manga as a "genre."

We, however, have treated it like a "philosophy."

For this book we have selected 100 artists. Roughly half are Japanese. The other half are American, German, British, and so on. Most of them are professional manga artists. A minority are illustrators or think of themselves as "artists." What these artists have in common is that they all admit to having been influenced by manga in one way or another. In some cases this influence is clear, since their work revolves around manga. In other cases, the influence is absolutely impossible to discern unless the artist themself owns up to it.

So we got these 100 artists, cartoonists and illustrators together and asked them twenty questions. Twenty questions on their relationship with manga, on their work, on their tricks, on their favorite drawing materials, on the tips they would like to give youngsters interested in drawing manga... Of these twenty questions, they were required to choose ten. And of course, they had to provide answers.

In a second stage, we asked these same 100 artists to send us ten pictures that "represented" or "illustrated" their ten replies. These pictures could be photographs, drawings, illustrations, sketches, and so on. Some pictures are directly linked to the answer given; in other extreme cases, the relationship is thoroughly enigmatic, and the artist is the only one that knows why it was chosen. Some of the artists in this book do not even like manga, although they recognize its total influence on their work. Others (the majority) are complete and utter manga fanatics.

That is what I meant when I said that this book treats manga like a "philosophy," not like a "genre" full of children with large heads and eyes like watermelons.

In any case, this is a book that needs to be discovered bit by bit. In my case, I was surprised to find a level of abstraction and concision common among Japanese artists which contrasts with the much more extrovert (and literal) replies of western artists. Some of the Japanese artists included in this book did not even reply to some of the questions: they just told us to "look at the picture" and you just have to get on with it. I must say that some of the replies are still something of an enigma for me, and that's after having read and re-read the book dozens of times. Asking them to explain would have been almost offensive. Not for them, but for me: giving me a literal explanation would mean that they were underestimating my ability to understand their kind of abstract reasoning.

In the book there is also a deliberate mix of professional artists and illustrators – in short, celebrities—and young artists and illustrators that have really only just started to explore the world of manga. This choice makes sense: normally, a mature, experienced illustrator tends to forget their origins, the tremendous effort they had to make to get where they are today, what they did or did not do, where they made mistakes and where they did the right thing. They are too tied up with deadlines. They have experience, but they do not have the naiveté of someone who is just starting out. Hence, we thought it would be interesting to include the voice of experience alongside that of the young and inexperienced: using a mix of both types of artist gives us a fairly faithful rendering of the territory that is home to the professional manga artist, but also to the amateur or semi-professional in the early years of the twenty first century.

Some of the answers are contradictory. Is manga an artform? "Of course," some say.

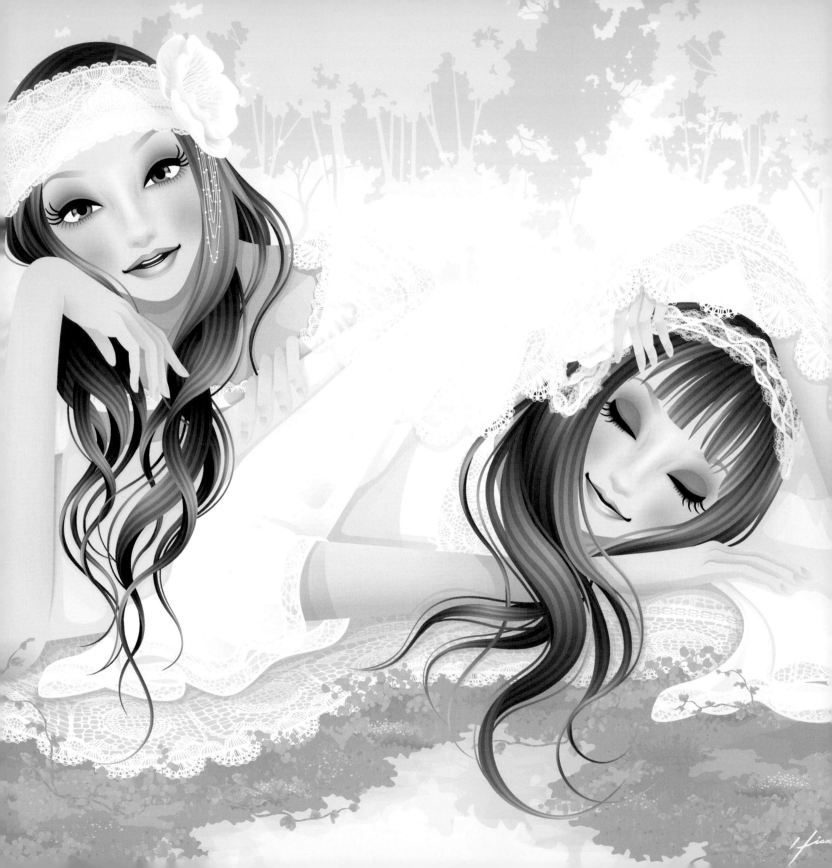

"Definitely not," say others. What advice would you give young illustrators who are just starting out? Some say "Copy the masters." "Don't copy anybody. Just look for your own style," say others.

They are all right.

And that is what makes this book attractive. Not the almost limitless range of artistic styles to be found in its pages. Not the hidden humor in some of the replies, or the irony, or wisdom. Not the dozens of different personalities, and the dozens of ways that different artists have of tackling what is ultimately the same task. But the combination of everything. Because there is one thing that is certain: no two readers will read the same thing in this book.

This is exactly what happens in manga. That is why this book, if not the best, is certainly one of the best books ever published on manga. On manga as it really is: not the one about the sad and slightly corny princesses, or the one with the post-apocalyptic barbarians, or the one with all the nuclear devastation. But the manga that contains anyone that has ever felt an undescribable emotion reading *Akira* or who has wept with *Grave of the Fireflies*. Whether they draw manga or not.

You know? They say that very few people saw Velvet Underground play when they were around at the end of the sixties. But they say that everyone that did ended up forming their own band. They did not form Velvet Underground. They formed their own group. That is just what this book demonstrates: anyone that has ever felt "the effect" of manga has devoted their life to art. Not necessarily to manga. But definitely to art.

1,000 Ideas

the occasional (tea) break

can work wonders too

001 WHERE DO THE IDEAS FOR YOUR DRAWINGS COME FROM? HOW DO YOU DO YOUR RESEARCH? Apart from the usual sources like music, films, books, Internet etc. it can be anything. Though while brushing my teeth I tend to get a lot of ideas strangely enough. I often get lost in my research.

002 WHAT DOES YOUR WORK DESK LOOK LIKE? WHAT CAN WE COME ACROSS? There are two phases on my desk. The mostly short and clean phase, and then there's the cramped version full of sketch blocks, art materials, my laptop, a graphics tablet and very often some tea.

003 WHAT IS THE FIRST THING YOU DO BEFORE SITTING DOWN TO DRAW? As bland as it might sound, I take a moment to concentrate on the task at hand and I usually get my tools ready, or I have to make space for them first.

004 DO YOU ALWAYS USE THE SAME TOOLS OR DO YOU CHANGE DEPENDING ON THE PIECE YOU'RE WORKING ON? It always depends on the individual piece I am working on. When I get an idea I want to put on paper, I automatically know what kind of material I should use.

005 WHAT ARE YOUR FAVORITE TOOLS OR DRAWING PROGRAMS, AND WHY? When I am working traditionally, it has to be markers. If it's a digital piece, then I prefer to work with Painter. Photoshop is essential nonetheless; and I shouldn't forget Manga Studio.

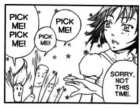

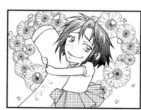

006 WHAT ADVICE WOULD YOU GIVE TO A NOVICE ILLUSTRATOR TRYING TO MAKE A NAME FOR HIMSELF? First of all, don't be shy. Take opportunities to get your portfolio reviewed, talk to other artists and go to conventions. They are a perfect place to get started and to meet like-minded people.

007 DO YOU FEEL THE NEED TO BETTER YOURSELF WHEN IT COMES TO YOUR WORK? TO WHAT EXTENT? Yes, and it's a constant struggle well knowing that you will never be fully satisfied. That's the drive, which keeps me improving. It's like this: next time you can do even better.

008 MANGA: IS IT ART? Honestly, why shouldn't it be art? There will always be people who say that's not art and those who say it is. Manga is relatively new to the Western world and still a novelty to the majority.

009 WHAT GOOD HABITS SHOULD A COMIC ILLUSTRATOR HAVE? Being critical about your own work. You should be realistic about your own abilities and improve steadily on the things you don't manage well enough yet. Be open-minded and observe consciously.

010 WHAT MAKES A COMIC SELL SUCCESSFULLY? I am pretty sure every comic creator and publisher would love to know a formula that works 100%. I would say a solid story, interesting characters and good art are indispensable along with promotion.

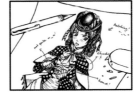
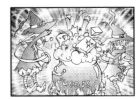

Aileen Strauch

http://kiwichameleon.com

Aileen Strauch is a freelance illustrator and comic artist who specializes in manga and anime inspired artwork. She always had a great interest in art, and has been an avid fan of manga and anime from a very young age. Originally self-taught, Aileen decided to take an initial hobby further and to broaden her skills. She loves to tell little stories with her illustrations, may it be just a moment's capture in time. She also writes tutorials, occasionally teaches drawing workshops and does demonstrations for artists' materials.

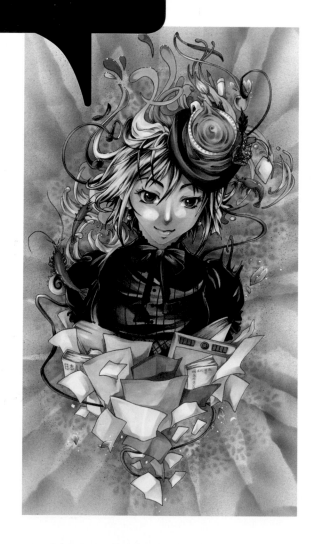

Akiko Matsuo

http://web.mac.com/matsuo_office

Akiko was born in 1975 and completed her studies at the University of Arts Graduate School in Osaka. She currently lives and works in Kamakura, in Kanagawa Prefecture. Since 2003 she has been working as a freelance artist. One of the many prizes she has received throughout her career is the *Grand Prize* of the 2007 Asia Digital Art Award, in the category of Still Images, along with several honorable mentions at the 2004 Aoyama Design Awards, and the 2005 Wacoal Renaissance Awards.

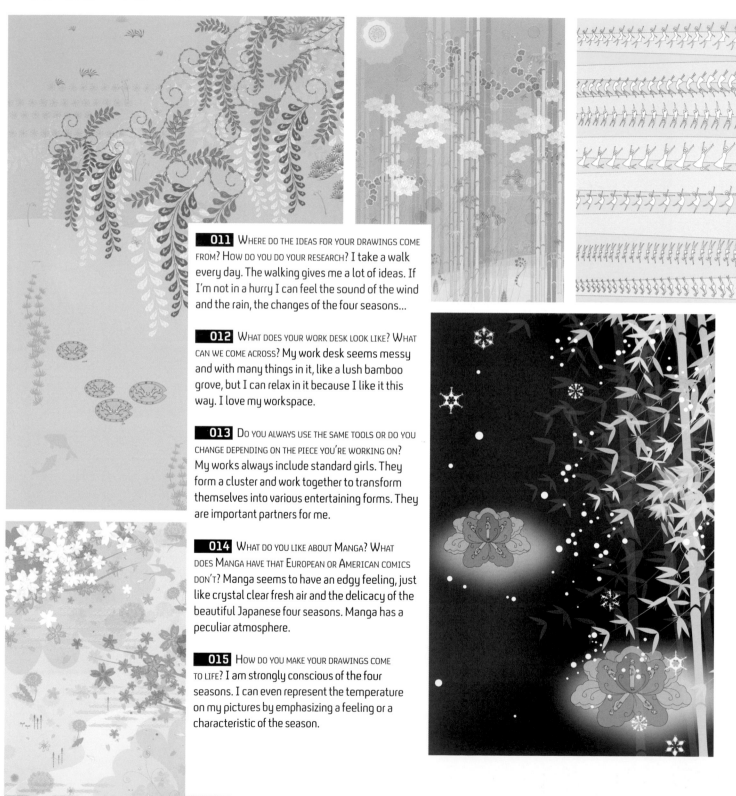

011 Where do the ideas for your drawings come from? How do you do your research? I take a walk every day. The walking gives me a lot of ideas. If I'm not in a hurry I can feel the sound of the wind and the rain, the changes of the four seasons...

012 What does your work desk look like? What can we come across? My work desk seems messy and with many things in it, like a lush bamboo grove, but I can relax in it because I like it this way. I love my workspace.

013 Do you always use the same tools or do you change depending on the piece you're working on? My works always include standard girls. They form a cluster and work together to transform themselves into various entertaining forms. They are important partners for me.

014 What do you like about Manga? What does Manga have that European or American comics don't? Manga seems to have an edgy feeling, just like crystal clear fresh air and the delicacy of the beautiful Japanese four seasons. Manga has a peculiar atmosphere.

015 How do you make your drawings come to life? I am strongly conscious of the four seasons. I can even represent the temperature on my pictures by emphasizing a feeling or a characteristic of the season.

016 WHAT ADVICE WOULD YOU GIVE TO A NOVICE ILLUSTRATOR TRYING TO MAKE A NAME FOR HIMSELF? The quick route to success is to do creative activities steadily every day. Even now I believe that success can blossom in a big way sometime in our life.

017 DO YOU FEEL THE NEED TO BETTER YOURSELF WHEN IT COMES TO YOUR WORK? TO WHAT EXTENT? My works should always take into account the concept of "age." I am especially conscious of colors. I would like to represent the age colors adequately.

018 WHY IS MANGA SO POPULAR IN THE WESTERN WORLD? The delicacy of manga is the key to its popularity. Though there are lots of things that have delicacy in the western world, I think that the delicacy of manga is unique.

019 WHAT GOOD HABITS SHOULD A COMIC ILLUSTRATOR HAVE? I hope they have the habit of trying to entertain people. I'm about to forget this habit because of my daily business, but I would like to keep it in mind.

020 WHAT MAKES A COMIC SELL SUCCESSFULLY? Having high goals leads to sales. For me, my goal is as magnificent as Mount Fuji. It is necessary to have a dream always. I will continue to do my best.

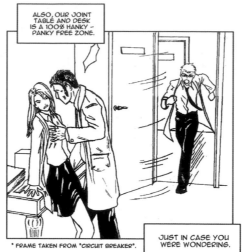

ALSO, OUR JOINT TABLE AND DESK IS A 100% HANKY-PANKY FREE ZONE.

JUST IN CASE YOU WERE WONDERING.

* FRAME TAKEN FROM "CIRCUIT BREAKER".

STOP! HE'S WEARING "WHITE-NET" - THAT SCREEN TONE CREASES REALLY EASILY!!

OH, THANK GOD.

* FRAME TAKEN FROM "UNNATURAL REMEDY".

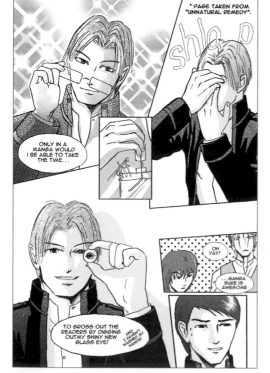

* PAGE TAKEN FROM "UNNATURAL REMEDY".

shla-p

ONLY IN A MANGA WOULD I BE ABLE TO TAKE THE TIME...

OH, YAY!

...MANGA SURE IS AWESOME

TO GROSS OUT THE READERS BY DIGGING OUT MY SHINY NEW GLASS EYE!

AND I WASHED MY HANDS!

021 WHO ARE YOUR FAVORITE ILLUSTRATORS? ARE YOU TRYING TO FOLLOW IN THEIR FOOTSTEPS? Angela: Minekura Kazuya, Hiromu Arakawa and Yumiko Shaku among many others. Other comics I like David Mack's *Kabuki* and Bill Willingham's *Fables*. I wouldn't say that I was trying to follow in their footsteps (is that even possible?) but I definitely take inspiration from them.

022 WHAT DOES YOUR WORK DESK LOOK LIKE? WHAT CAN WE COME ACROSS?. Gwen: I don't actually have a desk — my husband and I share the dining room table as a sort of office space, and move away the books and computers when we need to eat.

023 WHAT IS THE FIRST THING YOU DO BEFORE SITTING DOWN TO DRAW? Angela: Make a cup of tea. What type though, now that varies...

024 WHAT ARE YOUR FAVORITE TOOLS OR DRAWING PROGRAMS, AND WHY? Angela: Technical pencils for hand drawing. Pilot, with purple or blue leads is best for penciling. I usually ink using dip pens — I use a G-pen for most of the line work, and Maru for fine work and hatching. Lately I've started inking some work with a fine brush.

025 WHAT DO YOU LIKE ABOUT MANGA? WHAT DOES MANGA HAVE THAT EUROPEAN OR AMERICAN COMICS DON'T? Gwen: I like how manga takes its time with setting a scene, sometimes just with a single image. Manga generally takes it's time more than European or American comics, scenes are allowed to develop slowly, and it's completely acceptable to spend time exploring the characters' inner lives.

026 How do you make your drawings come to life? Angela: A good jolt of electricity and some manic laughter usually does it. Otherwise, changing the angles around, using different viewpoints to create drama.

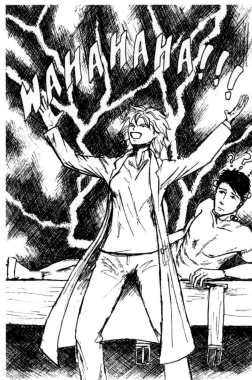

027 What advice would you give to a novice illustrator trying to make a name for himself? Angela: Get to know people in the field, make contacts, make friends, get your work out there. Take advice and improve what you do, and then show as many people as possible. Networking is good. I wish I was better at it.

028 Do you feel the need to better yourself when it comes to your work? To what extent? Gwen: There is always room for improvement. In my case, I always strive to find the characters' individual voices for the dialogue. I want readers to know who is speaking even if you only see bubbles over a tone background or an establishing shot of a building.

029 Manga: is it art? Angela: That question... I did my degree in fine art, and learned to hate the question, "So, what is art?" Its art if people say its art, otherwise its not. I don't think it matters.

030 What is the most important lesson you have learned that you would like to pass on to others? Gwen: Be as original as possible. By this I mean try to come up with either an idea that no one has had before, or a completely different spin on a tried and tested type of story.

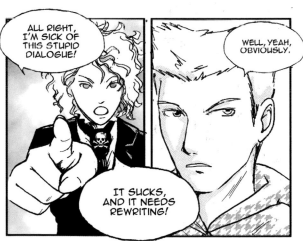

* FRAMES TAKEN FROM "CIRCUIT BREAKER".

Angela Wraight & Gwen Kortsen

www.angelawraight.co.uk

Angela Wraight is a painter as well as a manga artist. She works in oils and acrylics, and studied her degree at Chelsea School of Fine Art, London. She's also currently a full time student at UCL, studying electronic publishing – the subject she thinks has some implications for the future of most areas of publishing, including manga.

Gwen Kortsen was born in Bergen, Norway. She has lived in the UK for several years, happily married to her husband, and the two of them run small Speedlines Publishing together. Together with Angela Wraight, she has created the mangas *Unnatural Remedy* and *Circuit Breaker*. You can contact Gwen at info@ suicidaltoys.com or gwen@ speedlinespublishing.com.

Anna Fitzpatrick

www.annafitzpatrickart.com

Anna Fitzpatrick is an illustrator, comic artist and designer. She is originally from Dublin, Ireland, and is currently living and working in Cambridge, UK.

She currently works on her graphic novel *Between Worlds* as well as many other projects with the UK-based small press comics circle IndieManga.

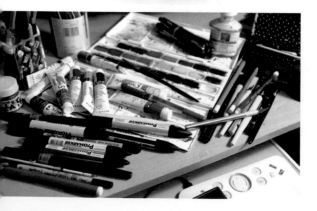

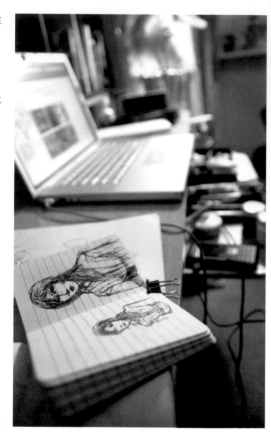

031 Where do the ideas for your drawings come from? How do you do your research? I get most of my ideas from my dreams. As soon as my head hits the pillow my imagination goes into overdrive (meaning I often end up getting no sleep!) When I'm awake, I look at many different sources for research, from other artists and creators to artistic movements.

032 Who are your favorite illustrators? Are you trying to follow in their footsteps? When I first started creating comics, my biggest influence was Miwa Ueda. These days, I love the work of Kenji Tsuruta, his work is highly underrated. He blends a beautiful detailed manga style with soft watercolors in his cover work and his stories are wacky and wonderful!

033 What does your work desk look like? What can we come across? My desk looks different every day! It depends on whatever I'm working on at the time. Usually I'll have my laptop there as I'm either using it to draw, do some research or just to play videos or music while I work. I always have sketchbooks nearby to jot down any ideas I get. I usually forget ideas fast, so I need to get them on paper as soon as I can!

034 Do you always use the same tools or do you change depending on the piece you're working on? I use something different for every project. Every time I create something new, I want to learn something new. I like to experiment between both traditional and digital media. So in some comics I've used nothing but ink and paper, others I've done on my computer from scratch.

035 What are your favorite tools or drawing programs, and why? I absolutely love to use pencil, watercolors and inks. Though it's hard to create a full comic with these. I usually use them for illustrations or for short comics. I would like to do a more ambitious project using watercolors and pencils someday. I love working digitally also for its ease and speed.

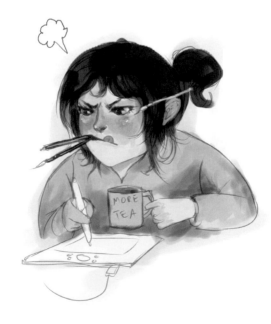

036 WHAT DO YOU LIKE ABOUT MANGA? WHAT DOES MANGA HAVE THAT EUROPEAN OR AMERICAN COMICS DON'T? I love the reach manga has. I love how there is a manga for everyone. It never talks down to its audience, it respects it. I love the pacing in manga. How it takes its time to give us the right atmosphere, using clever panelling and layouts to set the perfect scene.

037 WHAT DIFFERENTIATES YOU FROM MANGA'S OTHER ILLUSTRATORS? I think every artist gives their own slant on manga. When I first began, I was obsessed with following the rules of manga, but as I've grown and gained experience, I've learned that one of the most important things is to create art that people can look at and instantly know who created it.

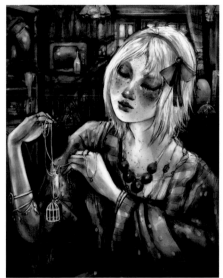

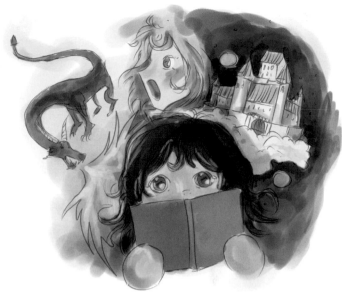

038 WHAT ADVICE WOULD YOU GIVE TO A NOVICE ILLUSTRATOR TRYING TO MAKE A NAME FOR HIMSELF? Don't worry so much about a "name" and focus your energy on creating something great. Put work into study of anatomy and environments. Look further than manga style and into great artists. Be constantly critical of your work, but don't be so critical you're too afraid to put pen to paper! Get a trusted friend to read your work and tell you honestly if it reads well. If you create great work, put it online, print it, sell it at conventions. Make friends with your fellow artists, the best contacts you'll ever make in the industry is your co-creators.

039 DO YOU FEEL THE NEED TO BETTER YOURSELF WHEN IT COMES TO YOUR WORK? TO WHAT EXTENT? Every single day. A true artist is always working towards improvement. There is never a point where an artist says "yeah, I'm perfect now." If I ever got to that stage, I'd be dead as an artist.

040 WHAT IS THE GREATEST ACKNOWLEDGEMENT YOU COULD HOPE TO ACHIEVE FOR YOUR WORK? To find others who do the same and work alongside them. Being a comic artist can be very lonely work. It's long hours and no one to talk to! Having other comic artists as my friends means that I can share my thoughts on life as a comic artist.

2009

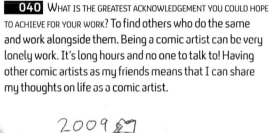

2010

THE FUTURE

041 WHERE DO THE IDEAS FOR YOUR DRAWINGS COME FROM? HOW DO YOU DO YOUR RESEARCH? I think the biggest research I do is watching my cats. I didn't do any kind of comics for six years so starting again was a real challenge. My editor and I decided to go for a very old-fashioned format and it took ages to find the correct sizes.

042 WHAT DOES YOUR WORK DESK LOOK LIKE? WHAT CAN WE COME ACROSS? I have a huge room with actually four tables. My assistant has her own working place and it's nice if you can work without sitting on each others lap. You might come across masses of paper I need for scribbles, my light-table, computers, alot of coffee cups, memos sticking practically everywhere and a lot of lamps.

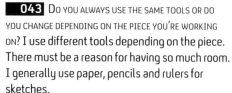

043 DO YOU ALWAYS USE THE SAME TOOLS OR DO YOU CHANGE DEPENDING ON THE PIECE YOU'RE WORKING ON? I use different tools depending on the piece. There must be a reason for having so much room. I generally use paper, pencils and rulers for sketches.

044 DO YOU PREFER THE CLASSIC GUIDELINES FROM MANGA OR EXPERIMENTING WITH NEW CHANNELS? The classic guidelines don't really work for my project since I work in a very old-fashioned Sunday Strip format, though I consider my characters more Japanese inspired than European. I think the meaning "manga" is stretchable as "comic" is. As long as people love what you do it shouldn't really matter. I guess.

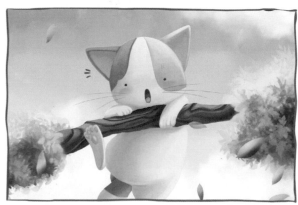

045 HOW DO YOU MAKE YOUR DRAWINGS COME TO LIFE? I normally think around way too long about the general idea of the comic and if the muse happens to hit me (normally very late at night) I do a very rough and normally unidentifiable sketch into my Moleskine. After that I do a clean sketch on paper, scan it and Lew flats the whole page in basic colors. I do the final painting and send those to my publisher for lettering.

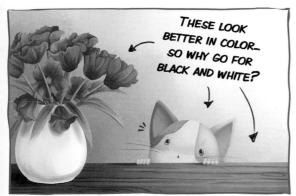

046 WHAT DIFFERENTIATES YOU FROM MANGA'S OTHER ILLUSTRATORS? I think as much as everybody is different. I try to do things in my own way (within the restricted format I'm bound to) and I think one of the very special things is that I work full-color without outlines. It can be quite annoying but it works best for me. :)

047 HOW IMPORTANT IS PROMOTION TO YOU? HOW DO YOU PROMOTE YOUR WORK? I work white-label when a company asks for it, which leads to practically zero promotion, but I generally prefer the other way. I like DeviantArt. The other thing is working versatile in different channels. I love doing board games as much as things for the iPad, as well as doing comics. People consider you more flexible that way—which is good. I guess.

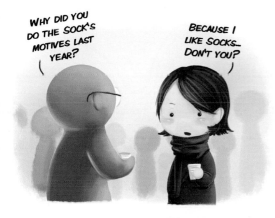

048 DO YOU FEEL THE NEED TO BETTER YOURSELF WHEN IT COMES TO YOUR WORK? TO WHAT EXTENT? I'm practically always restless and unsatisfied. It's not like "gah, that looks so ugly" but more like "looks good but I think I could make it better." It's no use to push yourself too much. I improve the most when I work on different projects because companies expect different things and that teaches me alot.

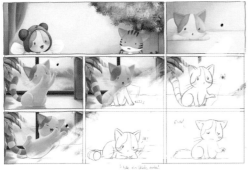

049 WHAT IS THE MOST IMPORTANT LESSON YOU HAVE LEARNED THAT YOU WOULD LIKE TO PASS ON TO OTHERS? Be brave, be curious, try to be patient and stay yourself. There is no recipe for becoming successful and a good artist, so generally I believe all feedback will teach you something and normally how to do it better next time, so don't fear that. It's part of the job.

050 WHAT MAKES A COMIC SELL SUCCESSFULLY? I think you have to push a button inside the heart of the reader. Somewhere where it hurts, feels fuzzy or horrified. Nothing is as bad as a perfectly drawn comic that is not able to create mood. I'd prefer a not-so-pretty but awfully charming artwork with an interesting story.

Anne Pätzke

www.trenchmaker.com

Anne was born in 1982 in Frankfurt (the small one) in Germany and decided at the age of 19 that Berlin would be a perfect place to work and live. She wrote and illustrated three children books published by Tokyopop in Germany. Last year she did socks motives, a board game, some things for the iPad, smartphone, puzzles, postcards and some more she probably forgot to mention. Anne still lives in Berlin with one man and two cats. She does comics.

Atsushi Ikeda

http://black-panzer.jpn.org

Atsushi Ikeda is a Japanese illustrator known because of his shadowgraphed robots (shadowgraph is an optical method that reveals non-uniformities in transparent media like air, water, or glass). His works have been reproduced mainly in large-scale posters, apparel and CD jackets.

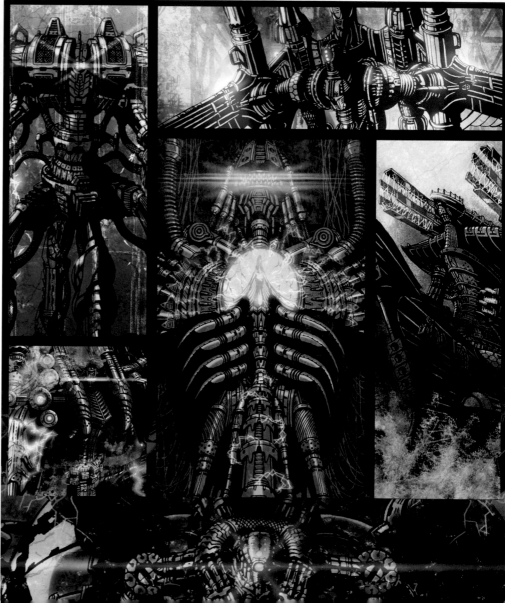

051 WHERE DO THE IDEAS FOR YOUR DRAWINGS COME FROM? HOW DO YOU DO YOUR RESEARCH? The ideas float in daily life. I observe a lot of my favorite things every day. I often take a look to my favorite machines.

052 WHAT IS THE FIRST THING YOU DO BEFORE SITTING DOWN TO DRAW? I drink coffee.

053 WHAT ARE YOUR FAVORITE TOOLS OR DRAWING PROGRAMS, AND WHY? I like to draw with paper and pencil, that's all. With them, feelings are expressed easily.

054 WHAT DO YOU LIKE ABOUT MANGA? WHAT DOES MANGA HAVE THAT EUROPEAN OR AMERICAN COMICS DON'T? I like freewheeling thinking. The United States has comic books, Europe has the BD and Japan has manga.

055 WHAT DIFFERENTIATES YOU FROM MANGA'S OTHER ILLUSTRATORS? I think that draw the shadows chiefly. Please, see and judge my pictures.

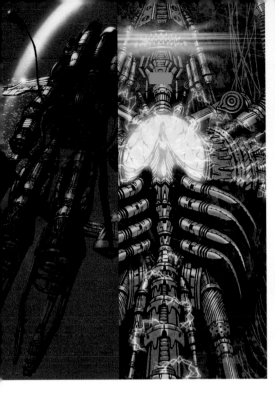

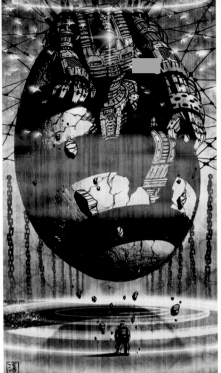

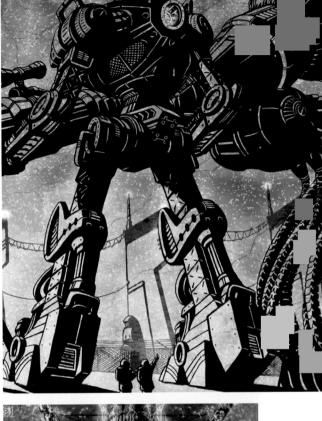

056 WHAT ADVICE WOULD YOU GIVE TO A NOVICE ILLUSTRATOR TRYING TO MAKE A NAME FOR HIMSELF? Believe in yourself.

057 WHAT HAS CHANGED ABOUT YOUR STYLE OF DRAWING SINCE YOU BEGAN? Now I draw with more detail. Please, compare the works.

058 MANGA: IS IT ART? Manga is art. My pictures are also art.

059 WHAT GOOD HABITS SHOULD A COMIC ILLUSTRATOR HAVE? To take frequent looks at his favorite things.

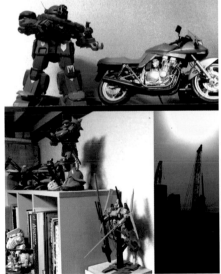

060 WHAT IS THE GREATEST ACKNOWLEDGEMENT YOU COULD HOPE TO ACHIEVE FOR YOUR WORK? To get people interested positively in my work.

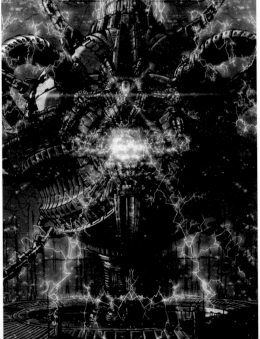

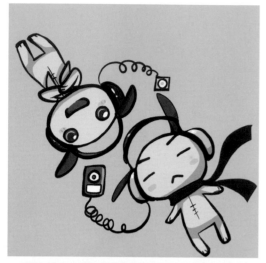

061 WHERE DO THE IDEAS FOR YOUR DRAWINGS COME FROM? HOW DO YOU DO YOUR RESEARCH? Most of my ideas come from observation. I watch and listen to people around me and let my imagination run wild.

062 WHAT DOES YOUR WORK DESK LOOK LIKE? WHAT CAN WE COME ACROSS? Honestly, it's a mess... but a controlled mess. Aside from art supplies and my computer, I have business paperwork all over the place. I work in pretty tight quarters, but as I do most of my work on my computer, I don't need too much space.

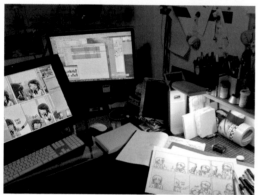

063 WHAT ARE YOUR FAVORITE TOOLS OR DRAWING PROGRAMS, AND WHY? My absolute must-haves are, for my comics: Colerase Light Blue pencils, Mono Erasers, Legal sized printer paper, Photoshop CS4, Painter XI and Wacom Cintiq 21UX. For my illustrations: Pentel Pocket Brush Pen, Copic Markers, Verithin Colored Pencils and Fabriano Hot Press Watercolor Paper.

064 DO YOU PREFER THE CLASSIC GUIDELINES FROM MANGA OR EXPERIMENTING WITH NEW CHANNELS? I prefer to learn how things were done traditionally, attempt to implement them into my own work, then experiment with new styles. In a world where art, be it music, fashion or comics, is influenced by many channels, it's only natural for things to evolve. I believe we all try to find a unique way of expressing one's self.

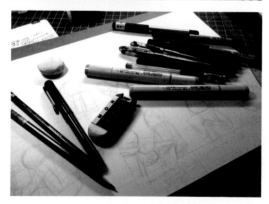

065 HOW DO YOU MAKE YOUR DRAWINGS COME TO LIFE? I like to focus on expressions and am working on improving my characters body language. I feel if my comics can be read without words, I've done my job.

066 WHAT ADVICE WOULD YOU GIVE TO A NOVICE ILLUSTRATOR TRYING TO MAKE A NAME FOR HIMSELF? Observation is the key to art. Take in as much of the world around you, don't be a hermit. We are influenced by everything we see, hear, do, especially the people we meet. Each person you meet will color your life and in small ways change you. Make those connections. Most importantly, share your work with others and seek out your peers. Take risks and challenge yourself.

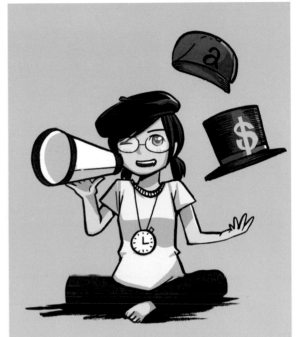

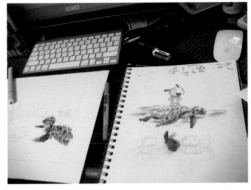

067 DO YOU FEEL THE NEED TO BETTER YOURSELF WHEN IT COMES TO YOUR WORK? TO WHAT EXTENT? I always want to better myself. I try to challenge myself to improve with each and every drawing I do. There's always room for improvement. I never want to sit and rest on my laurels.

068 MANGA: IS IT ART? Of course!

069 WHAT IS THE MOST IMPORTANT LESSON YOU HAVE LEARNED THAT YOU WOULD LIKE TO PASS ON TO OTHERS? To make a career in comics (and art in general), you must be willing to work hard and sacrifice your free time. You have to juggle many hats: artist, writer, and business person. In this ever-changing world, you must be creative and quickly adapt.

070 WHAT IS THE GREATEST ACKNOWLEDGEMENT YOU COULD HOPE TO ACHIEVE FOR YOUR WORK? To have people look at my work, and smile.

Audra Ann Furuichi

www.nemu-nemu.com

Kyubikitsy (aka Audra Furuichi) draws and colors pretty pictures while KimonoStereo (aka Scott Yoshinaga) does just about everything else around here. Both collaborate on their story lines (with a little help from some stuffed friends). The two currently reside in Honolulu (Hawaii), where they have created KimonoKitsy Studios (and for your interest, on October 31st of 2007 the duo teamed up for the ultimate project: marriage!) In September of 2007, Audra took the big leap and made producing the comic series *nemu***nemu* her full-time job. *nemu***nemu* is published every Monday, Wednesday and Friday. If you live in East Oahu, *nemu***nemu* appears monthy in the East Oahu Sun News

Ayako Okubo

http://web.me.com/kitekiss

Ayako Okubo is a caricaturist and artist from Tokyo. Her cartoon style is poetic, and known by having been owned by Museum of Tokyo University of Arts. Ayako works across different fields, including Japanese cartoon, philosophy, entertainment, and research. She has approached manga culture and contemporary art from her own unique angle. Recently, she has been designing characters for a TV animation series.

071 WHERE DO THE IDEAS FOR YOUR DRAWINGS COME FROM? HOW DO YOU DO YOUR RESEARCH? From books and more books.

072 WHAT DOES YOUR WORK DESK LOOK LIKE? WHAT CAN WE COME ACROSS? It's like a sweet sea.

073 WHAT IS THE FIRST THING YOU DO BEFORE SITTING DOWN TO DRAW? I force mind switch.

074 WHAT ARE YOUR FAVORITE TOOLS OR DRAWING PROGRAMS, AND WHY? Just Pen. Feeling-goood grip!

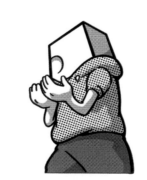

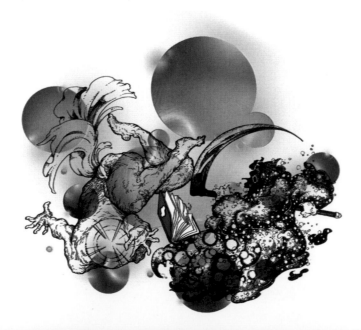

075 DO YOU PREFER THE CLASSIC GUIDELINES FROM MANGA OR EXPERIMENTING WITH NEW CHANNELS? Both are wonderful.

076 How do you make your drawings come to life? One of my principles is "not to wake up the sleeping man."

077 What has changed about your style of drawing since you began? It's the same since I was five years old.

078 Manga: is it art? Manga is just manga.

079 What is the most important lesson you have learned that you would like to pass on to others? To give up childlike ideas.

080 What good habits should a comic illustrator have? To travel at the speed of light.

い〜の
い〜の

081 WHERE DO THE IDEAS FOR YOUR DRAWINGS COME FROM? HOW DO YOU DO YOUR RESEARCH? My ideas come from my dreams, personal life happenings and things seen on TV, in movies or read in books. Most of my research is done through the Internet, books and personal experiences.

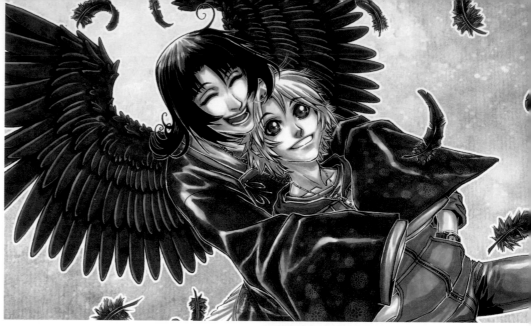

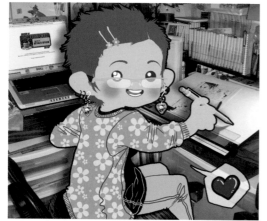

082 WHAT DOES YOUR WORK DESK LOOK LIKE? WHAT CAN WE COME ACROSS? A chaotic mess until I move things in order to work. There are old sales receipts and jewelry, art markers and drawing supplies, my computer and tablet and stacks of manga, artbooks and artwork.

083 WHAT ARE YOUR FAVORITE TOOLS OR DRAWING PROGRAMS, AND WHY? Various art markers, inking pens, Deleter ComicWorks and Photoshop are my favorite tools. I love the feeling of working with traditional medium, and I love the ease of editing my work digitally.

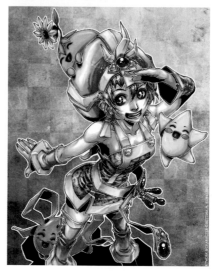

084 WHAT DO YOU LIKE ABOUT MANGA? WHAT DOES MANGA HAVE THAT EUROPEAN OR AMERICAN COMICS DON'T? The art and storytelling styles and personal connections I get from most manga series stories and characters appeal far more to me than that of most European or American comics.

085 HOW DO YOU MAKE YOUR DRAWINGS COME TO LIFE? I try to get into the mind of the characters to get a better feel for them in order to capture their personality and character within the artwork. And sticking your tongue out while drawing helps too!

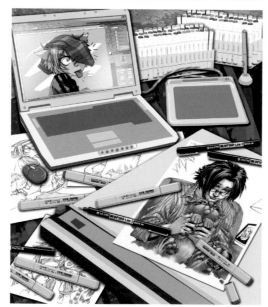

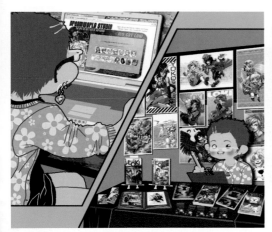

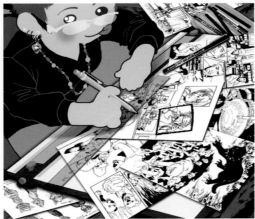

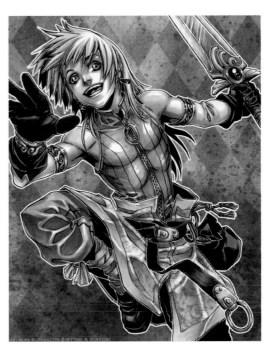

086 WHAT ADVICE WOULD YOU GIVE TO A NOVICE ILLUSTRATOR TRYING TO MAKE A NAME FOR HIMSELF? Put yourself out there! Be it selling your work at conventions or posting it on online art communities. The more you make yourself and your work visibly present, the more you'll become known.

087 DO YOU FEEL THE NEED TO BETTER YOURSELF WHEN IT COMES TO YOUR WORK? TO WHAT EXTENT? Absolutely! In most everything, from storytelling to anatomy to how I use both traditional and digital mediums, I'm always looking to improve something. One can never stop at improving her work!

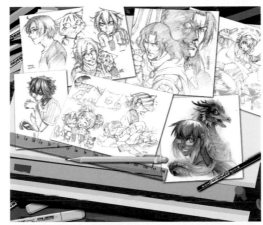

088 MANGA: IS IT ART? It most certainly is! From each little panel on every page to the full colored covers and creating all series related merchandise, such as posters, figures and animation, it's all works of art!

089 WHAT GOOD HABITS SHOULD A COMIC ILLUSTRATOR HAVE? Practice, practice, practice! Be it simple little sketches to full blown full colored completed illustrations, practice makes perfect, improves your skills and keeps you in shape!

090 WHAT IS THE GREATEST ACKNOWLEDGEMENT YOU COULD HOPE TO ACHIEVE FOR YOUR WORK? Having my series turned into an animated or live action show or movie! Seeing and hearing the characters I've breathed life into moving on screen would be an absolutely incredible accomplishment!

Bettina M. Kurkoski

http://dreamworldstudio.net

Bettina M. Kurkoski, living in Plymouth, Massachusetts, defines herself as creator, writer, penciller, inker, toner, coffee maker and dark chocolate eater. She's been drawing since she can remember. Throughout elementary school, she'd entertain herself drawing thousand of pictures of Garfield. By the time she hit seventh grade, she was bitten by the comic book bug and had a healthy dosage of anime. She then began creating her own characters and comics with a very eighties flare. She then went off to college and majored and graduated with a bachelor of fine arts in illustration from UMass-Dartmouth. After college, she took up some regular Joe jobs to pay back college loans and rekindled her love for anime. Through this addiction her style evolved with a very anime look to it. Even though she did go to college, she's pretty much 80 percent self taught! Bettina M. Kurkoski is the owner of Dreamworld Studio.

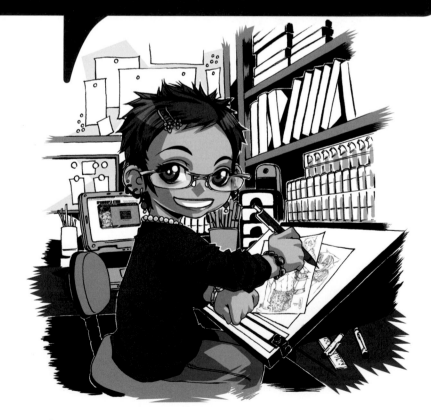

C. Lijewski

www.heavy-gauge.net

C. Lijewski is an artist located in Atlanta. She got a degree in sequential art at the Savannah College of Art and Design. Her favorite comics are *MPD Psycho, Bleach, Freesia, King of Bandit Jing,* *Dorohedoro* and *Pink Sniper.* Regarding music, her tastes are Ellegarden, Nightmare, AKFG, An Café, Zabadak, Yasunori Mitsuda, Scudelia Electro, Cake, Akira Yamaoka and Shoji Meguro. When asked about games, she gives the names of *Xenogears, Final Fantasy X, NIER, Tales of the Abyss, Earthbound, Shadow Hearts* and *Devil May Cry.*

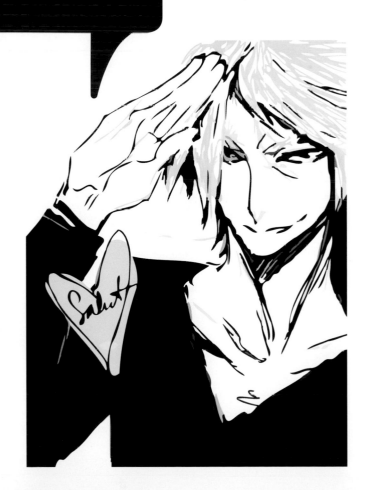

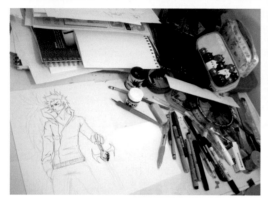

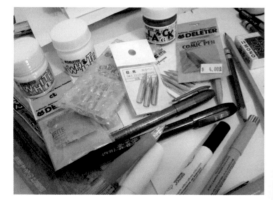

091 WHERE DO THE IDEAS FOR YOUR DRAWINGS COME FROM? HOW DO YOU DO YOUR RESEARCH? Music is my biggest influence, listening to a special track can really form an image and idea in my mind. I also find inspiration from real life events, my darker works a lot of times are inspired by true crime documentaries and real life events.

092 WHO ARE YOUR FAVORITE ILLUSTRATORS? ARE YOU TRYING TO FOLLOW IN THEIR FOOTSTEPS? I have so many, it's hard to list just a few. I guess if I had to pick a top five I'd say Sho-u Tajima, Kubo Tite, Shirow Miwa, Jiro Matsumoto and Q. Hayashida. I tend to like strong ink artists who have a good grasp of spotting blacks and balancing black and white.

093 WHAT DOES YOUR WORK DESK LOOK LIKE? WHAT CAN WE COME ACROSS? Messy, very messy. My drawing desk is usually covered with sketches, character design sheets, names, scripts, you name it. If I'm working on a comic the thing is covered in all my reference material, leaving me just enough room to draft a page.

094 DO YOU ALWAYS USE THE SAME TOOLS OR DO YOU CHANGE DEPENDING ON THE PIECE YOU'RE WORKING ON? When I come up with an idea for an illustration I usually picture it in it's final version, meaning if I'm going to work in CG or maybe plain inks or Copics I'll know from the beginning. I work in different ways for different mediums.

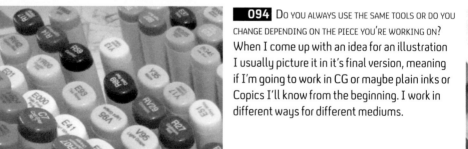

095 WHAT ARE YOUR FAVOURITE TOOLS OR DRAWING PROGRAMS, AND WHY? Analog media is my preferred choice. I really like sketching and inking traditionally. I like dip pens like the Maru and G-pen but will also use liner pens like Microns. I also prefer using Copics for colors.

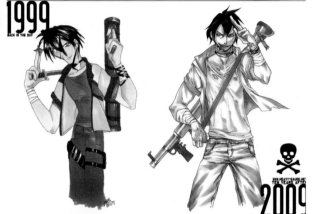

096 WHAT DO YOU LIKE ABOUT MANGA? WHAT DOES MANGA HAVE THAT EUROPEAN OR AMERICAN COMICS DON'T? I personally like the vast array of different styles and stories found in manga. That's what drew me to it in the first place. Pretty much anything you like you can find a manga written about, it covers all genres and all demographics. It's a very versatile form of sequential art, it caters to everyone!

097 WHAT DIFFERENTIATES YOU FROM MANGA'S OTHER ILLUSTRATORS? Analog arts aren't as popular with American manga artists and illustrators, we tend to be a very digital group I think, so maybe being an old skool traditional artist in a sea of digital helps? Especially with inking, everyone seems to like digital inking these days but I still love traditional.

098 DO YOU FEEL THE NEED TO BETTER YOURSELF WHEN IT COMES TO YOUR WORK? TO WHAT EXTENT? Of course! There's always something I can learn to do better, but the only way to learn to do it better is to keep working and to keep growing as an artist. Anyone who thinks his art is as good as it gets or as good as it needs to be is going to stagnate as an artist.

099 MANGA: IS IT ART? Of course! Not only is manga visual art it's also art of the written word since you need to have a story and dialogue to go along with your illustrations.

100 WHAT IS THE GREATEST ACKNOWLEDGEMENT YOU COULD HOPE TO ACHIEVE FOR YOUR WORK? If people read and like my work I'm happy, that's really all I need. When I get a nice letter from a reader that makes all the hard work seem worth it. People taking the time to thank you for your work, is really a great feeling, too.

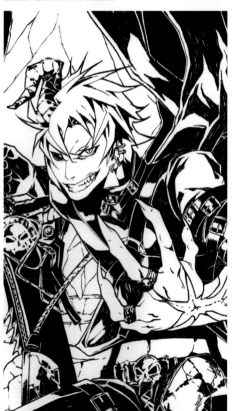

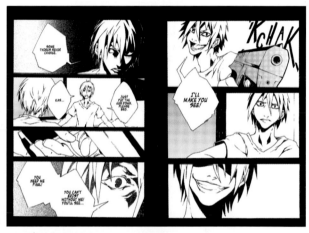

101 WHERE DO THE IDEAS FOR YOUR DRAWINGS COME FROM? HOW DO YOU DO YOUR RESEARCH? I go out when I need some inspiration, since quite often I'm in a public transport when a good idea comes. I also collect a variety of images and quotes, whatever stimulates my imagination and emotions.

102 WHO ARE YOUR FAVORITE ILLUSTRATORS? ARE YOU TRYING TO FOLLOW IN THEIR FOOTSTEPS? If I have to choose one, it's Asumiko Nakamura. I haven't thought about following her but I just admire her creations, especially her ways of storytelling and her line drawings.

103 WHAT DOES YOUR WORK DESK LOOK LIKE? WHAT CAN WE COME ACROSS? I use my beloved Mac to work. My baby is actually a laptop so I put him on a pile of thick books so my eye level is even with the monitor.

104 WHAT ARE YOUR FAVORITE TOOLS OR DRAWING PROGRAMS, AND WHY? I use Manga Studio and Photoshop most of the time. They are practical (less messy) and economical (smaller space is needed).

105 HOW DO YOU MAKE YOUR DRAWINGS COME TO LIFE? Facial expressions! I always focus on a character's facial expressions and any other aspects that express a character's feelings and each scene's atmosphere.

107 Manga: is it art? Yes and no. It can be but it doesn't have to be. This kind of flexibility is one of the greatest things about manga.

108 What is the most important lesson you have learned that you would like to pass on to others? In order to meet a deadline, draw at least one panel every day even when you feel extremely dull.

109 What good habits should a comic illustrator have? Having two sides: one is a cool "third person's view" side to see your work critically and the other is "full of confidence and love toward your own work" side.

110 What is the greatest acknowledgement you could hope to achieve for your work? I would love to see my work reproduced as anime! If this dream comes true I will definitely take a part in casting voice actors!

106 Do you feel the need to better yourself when it comes to your work? To what extent? Yes. I seriously need to improve my time management skills. As for manga technique, there are so many things I want to develop and I think I'll never be satisfied...

Chie Kutsuwada

http://chitan-garden.blogspot.com

Chie Kutsuwada was born in Japan. After graduating from the Royal College of Art, she is now based in London working as a professional manga artist. She attends regular manga-related events and runs manga workshops at various institutions around UK such as the British Museum and Victoria & Albert Museum. She usually creates her own original stories as well as illustrations like *King of a Miniature Garden* (2007), her first manga, and *Moonlight*, which was shortlisted in the Manga Jiman competition organised by the UK Japan Embassy. She also produced the artwork for Shakespeare's *As You Like It* (SelfMadeHero), *Hagakure* (Kodansha) and others.

my soul

David 'Def' Füleki

www.manga-madness.de

David Füleki asked to write his own biography. Here it's: "Ouf! Biography... Hmmm... I hatched out of my egg in 1985. By the way: It was exactly that day and that hour when a cataclysmic earthquake devastated Mexico City and killed about 10.000 people. Even today I feel a little guilty for that. Anyway! I was somehow raised in East Germany and became a well-behaved boy. Later, I developed a self-destructive obsession with schnitzel. My illustrations have circulated through orbit since 1997, my comics since 2001. Besides the artistic stuff I also learned "something senseful" (the rather geeky study of media communication). The end?"

111 WHERE DO THE IDEAS FOR YOUR DRAWINGS COME FROM? HOW DO YOU DO YOUR RESEARCH? A lot of my ideas are the result of time consuming brainstormings. But I always keep space for spontaneous inspiration. That gives your work that special touch of unpredictability and sometimes insanity.

112 WHAT DOES YOUR WORK DESK LOOK LIKE? WHAT CAN WE COME ACROSS? It looks like Kosovo during war. However, I've learned to master the chaos.

113 DO YOU ALWAYS USE THE SAME TOOLS OR DO YOU CHANGE DEPENDING ON THE PIECE YOU'RE WORKING ON? There are some favorites — different pens for inking, copics or gouache for coloring etc. But I literally try to use everything crossing my paths, including grass, dirt, coffee, flowers, pudding and so on. No joke.

114 HOW IMPORTANT IS PROMOTION TO YOU? HOW DO YOU PROMOTE YOUR WORK? Promo plays a major part in the whole process of becoming reasonably well-known. Blogs, Facebook and signing sessions aren't less important than working on your style. Especially in your early years.

115 WHAT ADVICE WOULD YOU GIVE TO A NOVICE ILLUSTRATOR TRYING TO MAKE A NAME FOR HIMSELF? Polarize! Trying something completely new often scares a majority of potential watchers or readers. But finding a niche for yourself is unavoidable if you don't want to sink in the mainstream.

116 WHAT HAS CHANGED ABOUT YOUR STYLE OF DRAWING SINCE YOU BEGAN? My pics don't look like expressionistic spaghetti vomit anymore (like my early works did).

117 MANGA: IS IT ART? No, it's just another word for comic. But as is the case with some non-Japanese works, there are some manga which break through the frontier of just being an illustrated story and become pieces of real art.

118 WHAT IS THE MOST IMPORTANT LESSON YOU HAVE LEARNED THAT YOU WOULD LIKE TO PASS ON TO OTHERS? Always eat your schnitzel! You'll need a lot of energy.

119 WHAT GOOD HABITS SHOULD A COMIC ILLUSTRATOR HAVE? You need endurance, tempo, a realistic valuation of your style (also know your weak points), self-confidence and balls — at least four of them!

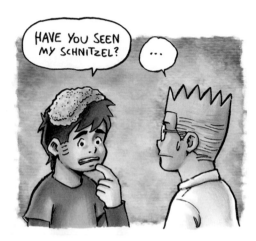

120 DO YOU FEEL THE NEED TO BETTER YOURSELF WHEN IT COMES TO YOUR WORK? TO WHAT EXTENT? I can't stand to see other artist's works and finding enormous differences in the level of professionalism regarding special aspects. It's always a great motivation to decrease those differences.

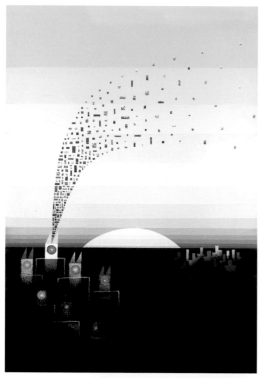

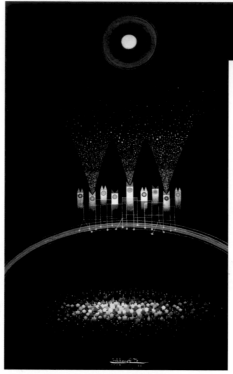

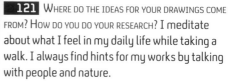

121 WHERE DO THE IDEAS FOR YOUR DRAWINGS COME FROM? HOW DO YOU DO YOUR RESEARCH? I meditate about what I feel in my daily life while taking a walk. I always find hints for my works by talking with people and nature.

122 WHO ARE YOUR FAVORITE ILLUSTRATORS? ARE YOU TRYING TO FOLLOW IN THEIR FOOTSTEPS? I respect Mr. Hasegawa Yoshifumi as a picture-book artist. I always make efforts to establish my own style of drawing, following the example of his attitude toward his works.

123 WHAT IS THE FIRST THING YOU DO BEFORE SITTING DOWN TO DRAW? The first thing I do is clean my room, then I wash my hands and make coffee. The last thing I do before sitting to draw is praying to draw well.

124 DO YOU ALWAYS USE THE SAME TOOLS OR DO YOU CHANGE DEPENDING ON THE PIECE YOU'RE WORKING ON? I usually use crayon and watercolor, but I use various drawing materials in each work to reproduce ideas or images faithfully.

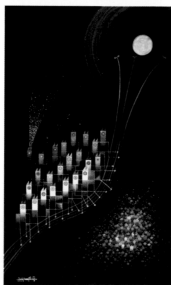

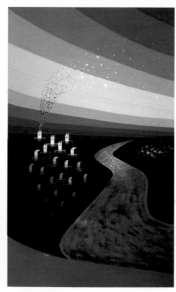

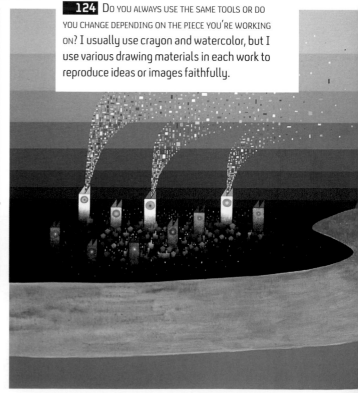

125 HOW DO YOU MAKE YOUR DRAWINGS COME TO LIFE? I try strongly to send happiness to the people who see my works.

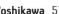

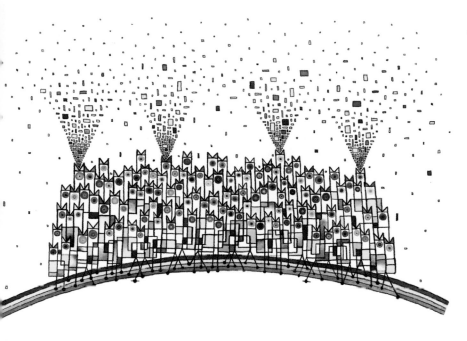

126 WHAT ADVICE WOULD YOU GIVE TO A NOVICE ILLUSTRATOR TRYING TO MAKE A NAME FOR HIMSELF? Making a name for yourself is difficult, but keeping one is even more difficult. It's important to continue learning and working hard with a modest attitude.

127 DO YOU FEEL THE NEED TO BETTER YOURSELF WHEN IT COMES TO YOUR WORK? TO WHAT EXTENT? Improvement in myself makes the quality of my drawings improve. Practicing Buddhism each day makes my mind grow richly.

128 WHAT HAS CHANGED ABOUT YOUR STYLE OF DRAWING SINCE YOU BEGAN? The change produced in my mind when I learned Nichiren Buddhism influences my drawings.

129 WHAT IS THE MOST IMPORTANT LESSON YOU HAVE LEARNED THAT YOU WOULD LIKE TO PASS ON TO OTHERS? My teacher taught me that there is no more happiness than aiming at common happiness to myself and other people. This is the best life.

130 WHAT IS THE GREATEST ACKNOWLEDGEMENT YOU COULD HOPE TO ACHIEVE FOR YOUR WORK? When I draw, I always put happiness and hope into my drawings to send them to the people who see my drawings.

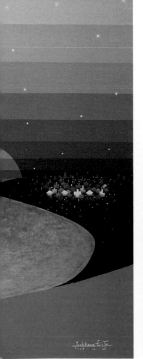

Eito Yoshikawa

http://home.att.ne.jp/kiwi/eito

Eito Yoshikawa was born in Osaka in 1971, and he started his career as an illustrator in 1988. In 1993 he mounted his first individual exhibition at the Paradise gallery in Osaka. This exhibition was followed by many others at the Chayamachi and Guild galleries in Osaka, the Paw in Hyogo, the White Cube in Kyoto, and Peter's Shop in Tokyo. His work is a regular feature in the magazines published by media conglomerate Asahi Shimbun Company.

Emiko Goto

www.emikogoto.com

After training as an illustrator, Emiko Goto started her career as a freelance artist and illustrator, which led her to work in the publishing and advertising industry. Her work has appeared on book covers, magazines and advertisements, and has also been seen in exhibitions in popular Japanese galleries, such as HB Gallery, Dazzle and the National Art Center in Kyoto.

131 WHO ARE YOUR FAVORITE ILLUSTRATORS? ARE YOU TRYING TO FOLLOW IN THEIR FOOTSTEPS? I am a fan of Hokusai, the ukiyo-e artist. I may be unconsciously following his work.

132 WHAT IS THE FIRST THING YOU DO BEFORE SITTING DOWN TO DRAW? I make a cup of tea and check my e-mails.

133 DO YOU ALWAYS USE THE SAME TOOLS OR DO YOU CHANGE DEPENDING ON THE PIECE YOU'RE WORKING ON? Generally I use drawing software. Sometimes I draw with crayons on paper. It depends on the work.

134 DO YOU PREFER THE CLASSIC GUIDELINES FROM MANGA OR EXPERIMENTING WITH NEW CHANNELS? I've been keeping my favorite classic mangas since I was child. But I like the new styles of manga, also. I love both.

135 HOW DO YOU MAKE YOUR DRAWINGS COME TO LIFE? Making drawings that include a story.

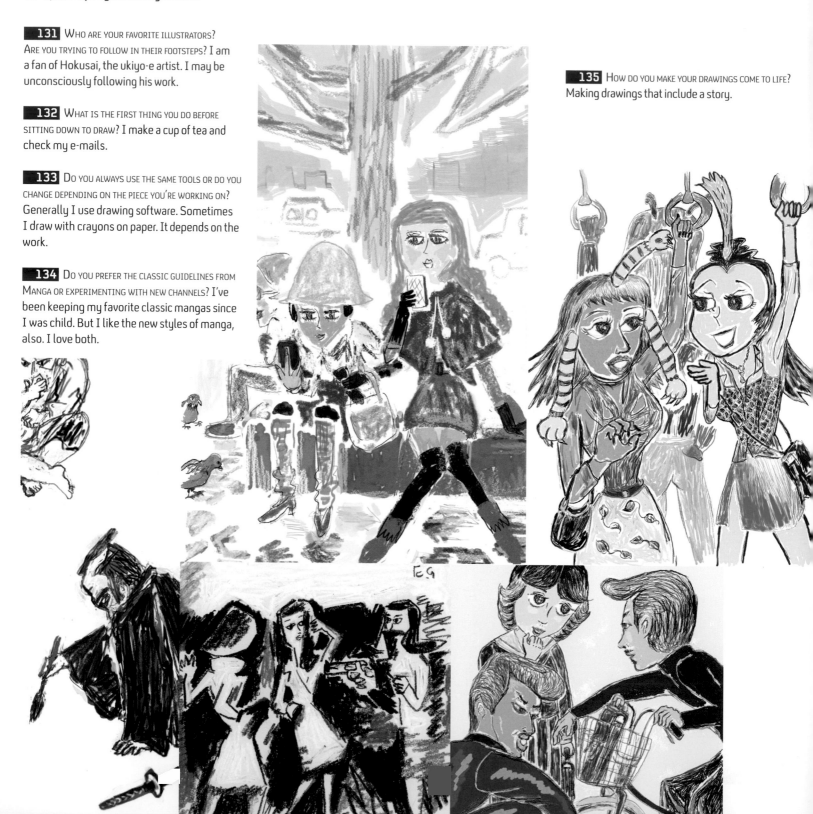

136 What advice would you give to a novice illustrator trying to make a name for himself? Be greedy, be honest.

137 What has changed about your style of drawing since you began? I have found new styles and changed.

138 Manga: is it art? Yes. There are many emotional mangas. Manga is as wonderful as art.

139 What good habits should a comic illustrator have? Focus on intriguing things.

140 What makes a comic sell successfully? When a comic touches people's heartstrings.

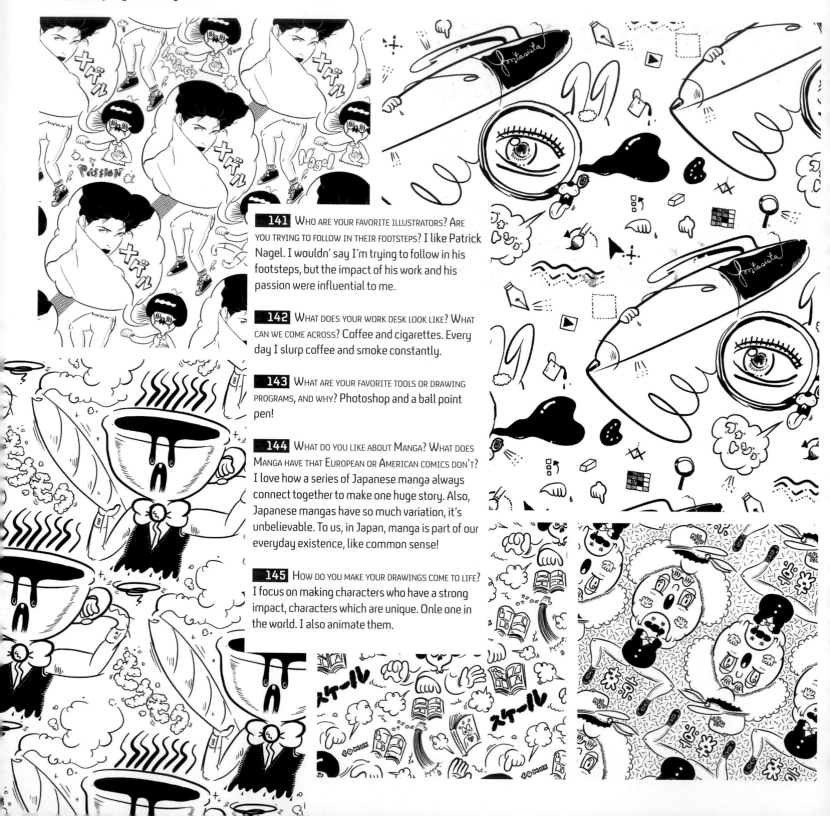

141 WHO ARE YOUR FAVORITE ILLUSTRATORS? ARE YOU TRYING TO FOLLOW IN THEIR FOOTSTEPS? I like Patrick Nagel. I wouldn' say I'm trying to follow in his footsteps, but the impact of his work and his passion were influential to me.

142 WHAT DOES YOUR WORK DESK LOOK LIKE? WHAT CAN WE COME ACROSS? Coffee and cigarettes. Every day I slurp coffee and smoke constantly.

143 WHAT ARE YOUR FAVORITE TOOLS OR DRAWING PROGRAMS, AND WHY? Photoshop and a ball point pen!

144 WHAT DO YOU LIKE ABOUT MANGA? WHAT DOES MANGA HAVE THAT EUROPEAN OR AMERICAN COMICS DON'T? I love how a series of Japanese manga always connect together to make one huge story. Also, Japanese mangas have so much variation, it's unbelievable. To us, in Japan, manga is part of our everyday existence, like common sense!

145 HOW DO YOU MAKE YOUR DRAWINGS COME TO LIFE? I focus on making characters who have a strong impact, characters which are unique. Onle one in the world. I also animate them.

146 WHAT ADVICE WOULD YOU GIVE TO A NOVICE ILLUSTRATOR TRYING TO MAKE A NAME FOR HIMSELF? Give yourself a name, one that's never been heard before, but when you hear it you won't forget it!

147 WHAT HAS CHANGED ABOUT YOUR STYLE OF DRAWING SINCE YOU BEGAN? I was strongly affected after seeing Moebius. Then, I started to take influence from those around me. For example, my friend who has a funny face, or animals and nature. I mixed them with characters and illustrations from my imagination, and that became my style. I'm also really into 80s and pop art!

148 MANGA: IS IT ART? I think so!

149 WHAT IS THE MOST IMPORTANT LESSON YOU HAVE LEARNED THAT YOU WOULD LIKE TO PASS ON TO OTHERS? To love. To care. To help people enjoy themselves. To make people happy.

150 WHAT IS THE GREATEST ACKNOWLEDGEMENT YOU COULD HOPE TO ACHIEVE FOR YOUR WORK? My own designer textiles. A way for my pictures to be multiplied over and over!

Fantasista Utamaro
www.fantasistautamaro.com

Fantasista Utamaro was born in the city of Fuji, Japan, in 1979. He graduated from Tama Art University in Textile Studies, and is currently one of the most innovative manga artists in Japan, as well as being a prestigious artist, illustrator, graphic and fashion designer. He is also an animation director and a member of the Mashcomix creators' union. His favorite movie is *Tron*, he is 5 ft 8 ins tall and an atheist. Fantasista Utamaro has received awards from Pictoplasma NYC Film Festival, Silhouette Film Festival Paris 2008, and was a finalist in 2008 for the Nike Bukatsu in the AD&D London. He has worked with brand names like Nike and Diesel, and took part in the Kuala Lumpur Design Week (Malaysia) in May 2010.

Faye Yong

http://fayeyong.com

Born and bred in Malaysia, Faye was training as a pianist before coming to the UK and getting lured to the dark side of drawing comics. Now she spends her daylight working for a games company, and moonlighting as a masked crusader of manga by night. She won third place in the *People's Choice Award* in Tokyopop's Rising Stars of Manga UK 3, and did work on a manga adaptation of *The Merchant of Venice*, published by SelfMadeHero. She has also contributed to self-published titles with leading UK manga collective, Sweatdrop Studios. Now she resides in London, doing her best to mangle the plummy British accent.

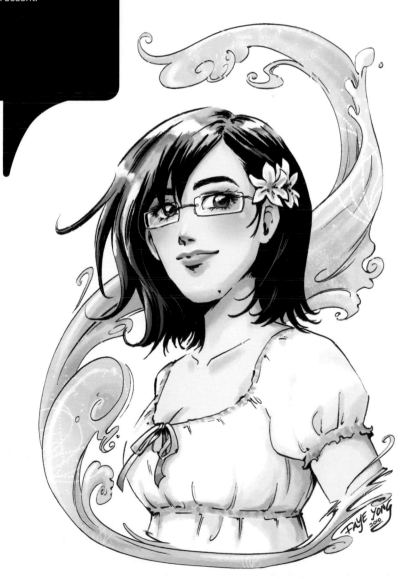

151 WHERE DO THE IDEAS FOR YOUR DRAWINGS COME FROM? HOW DO YOU DO YOUR RESEARCH? They come from that deep dark place in my psyche that's filled with flowers, makeup, sparkly pretty things and occasionally a deep meaningful thought. Also, Google and me are like Best Friends Forever!

152 WHO ARE YOUR FAVORITE ILLUSTRATORS? ARE YOU TRYING TO FOLLOW IN THEIR FOOTSTEPS? My favorite illustrators change from time to time. Currently they are Jana Schirmer, Judith Park, Christophe Vacher and Jean-Léon Gérôme. I'm not trying to follow their career footsteps, but rather aspiring to one day be as skilled as they are.

153 WHAT DOES YOUR WORK DESK LOOK LIKE? WHAT CAN WE COME ACROSS? My desk is a combination of working space and vanity table. All my weapons of choice in one place! You're just as likely to find lipstick and nail varnish next to my Wacom stylus.

154 WHAT IS THE FIRST THING YOU DO BEFORE SITTING DOWN TO DRAW? Recharge my lovelove happy batteries by hugging my husband. No, really. I find the happy energy charges the creative surge, which in turn compounds the happy buzz which feeds even more creative energy, like an endless happy creative cycle!

155 WHAT ARE YOUR FAVORITE TOOLS OR DRAWING PROGRAMS, AND WHY? My tools of choice are my trusty Wacom tablet, Photoshop, Illustrator and Manga Studio. I love the endless possibilities available to me with just one stroke without the mess of having papers, canvas, giant easels and art materials.

156 Do you feel the need to better yourself when it comes to your work? To what extent? My main goal in art is always to improve and try new things, be they big or small. I feel that the day I stop trying to learn and improve is the day I fall off the Mount Everest of Artistic Growth into the abyss of Uncreativity.

157 What has changed about your style of drawing since you began? Growing up and being exposed to more art, design and influences has definitely changed the way I draw. I like drawing more "manly" male characters now compared to the *bishounen* pretty boys favored in typical *shoujo* manga.

158 What is the most important lesson you have learned that you would like to pass on to others? Listen to your tutors/seniors when they suggest you try drawing something other than just manga. You may find whole new experiences and techniques that you enjoy by looking outside of the manga scope that you can apply to your art.

159 What good habits should a comic illustrator have? Draw actual comic pages! Drawing pin-up artwork is a different skillset to drawing comics. You need to hone both your art skills and storytelling skills to be a good comic illustrator.

160 What is the greatest acknowledgement you could hope to achieve for your work? Maybe one day to receive a prestigious award, or get paid millions to have my comic turned into a blockbuster movie. On the more realistic side: for people to enjoy my work and continue to support me by buying my books. Thank you!

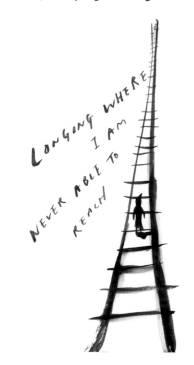

LONGONG WHERE I AM NEVER ABLE TO REACH

161 WHERE DO THE IDEAS FOR YOUR DRAWINGS COME FROM? HOW DO YOU DO YOUR RESEARCH? I always long for a place where I am never able to reach. I imagine the place in my head first then try to find the similar photos in the books. It could be 13th century's Middle Eastern, or late 19th century of chaotic Shanghai. I need a real fact when I make my world and love to mix them with imagination.

162 WHO ARE YOUR FAVORITE ILLUSTRATORS? ARE YOU TRYING TO FOLLOW IN THEIR FOOTSTEPS? I cannot count all the illustrators and artists who have influenced me. There are so many! But please let me mention two artists, Alexander Brodsky and Ilya Utkin. They are Russian architects. In late 80s they submitted many unbuildable architectural plans to Japanese competitions and finally won the prizes. They collected uncollectable elements and planned unbuildable buildings. Their plans were beautifully drawn, and full of stories.

163 WHAT DOES YOUR WORK DESK LOOK LIKE? WHAT CAN WE COME ACROSS? There are so many things that disturb me to draw. Phew...

164 WHAT IS THE FIRST THING YOU DO BEFORE SITTING DOWN TO DRAW? Check e-mail. I don't know why, it's really hard to quit even if I know no one has sent me anything.

CHECKING EMAIL NEVER ENDS

165 WHAT ARE YOUR FAVOURITE TOOLS OR DRAWING PROGRAMS, AND WHY? Ink! Because it's so easy!

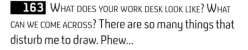

I have a mission to spread their names.

A MUST BUY BOOK OF LIFE

The Artists who collect Uncollectable

BRODSKY & UTKIN

book available from Princeton Architectural Press NY

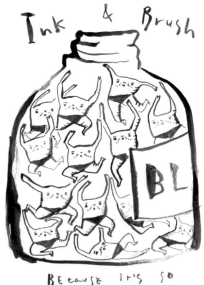

Ink & Brush

BL

BECAUSE IT'S SO EASY

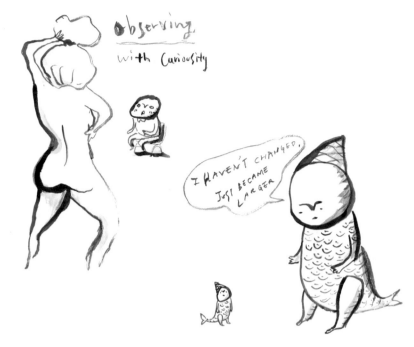

166 WHAT DO YOU LIKE ABOUT MANGA? WHAT DOES MANGA HAVE THAT EUROPEAN OR AMERICAN COMICS DON'T? I love the way of using space in manga. I can feel more about time flow, which enriches the atmosphere and widens the world of the story.

167 HOW DO YOU MAKE YOUR DRAWINGS COME TO LIFE? I still follow what art school taught me, observing and drawing with curiosity wherever I am. It really works!

168 WHAT HAS CHANGED ABOUT YOUR STYLE OF DRAWING SINCE YOU BEGAN? I haven't changed my style a lot since I was schoolgirl. But I have changed the scale of my drawing. The more I draw, the more I can be free. So I feel less scared about drawing in larger sizes.

169 WHAT IS THE MOST IMPORTANT LESSON YOU HAVE LEARNED THAT YOU WOULD LIKE TO PASS ON TO OTHERS? When you do research, do not just use a photocopy, scan, print out, or a photo, please draw what you see! When you draw, your eyes see the object more carefully and your brain remembers it more clearly! Then you don't have to review what you researched, because it's already yours.

170 WHAT GOOD HABITS SHOULD A COMIC ILLUSTRATOR HAVE? Persistence! This is what constructs manga.

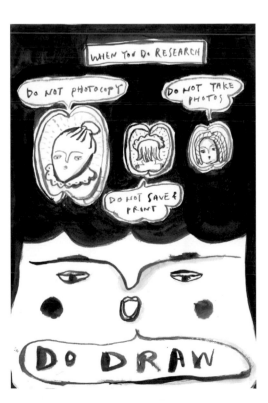

Haruka Shinji

www.harukashinji.com

Haruka is an illustrator and storyteller inspired by history and travel. Old maps, railway trucks, folktales, and shabby bric-a-brac as well as historical museum collections are all important sources for building her world. In her daily life, she observes people's peculiarities, their desires and obsessions to create her characters. Her imagination connects these fragments of real life and historical elements, and then creates stories. She tells these stories in book format or as sets of prints, and also applies them to everyday goods like tableware and toys to let her world reach out to us. She has been shortlisted for *McMillan Children's Book Prize* and earned the Silver award by the Association of Illustrators. After finishing her study at Royal College of art in London, she is now back in Tokyo, and continues to get her hands busy for scribbling and coloring.

Hayden Scott-Baron

http://starfruitgames.com

Hayden Scott-Baron, often going by the the name 'Dock,' is a professional artist for video games and comics. He produced artwork for the *Rollercoaster Tycoon, Thrillville* and *Lostwinds* games, as well as the iPhone game *Tumbledrop*. He is part of Sweatdrop Studios, and was part of Tokyopop's Rising Stars of Manga UK & Ireland #3. Hayden is also the author of *Digital Manga Techniques* and *Manga Clip Art*.

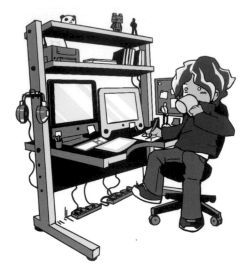

171 WHERE DO THE IDEAS FOR YOUR DRAWINGS COME FROM? HOW DO YOU DO YOUR RESEARCH? I look outside for inspiration. Not just from your window, but also everywhere in life. Pay attention to how people dress and behave, and how things are designed. Try to imagine what is around an unfamiliar corner, and try to bring this to your work.

172 WHAT DOES YOUR WORK DESK LOOK LIKE? WHAT CAN WE COME ACROSS? I use an A4 Intuos graphics tablet that I bought ten years ago, with my iMac and extra monitor. The b&w laser printer is useful to print smudge-resistant lines to be colored with alcohol-based markers. I use keep a flatbed scanner and sketchbooks. My figurine selection varies from month to month.

173 DO YOU ALWAYS USE THE SAME TOOLS OR DO YOU CHANGE DEPENDING ON THE PIECE YOU'RE WORKING ON? I usually try to use the right tool for the right job. It's sometimes okay to hammer a nail with a shoe, or loosen a screw with a knife, but if you're doing it lots of times you'll want to be able to work faster with better results. It's good to mix digital and non-digital mediums too.

174 WHAT ARE YOUR FAVORITE TOOLS OR DRAWING PROGRAMS, AND WHY? For higher resolution line illustration, which includes all comics, I always use eFrontier Manga Studio, whereas for most other illustration and texture work I'll use Photoshop. For 3D work I use 3D Studio MAX.

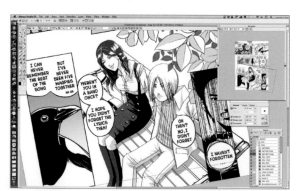

175 HOW DO YOU MAKE YOUR DRAWINGS COME TO LIFE? Even still images can be exciting and dynamic. An interesting image will always pose more questions than it presents answers, and you can suggest movements, events and even a story from just a prop or a sideways glance.

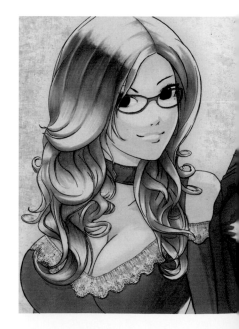

176 How important is promotion to you? How do you promote your work? It's important to get your work out there. Always make sure your work is available on the Internet, and let people contact you via Twitter, Facebook or whatever other services are popular. Make it very simple and easy for people to see your work.

177 What advice would you give to a novice illustrator trying to make a name for himself? Establish your own identity! If you're just producing similar work to everyone else, you become forgettable, or people can even mistake you for another person. It's good to have your name and personal information, and perhaps update a blog so fans can learn more about you.

178 Do you feel the need to better yourself when it comes to your work? To what extent? I often need to be bolder! Don't be shy with any aspect of your art. Color is a good example — people are often very indecisive with their use of color or shade, often afraid to change the image from the existing sketch or inks. Taking the risk is the only way to make your work stand out.

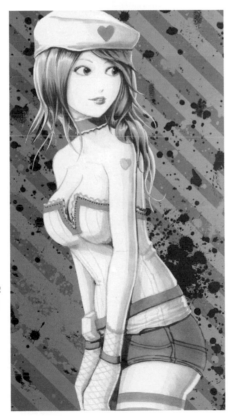

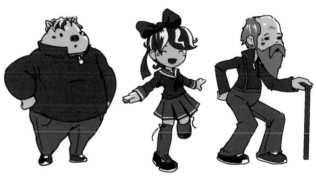

179 What is the most important lesson you have learned that you would like to pass on to others? Reach for the sky! It's going to be difficult, and a lot of hard work, but you'll get there. You don't even need to have a plan; just invest in the parts of your life that excite and interest you. Always be open to new possibilities!

180 What good habits should a comic illustrator have? Always watch out for deadlines! If you're too slow, or don't pay attention to the date, you can miss out on opportunities, or be forced to present artwork that you're unhappy with. If you produce the work early it also gives you chance to reflect on the quality and fix mistakes.

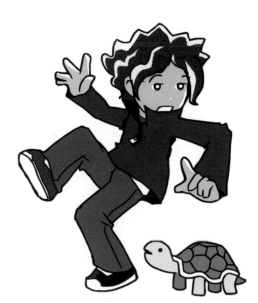

181 WHERE DO THE IDEAS FOR YOUR DRAWINGS COME FROM? HOW DO YOU DO YOUR RESEARCH? Usually when I am not thinking about anything, I get ideas. For example, when I am running, riding a train, taking a nap, or taking a shower. I don't do much research, because I tend to draw about things that don't exist.

182 WHAT DOES YOUR WORK DESK LOOK LIKE? WHAT CAN WE COME ACROSS? Fountain pen, ink, pencil, Imac, Wacom Cintiq tablet, empty coffee cans, and lots of papers everywhere.

183 WHAT ARE YOUR FAVORITE TOOLS OR DRAWING PROGRAMS, AND WHY? Other than using usual comic tools like pens and inks, I like using Photoshop and Comic Studio Pro to do comics. I especially like Comic Studio Pro because I can use it to do everything from comics, illustrations, to a children's book. I also like the fact that they always update their product to make it better.

184 WHAT DO YOU LIKE ABOUT MANGA? WHAT DOES MANGA HAVE THAT EUROPEAN OR AMERICAN COMICS DON'T? That it has so much freedom. There's a manga for everyone, from little kids to adults with a wide variety of themes and subjects. They even have comics about cooking, making sake, or about taking a bath, and I think that variation in theme is what makes manga unique, more so than the appearance, when comparing it to Western comic books.

185 HOW IMPORTANT IS PROMOTION TO YOU? HOW DO YOU PROMOTE YOUR WORK? Important. Apart from promoting and selling my work on my website, I get a booth and promote at conventions like Comic Con in San Diego.

186 DO YOU FEEL THE NEED TO BETTER YOURSELF WHEN IT COMES TO YOUR WORK? TO WHAT EXTENT? Yes. Drawing, making art, making manga, is like physical exercise, and if I stop for even a day, I can feel that my drawings are not as good as the day before. So I try to draw every single day to at least retain my ability, but when you draw for 365 days, you end up getting better at what you do. And that's the least I can do to better myself.

187 WHAT HAS CHANGED ABOUT YOUR STYLE OF DRAWING SINCE YOU BEGAN? After living in Los Angeles for sixteen years of my life, I moved back to Tokyo, and though I am not too conscious of it, all my friends told me that my style has changed a lot since then. I think it has gotten little happier and brighter (though I am still making comics about zombies).

188 WHAT IS THE MOST IMPORTANT LESSON YOU HAVE LEARNED THAT YOU WOULD LIKE TO PASS ON TO OTHERS? Draw every day.

189 WHAT GOOD HABITS SHOULD A COMIC ILLUSTRATOR HAVE? Draw every day.

190 WHAT IS THE GREATEST ACKNOWLEDGEMENT YOU COULD HOPE TO ACHIEVE FOR YOUR WORK? Make a comic that I can be proud of, make something that I want to put in my coffin.

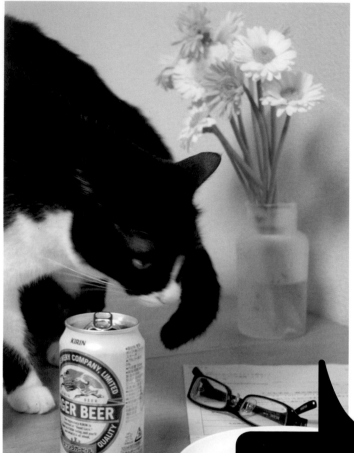

Heisuke Kitazawa (PCP)

www.hypehopewonderland.com

Heisuke Kitazawa aka PCP is a freelance illustrator/designer based in Orange County, California, and Tokyo. PCP has worked with clients ranging from Honda to Nintendo. He has done some interesting illustrations on messenger bags and wallets for Poketo, the apparel and accessory store. His other interest lies in creating beautiful picture books that are on sale at his website. As a friend of his says, "He gets to work with some great bands like The Postal Service and Dublab, doing cover illustrations for their album releases. When he's not stressed out working in Tokyo, he is enjoying the sun, sand and sea in Orange County, while working with various clients in both locations."

Hirochi Maki

http://makihirochi.com

Hirochi Maki made her debut on the weekly Japanese seinen manga magazine *Big Comic Spirits*, published by Shogakukan. After working as the assistant to two very well-known manga artists, Hanayo Hanatsu and Serizawa Naoki, she presented her work widely in *seinen* and *josei* manga magazines, fashion magazines and animated web films. Today, she serializes her works in the *seinen* manga magazine *Weekly Manga Sunday*. Right now, she's planning to "put more effort" into her work as an illustrator. Her hobbies are card and board games.

191 WHERE DO THE IDEAS FOR YOUR DRAWINGS COME FROM? HOW DO YOU DO YOUR RESEARCH? My drawing ideas develop when I'm talking to my friends or boyfriend, at a music live show and looking at other people's pieces of work. My work is always revolving around the people I am around. I research by interacting with people.

192 WHO ARE YOUR FAVORITE ILLUSTRATORS? ARE YOU TRYING TO FOLLOW IN THEIR FOOTSTEPS? My favorite illustrator is a Japanese artist, Ryo Ikuemi. Her stories are always very moving and stay in readers' hearts and stay with them for a long time. I want to produce something alike, like a charm that someone would want to hold everyday.

193 WHAT DOES YOUR WORK DESK LOOK LIKE? WHAT CAN WE COME ACROSS? My desk is L-shaped with a computer and printer on it. I have my favorite pictures and ads posted up on the wall facing me when sit at my desk. A sheep kinetic sculpture is dangling above the desk; my desk area looks very busy.

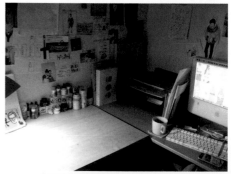

194 WHAT IS THE FIRST THING YOU DO BEFORE SITTING DOWN TO DRAW? When drawing, you stay inside and tend to get lazy, so to maintain my aesthetic consciousness, I curl my hair, dress nicely and prepare a nice hot cup of coffee before I start drawing.

195 DO YOU ALWAYS USE THE SAME TOOLS OR DO YOU CHANGE DEPENDING ON THE PIECE YOU'RE WORKING ON? Yes. When I write essay mangas, I use the Multiliner by Copic and when I write story mangas, I use Marupen by Zebra. For color scripts, I like to use Sketch by Copic.

196 WHAT ARE YOUR FAVORITE TOOLS OR DRAWING PROGRAMS, AND WHY? My favorite tool for drawing is the mechanical pencils by Staedtler. I like it because it can hold many pencil leads, it is thin and narrow and easy to hold, and it weighs a little heavier than other mechanical pencils which create stability.

197 WHAT DO YOU LIKE ABOUT MANGA? WHAT DOES MANGA HAVE THAT EUROPEAN OR AMERICAN COMICS DON'T? What I like about manga is that manga artists take on the role as a director, scriptwriter, producer, and as director for casting, costume, and screen image all by themselves. I'm sorry but I don't really know mangas outside of Japanese ones.

198 HOW DO YOU MAKE YOUR DRAWINGS COME TO LIFE? For example, when drawing a human character, drawing facial expressions that shows its feelings without the use of obvious symbols such as tears and sweat drops, help put life into the drawings and character.

199 WHAT ADVICE WOULD YOU GIVE TO A NOVICE ILLUSTRATOR TRYING TO MAKE A NAME FOR HIMSELF? To produce and increase the number of the pieces of work and to continuously present your work. Draw numerous pieces which you might regret later and make many mistakes. And, important, listen to other people's opinions.

200 WHAT HAS CHANGED ABOUT YOUR STYLE OF DRAWING SINCE YOU BEGAN? My style of drawing in the past was realistic but these days I try to omit lines to make the drawings simple. Before, I always needed to "add" more to my work but right now to "reduce" has become an important task.

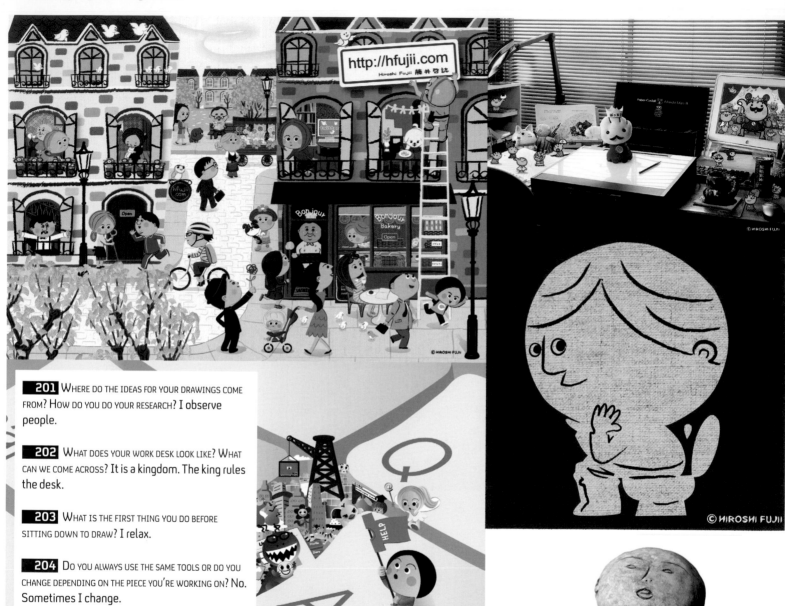

201 WHERE DO THE IDEAS FOR YOUR DRAWINGS COME FROM? HOW DO YOU DO YOUR RESEARCH? I observe people.

202 WHAT DOES YOUR WORK DESK LOOK LIKE? WHAT CAN WE COME ACROSS? It is a kingdom. The king rules the desk.

203 WHAT IS THE FIRST THING YOU DO BEFORE SITTING DOWN TO DRAW? I relax.

204 DO YOU ALWAYS USE THE SAME TOOLS OR DO YOU CHANGE DEPENDING ON THE PIECE YOU'RE WORKING ON? No. Sometimes I change.

205 WHAT ARE YOUR FAVOURITE TOOLS OR DRAWING PROGRAMS, AND WHY? The computer.

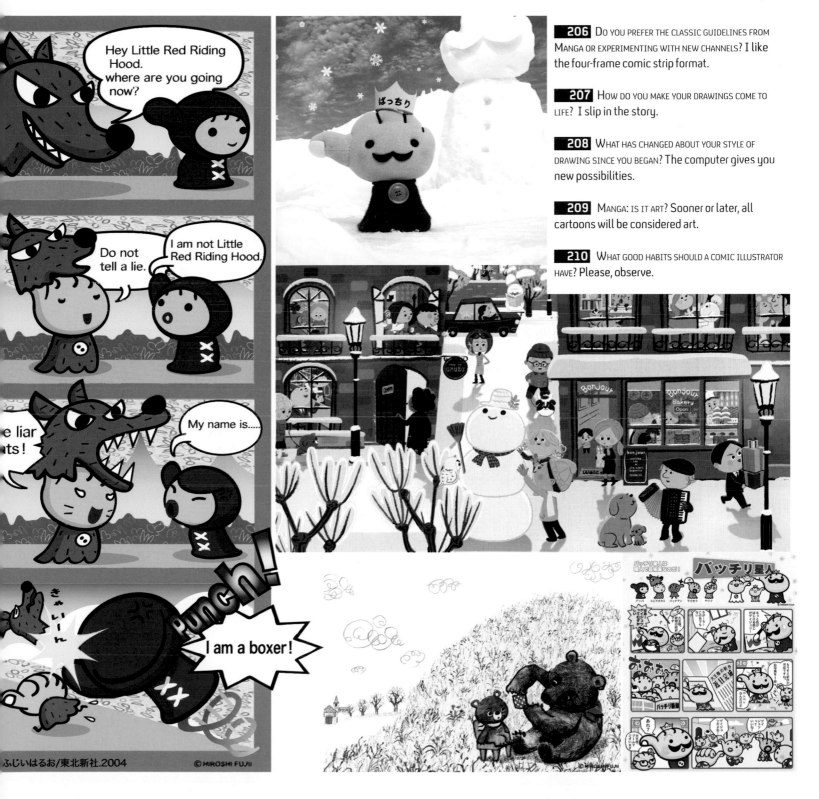

206 DO YOU PREFER THE CLASSIC GUIDELINES FROM MANGA OR EXPERIMENTING WITH NEW CHANNELS? I like the four-frame comic strip format.

207 HOW DO YOU MAKE YOUR DRAWINGS COME TO LIFE? I slip in the story.

208 WHAT HAS CHANGED ABOUT YOUR STYLE OF DRAWING SINCE YOU BEGAN? The computer gives you new possibilities.

209 MANGA: IS IT ART? Sooner or later, all cartoons will be considered art.

210 WHAT GOOD HABITS SHOULD A COMIC ILLUSTRATOR HAVE? Please, observe.

Hiroshi Fujii

http://web.me.com/hfujii

Hiroshi Fujii lives in downtown Tokyo. He works for cartoons, animation, picture books and illustration. His work is as plentiful as it is amazing: if you visit Japan, you will see Hiroshi Fujii's works on television, in animation series, textbooks, in giant posters, magazines, and on the web. Right now, he's working on a new picture book that will be published in a few months. His working method is easy: he draws with pencil, then he paints his illustrations and then he finishes the picture with the computer.

Holly Segarra

www.professionallycute.com

Holly Segarra has been the appointed CEO of Cute since birth. (Though some sources argue since her zygote state.) She is a 2X-year-old girl who is cute and funny. Everyone loves her. Don't you? Her dream is to use her cuteness and charm to change the world. She also suffers from severe potty mouth.

211 WHERE DO THE IDEAS FOR YOUR DRAWINGS COME FROM? HOW DO YOU DO YOUR RESEARCH? Everything and anything adorable! I am attracted to cute things, so it's what comes out in my art. It's very easy for me to find inspiration or ideas. It can be cute music, clothing, magazines, or even someone dressed really nice. For instance, I'll be on the train observing a person who catches my interest and I will make up a story for them in my head.

212 WHO ARE YOUR FAVORITE ILLUSTRATORS? ARE YOU TRYING TO FOLLOW IN THEIR FOOTSTEPS? My favorite artists are Osamu Tezuka, Bruce Timm, Junko Mizuno, Adam Hughes, Hideo Azuma, Dustin Nguyen, Karl Kerschl and early Rumiko Takahashi. All of the artists do have one thing in common though. They draw very cute girls. I wouldn't say I am following in anyone's footsteps, but they do have an influence on my art.

213 WHAT DOES YOUR WORK DESK LOOK LIKE? WHAT CAN WE COME ACROSS? As you can probably tell from the photo, I also like to sew. So on my desk there are a lot of sewing and craft-related items as well as my drawing utensils. In the blue hanging file I keep all my sewing patterns that I have created from scratch. I usually have DVDs out on my desk too (not pictured), so that I have background noise while I work. I also have a lovely view of the sheep in my yard while I work.

214 WHAT IS THE FIRST THING YOU DO BEFORE SITTING DOWN TO DRAW? I always have to start my work day with coffee! Without it it's hard for this girl to focus. To be honest, I am currently enjoying a cup right now for this interview.

215 DO YOU ALWAYS USE THE SAME TOOLS OR DO YOU CHANGE DEPENDING ON THE PIECE YOU'RE WORKING ON? I am a same tool user. I have tried my hand at watercolor, gauche, dyes, charcoal, pencils, and pretty much every other traditional medium under the sun, but I am attracted to more bold and consistent colors. I think CG or markers suit my work best anyways.

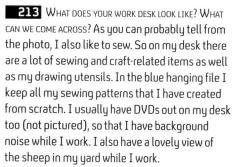

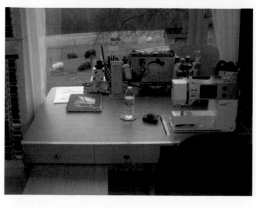

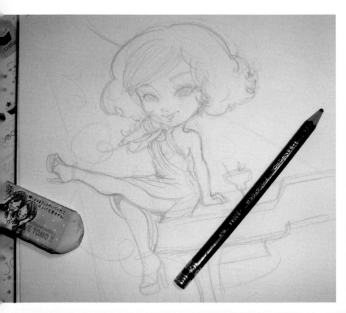

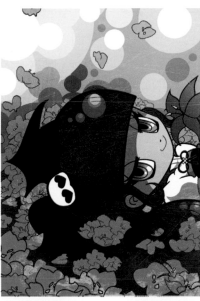

216 HOW DO YOU MAKE YOUR DRAWINGS COME TO LIFE? I like to get into my character's head. I find that you get more interesting pieces if you actually plan and think about how your character would act naturally in the environment. I feel art is part skill and part interesting content.

217 WHAT DIFFERENTIATES YOU FROM MANGA'S OTHER ILLUSTRATORS? Cuteness factor! And by that I mean my own personal touch. Sometimes I draw cute funny things. Sometimes I drew cute and creepy things. Overall I try to deliver cuteness and characters that are unique and interesting.

218 DO YOU FEEL THE NEED TO BETTER YOURSELF WHEN IT COMES TO YOUR WORK? TO WHAT EXTENT? Oh god, always. I feel there is always something I can be doing better. Even though I went to art school, I am still studying and trying to improve both technically and style wise. I feel it's a good attitude to have, though, because I can see an improvement in my work over the years.

219 WHAT IS THE MOST IMPORTANT LESSON YOU HAVE LEARNED THAT YOU WOULD LIKE TO PASS ON TO OTHERS? This ties up with the above question. Always aim to improve. There are always new things to learn even if you are 87 and makin' dookies in your jam-jams. Besides, things get boring if you don't challenge yourself so get out of your comfort zone from time to time. Also, be open to criticism but also don't be defeated by it. There is no time for feeling bad for yourself. Now get to work, nerd!

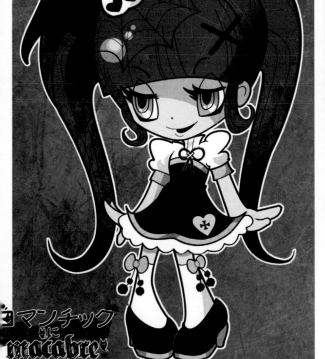

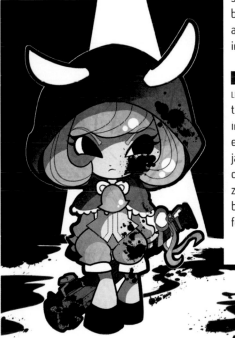

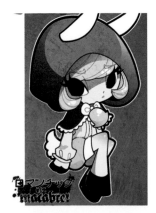

220 WHAT ARE YOUR FAVORITE TOOLS OR DRAWING PROGRAMS, AND WHY? My favorite tool is my non-repro blue drawing pencil. This is incredibly silly though because it's not for any technical reason. I just enjoy it. And the only drawing program I use is Adobe Photoshop. I do everything from clean up, to lettering, to inking, to toning and coloring with it. And I don't use a tablet, it's all done with a mouse.

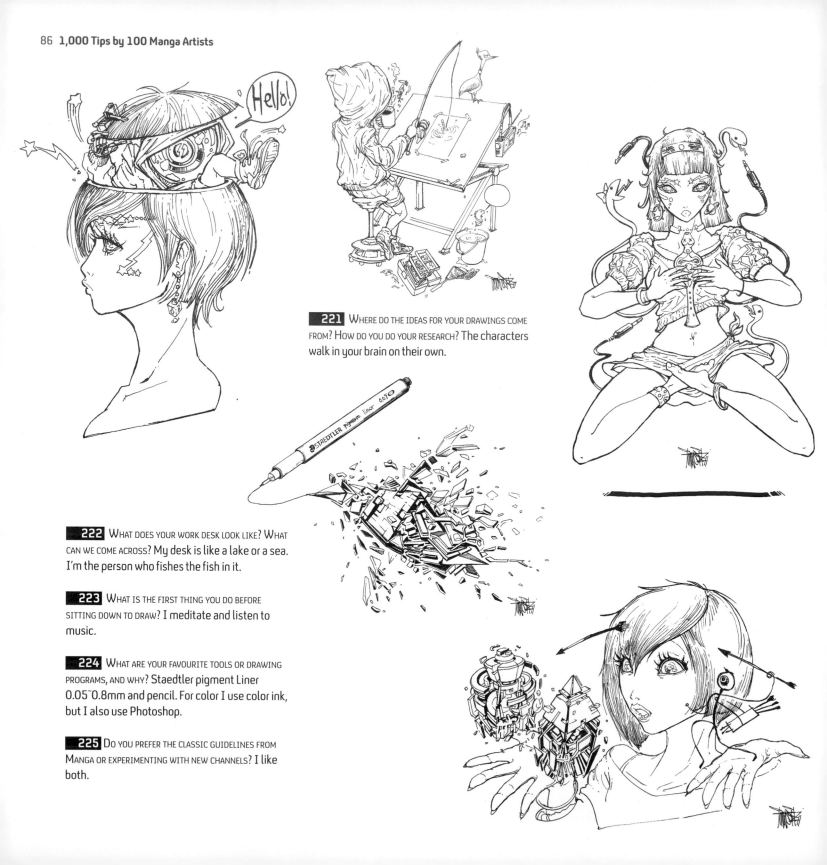

221 Where do the ideas for your drawings come from? How do you do your research? The characters walk in your brain on their own.

222 What does your work desk look like? What can we come across? My desk is like a lake or a sea. I'm the person who fishes the fish in it.

223 What is the first thing you do before sitting down to draw? I meditate and listen to music.

224 What are your favourite tools or drawing programs, and why? Staedtler pigment Liner 0.05~0.8mm and pencil. For color I use color ink, but I also use Photoshop.

225 Do you prefer the classic guidelines from Manga or experimenting with new channels? I like both.

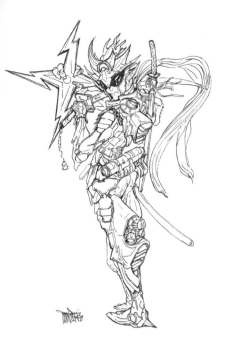

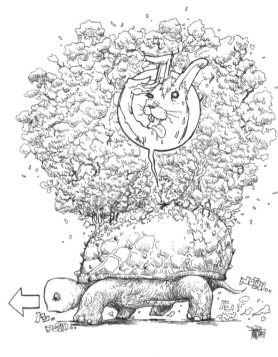

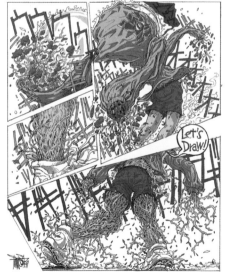

226 WHAT DO YOU LIKE ABOUT MANGA? WHAT DOES MANGA HAVE THAT EUROPEAN OR AMERICAN COMICS DON'T? We like the absurd. We have robots and samurais.

227 HOW DO YOU MAKE YOUR DRAWINGS COME TO LIFE? I start my works perplexed, walking like a turtle. But then the rabbit leaps from the grass and the character starts to live. The deadline (the turtle) is always defeated.

228 WHAT ADVICE WOULD YOU GIVE TO A NOVICE ILLUSTRATOR TRYING TO MAKE A NAME FOR HIMSELF? Don't abandon immediately, try moving the hand. Persevere.

229 MANGA: IS IT ART? From the point of view of modern art, a cartoon is cartoon. But from the point of view of the person who draw cartoons, it's art if you think it's art. It's possible to think freely.

230 WHAT GOOD HABITS SHOULD A COMIC ILLUSTRATOR HAVE? Keeping deadlines. Make good use of time.

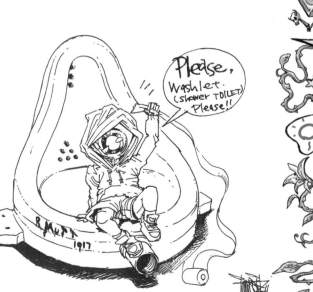

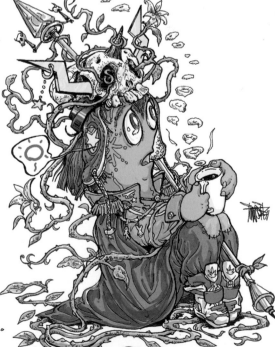

Imaitoonz

www.imaitoonz.com

Imaitoonz was born in 1971, and graduated from Tama Art University in Tokyo. He's the author of the well-known sci-fi manga *Dead Leaves*. He combines in his works analog and digital techniques.

He has worked for MTV, Nike Japan, Reebok, Walt Disney, Coca-Cola and Sega, among many other famous companies. Imaitoonz owns a very personal style that he calls "alternative formalism and expressionism," a style that can be seen in his character designs, manga comics, illustrations and art.

Irene Flores

beanclamchowder.com

Irene is a Virgo, does not enjoy long walks on the beach, but does like fine dining. Growing up in the Philippines, her art was heavily influenced by Japanese animation and American comic books. She currently resides in San Luis Obispo, California, and has worked for Tokyopop, Impact Books, Marvel, and DC Comics. Her goals for the future include creating another graphic novel, and eating a Monte Cristo sandwich.

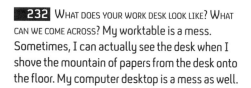

231 WHO ARE YOUR FAVORITE ILLUSTRATORS? ARE YOU TRYING TO FOLLOW IN THEIR FOOTSTEPS? So many artists inspire me. Takeshi Obata, Eiichiro Oda, Adam Hughes, James Jean, to name a few.

232 WHAT DOES YOUR WORK DESK LOOK LIKE? WHAT CAN WE COME ACROSS? My worktable is a mess. Sometimes, I can actually see the desk when I shove the mountain of papers from the desk onto the floor. My computer desktop is a mess as well.

233 WHAT IS THE FIRST THING YOU DO BEFORE SITTING DOWN TO DRAW? Coffee. And then more coffee. Then I browse the Internet. And then I might drink a coffee while browsing the Internet.

234 DO YOU ALWAYS USE THE SAME TOOLS OR DO YOU CHANGE DEPENDING ON THE PIECE YOU'RE WORKING ON? In general, my tools are a pencil, pen and paper. I do mix up the paper weight and type, my pencil leads, and I switch around from brushpens and technical pens.

235 WHAT ARE YOUR FAVORITE TOOLS OR DRAWING PROGRAMS, AND WHY? My favorite tools would have to be a Pentel Pocket Brushpen, a weighted Super Promecha mechanical pencil with HB lead, Deleter plain B paper, a Wacom tablet and Photoshop CS3.

236 WHAT DO YOU LIKE ABOUT MANGA? WHAT DOES MANGA HAVE THAT EUROPEAN OR AMERICAN COMICS DON'T? I love the exaggerated visual cues. The super visible sweatdrops, throbbing veins, even the sparkles and feathers that show up alot in *shoujo* manga.

237 HOW IMPORTANT IS PROMOTION TO YOU? HOW DO YOU PROMOTE YOUR WORK? Self-promotion is very important to me. Unfortunately, I'm not very good at it. When I do get around to promotion, it's usually online.

238 WHAT ADVICE WOULD YOU GIVE TO A NOVICE ILLUSTRATOR TRYING TO MAKE A NAME FOR HIMSELF? Be confident in your skill, be accepting of constructive criticism and have a tough skin. There will always be people that don't like your work. Don't let it get to you.

239 DO YOU FEEL THE NEED TO BETTER YOURSELF WHEN IT COMES TO YOUR WORK? TO WHAT EXTENT? I will always work to get better at drawing, well, everything. The day might come when I'll have to draw steampunk, or dinosaurs, UFOs, schoolkids, alpacas, etc. There are so many things to study and draw.

240 WHAT HAS CHANGED ABOUT YOUR STYLE OF DRAWING SINCE YOU BEGAN? Through the years I've taken bits and pieces from the styles of various artists I admire and mashed them all together. I've also learned better anatomy and more practice, in general, has improved the quality of my work.

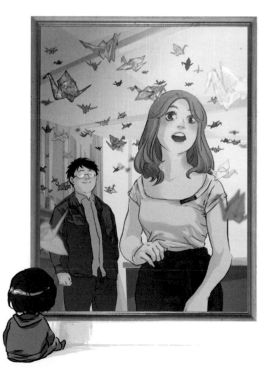

241 WHERE DO THE IDEAS FOR YOUR DRAWINGS COME FROM? HOW DO YOU DO YOUR RESEARCH? I get my best inspiration from reading books and watching movies. And when I get a good idea, I usually research it on the Internet, or visit the library for the best visual reference.

242 WHAT DOES YOUR WORK DESK LOOK LIKE? WHAT CAN WE COME ACROSS? Me, sleeping after a tough deadline. Also my TV, laptop computer, multiple coffee cups, and a messy assortment of pencils and pens.

243 WHAT IS THE FIRST THING YOU DO BEFORE SITTING DOWN TO DRAW? I make coffee!

244 DO YOU PREFER THE CLASSIC GUIDELINES FROM MANGA OR EXPERIMENTING WITH NEW CHANNELS? While I typically hate adhering to rules and guidelines, I think it's the story that dictates the style of the art. There are infinite stylistic possibilities, and an appropriate place to draw classic manga therein.

245 HOW DO YOU MAKE YOUR DRAWINGS COME TO LIFE? I try to always ink my drawings with great confidence. A confident line imbues my work with movement and spirit it would not have, otherwise.

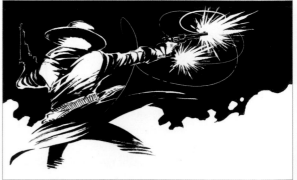

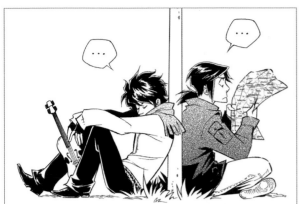

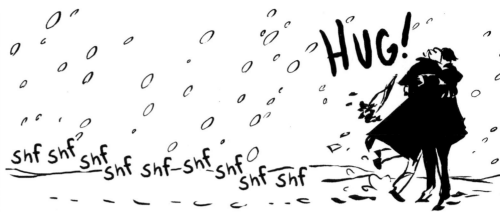

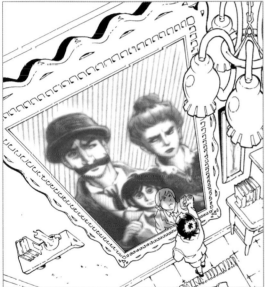

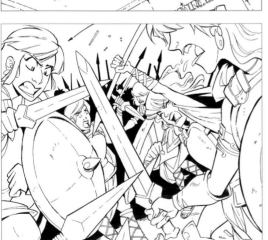

246 DO YOU FEEL THE NEED TO BETTER YOURSELF WHEN IT COMES TO YOUR WORK? TO WHAT EXTENT? It's not in my nature to feel content with my work. I'm always looking for things that could be improved, or new directions to take my art.

247 WHAT HAS CHANGED ABOUT YOUR STYLE OF DRAWING SINCE YOU BEGAN? Pretty much everything. Artistically speaking, I can't sit still. I'm currently exploring a style-change where I draw with more gesture and less detail.

248 MANGA: IS IT ART? It can be. If you are expressing or revealing personal truths and beliefs with your manga, I'd call that art.

249 WHAT IS THE MOST IMPORTANT LESSON YOU HAVE LEARNED THAT YOU WOULD LIKE TO PASS ON TO OTHERS? Be fearless. Never let your insecurities stop you from drawing.

250 WHAT GOOD HABITS SHOULD A COMIC ILLUSTRATOR HAVE? Draw from life whenever you can. The visual language of manga is an abstraction of life, so the better your life-drawing skills are, the better your manga will be.

Joanna Estep

www.joannaestep.com

Joanna is a comic artist, writer, doodler, and accomplished whateverist. She got her start drawing manga when she was chosen to illustrate Tokyopop's three-volume *Roadsing* series. In addition to all that fun stuff, Joanna has done work for/with Image Comics, Tor Fantasy, Comicmix, Viz Media, Archaia Press, and Jim Henson Studios, and she has received the Charles Logan Smith Award and the S.P.A.C.E Prize for her work in sequential art. She presently resides in the wilds of Wisconsin, where she likely spends too much time daydreaming, and not enough time drawing.

Joanna Zhou

www.chocolatepixels.com

Joanna was born in China, grew up in Vienna and studied graphic design in London. She is a full-time illustrator and designer specializing in *kawaii* style and has worked closely with Momiji and Eyeko. Her manga-inspired products have been sold in Topshop, Urban Outfitters, Kidrobot, Selfridges, and featured in magazines including *ComputerArts*, *Dazed&Confused*, *Grazia* and *Elle Decoration*. In her free time, Joanna likes lazy Sundays, soy lattés, house music, macaroons and collecting things with koalas on them.

251 WHERE DO THE IDEAS FOR YOUR DRAWINGS COME FROM? HOW DO YOU DO YOUR RESEARCH? High-energy places inspire me! I love urban cities, shops, clubs, and cafés because they get me thinking about the stories and styles of all the people who go there. I travel when possible and collect foreign magazines.

252 WHAT DOES YOUR WORK DESK LOOK LIKE? WHAT CAN WE COME ACROSS? I try to avoid clutter, as I'm so messy by nature it might spiral out of control. Ideally, it's just the Macbook, Wacom, Blackberry, water and sweets.

253 HOW DO YOU MAKE YOUR DRAWINGS COME TO LIFE? The facial expression needs to look just right otherwise people won't make an emotional connection with the character.

254 WHAT DIFFERENTIATES YOU FROM MANGA'S OTHER ILLUSTRATORS? My main field is combining manga art with graphic design to create fun Japanese-influenced branding, products and packaging.

255 HOW IMPORTANT IS PROMOTION TO YOU? HOW DO YOU PROMOTE YOUR WORK? Choosing the right projects is the best way of getting exposure. Designing for retail will automatically bring PR, and save you a lot of time and money too.

256 WHAT ADVICE WOULD YOU GIVE TO A NOVICE ILLUSTRATOR TRYING TO MAKE A NAME FOR HIMSELF? Aim for the jobs that look good on your CV and not the jobs that pay more but you will get very little or irrelevant exposure. It will be an investment that pays off much further down your career.

257 WHAT HAS CHANGED ABOUT YOUR STYLE OF DRAWING SINCE YOU BEGAN? I used to try very hard to make my style look typically manga, but now I value developing an individual style based on a variety of inspirations.

258 WHY IS MANGA SO POPULAR IN THE WESTERN WORLD? Western pop culture is dominated by absolutes: pure good, pure evil, pure innocence or pure seduction. Manga opens a fascinating door of simultaneous opposites, cute yet creepy, naive yet sexy, which can be refreshing in its honesty and macabre in its taboos.

259 WHAT IS THE MOST IMPORTANT LESSON YOU HAVE LEARNED THAT YOU WOULD LIKE TO PASS ON TO OTHERS? Don't take rejection personally. The creative industry is so competitive that disappointments are inevitable. Dealing with setbacks is a far more valuable learning curve than simply powering ahead with ambition.

260 WHAT GOOD HABITS SHOULD A COMIC ILLUSTRATOR HAVE? Discipline, humility and professionalism. Always respect your clients and never ignore a deadline because you simply weren't feeling inspired. Your work is just a commodity, like everything else on the free market so force yourself to create it on schedule!

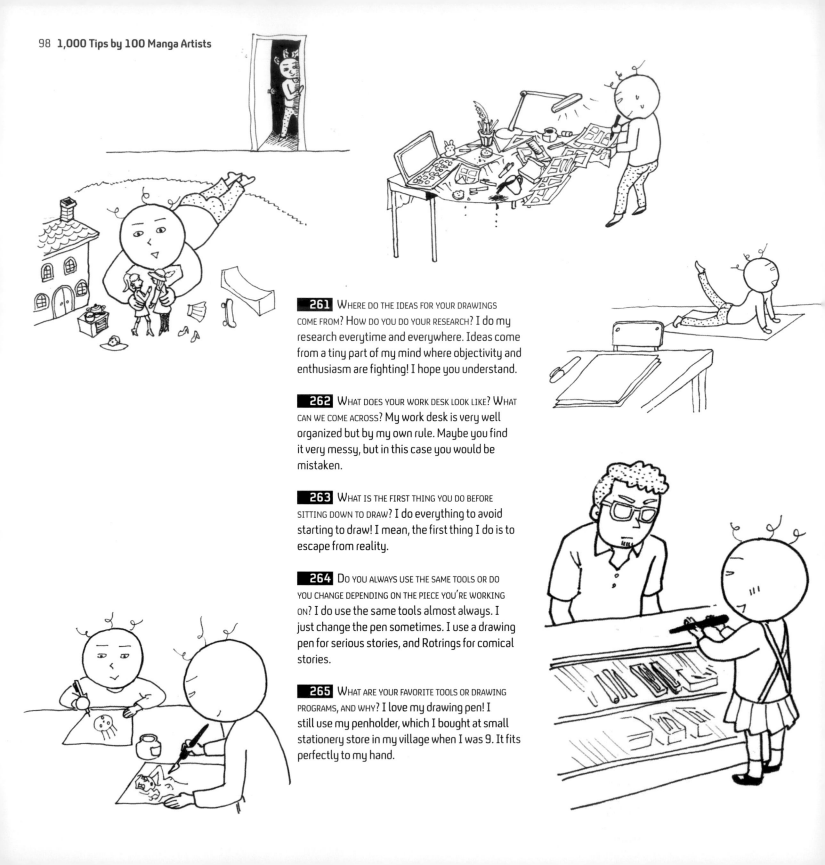

261 WHERE DO THE IDEAS FOR YOUR DRAWINGS COME FROM? HOW DO YOU DO YOUR RESEARCH? I do my research everytime and everywhere. Ideas come from a tiny part of my mind where objectivity and enthusiasm are fighting! I hope you understand.

262 WHAT DOES YOUR WORK DESK LOOK LIKE? WHAT CAN WE COME ACROSS? My work desk is very well organized but by my own rule. Maybe you find it very messy, but in this case you would be mistaken.

263 WHAT IS THE FIRST THING YOU DO BEFORE SITTING DOWN TO DRAW? I do everything to avoid starting to draw! I mean, the first thing I do is to escape from reality.

264 DO YOU ALWAYS USE THE SAME TOOLS OR DO YOU CHANGE DEPENDING ON THE PIECE YOU'RE WORKING ON? I do use the same tools almost always. I just change the pen sometimes. I use a drawing pen for serious stories, and Rotrings for comical stories.

265 WHAT ARE YOUR FAVORITE TOOLS OR DRAWING PROGRAMS, AND WHY? I love my drawing pen! I still use my penholder, which I bought at small stationery store in my village when I was 9. It fits perfectly to my hand.

266 Do you prefer the classic guidelines from Manga or experimenting with new channels? I feel so. But you should not be totally content with yourself and your life. No friction, no creation! That's my opinion.

267 Manga: is it art? Some images of manga can be art. But in my opinion, manga is absolutely not art because it has a different purpose. I mean, art is made to feel it; manga is made to be read!

268 What is the most important lesson you have learned that you would like to pass on to others? Not to cross with your assistants when you are stressed. And with your family, either. This is very important.

269 What good habits should a comic illustrator have? Eating rice. Chew thirty times each bite. Seriously.

270 What is the greatest acknowledgement you could hope to achieve for your work? "She did very well."

Junko Kawakami

Junko Kawakami was born in Tokyo in 1973. She moved to the countryside with her family, and started to draw at the age of three. She wanted to be a mangaka during all her childhood. She then moved again to Tokyo and started to live alone when she was twenty. She traveled all along Asia between the age of twenty and twenty, and then she started to work as a mangaka. In 2004, she moved to Paris, in order to work with some Belgian publishers, in addition to her Japanese clients.

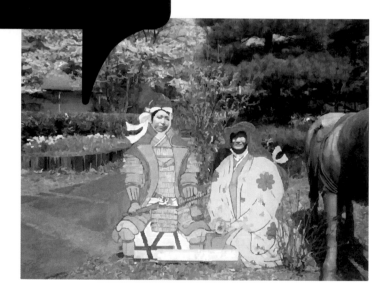

Kana Nagano

www.ne.jp/asahi/lady/anemoon

Kana Nagano (Nara Prefecture, 1976), is a professional illustrator. She graduated from the Department of Art and Humanities at Wako University, and since then has worked as a freelance illustrator, primarily for magazines. Strongly influenced by manga artforms, Kana hopes to move on from magazines and go on to illustrate novels, particularly those featuring mystery and suspense, which are her favorite genres. When asked about her hobby, she mentions the names of Patricia Highsmith and Jim Thompson.

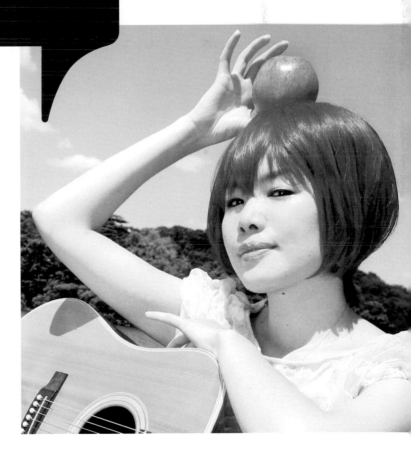

271 WHERE DO THE IDEAS FOR YOUR DRAWINGS COME FROM? HOW DO YOU DO YOUR RESEARCH? When I'm shocked by a word or a scene, the ideas come into my mind like a falling star.

272 WHO ARE YOUR FAVORITE ILLUSTRATORS? ARE YOU TRYING TO FOLLOW IN THEIR FOOTSTEPS? My favorite illustrators are Akira Uno and Milton Glaser. I try to use their points of view sometimes.

273 WHAT DOES YOUR WORK DESK LOOK LIKE? WHAT CAN WE COME ACROSS? My work desk has many uses. Drawing illustrations, having meals, using the PC, and so on. It's always busy.

274 WHAT IS THE FIRST THING YOU DO BEFORE SITTING DOWN TO DRAW? I have a cup of coffee.

275 DO YOU ALWAYS USE THE SAME TOOLS OR DO YOU CHANGE DEPENDING ON THE PIECE YOU'RE WORKING ON? A pen, black ink, paper, eraser and ruler. I've been using these drawing tools for ten years.

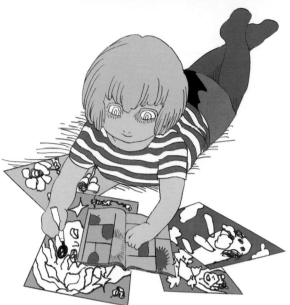

276 Wʜᴀᴛ ᴀʀᴇ ʏᴏᴜʀ ꜰᴀᴠᴏʀɪᴛᴇ ᴛᴏᴏʟꜱ ᴏʀ ᴅʀᴀᴡɪɴɢ ᴘʀᴏɢʀᴀᴍꜱ, ᴀɴᴅ ᴡʜʏ? My favorite tool is the pen. It can draw lines both thin and thick. It's very useful when I draw hair.

277 Dᴏ ʏᴏᴜ ᴘʀᴇꜰᴇʀ ᴛʜᴇ ᴄʟᴀꜱꜱɪᴄ ɢᴜɪᴅᴇʟɪɴᴇꜱ ꜰʀᴏᴍ Mᴀɴɢᴀ ᴏʀ ᴇxᴘᴇʀɪᴍᴇɴᴛɪɴɢ ᴡɪᴛʜ ɴᴇᴡ ᴄʜᴀɴɴᴇʟꜱ? I prefer the classic guidelines. When I was young, I copied several mangas. They were a wonderful drawing teacher for me.

278 Wʜᴀᴛ ᴅᴏ ʏᴏᴜ ʟɪᴋᴇ ᴀʙᴏᴜᴛ Mᴀɴɢᴀ? Wʜᴀᴛ ᴅᴏᴇꜱ Mᴀɴɢᴀ ʜᴀᴠᴇ ᴛʜᴀᴛ Eᴜʀᴏᴘᴇᴀɴ ᴏʀ Aᴍᴇʀɪᴄᴀɴ ᴄᴏᴍɪᴄꜱ ᴅᴏɴ'ᴛ? Japanese manga is full of lyricism. Its drawings express the condition of the mind. I like that about manga.

279 Hᴏᴡ ᴅᴏ ʏᴏᴜ ᴍᴀᴋᴇ ʏᴏᴜʀ ᴅʀᴀᴡɪɴɢꜱ ᴄᴏᴍᴇ ᴛᴏ ʟɪꜰᴇ? I imagine that I'm a landscape painter. My emotions give life to my drawings.

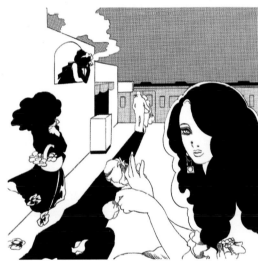
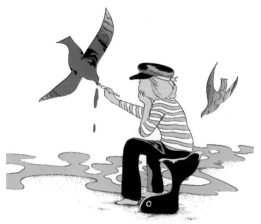

280 Wʜᴀᴛ ᴅɪꜰꜰᴇʀᴇɴᴛɪᴀᴛᴇꜱ ʏᴏᴜ ꜰʀᴏᴍ Mᴀɴɢᴀ'ꜱ ᴏᴛʜᴇʀ ɪʟʟᴜꜱᴛʀᴀᴛᴏʀꜱ? My illustration is a twinkling in the blink of an eye. Like a shooting star.

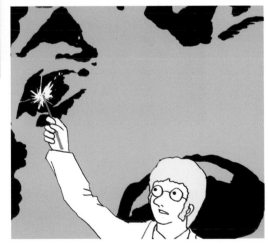

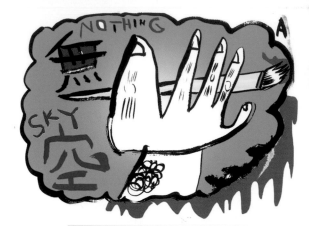

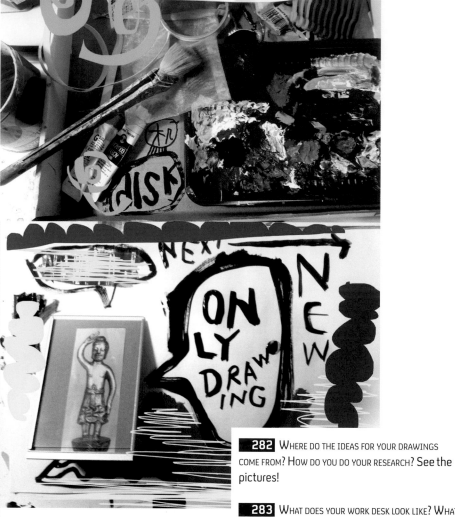

281 WHAT DIFFERENTIATES YOU FROM MANGA'S OTHER ILLUSTRATORS? I jack up, I concentrate, and I head to the sky. As in zen tradition.

282 WHERE DO THE IDEAS FOR YOUR DRAWINGS COME FROM? HOW DO YOU DO YOUR RESEARCH? See the pictures!

283 WHAT DOES YOUR WORK DESK LOOK LIKE? WHAT CAN WE COME ACROSS? I place in it the color palette, the brush, the water… It's similar to preparing the lunch box for the day.

284 DO YOU ALWAYS USE THE SAME TOOLS OR DO YOU CHANGE DEPENDING ON THE PIECE YOU'RE WORKING ON? I always say to myself: "change, change, change, go, go, go!"

285 DO YOU PREFER THE CLASSIC GUIDELINES FROM MANGA OR EXPERIMENTING WITH NEW CHANNELS? I always think that I need to experiment. But you should also be concerned about the real world. You need to put a little realism somewhere in your work.

286 WHAT ADVICE WOULD YOU GIVE TO A NOVICE ILLUSTRATOR TRYING TO MAKE A NAME FOR HIMSELF? Keep a sense of absolute power.

287 WHAT HAS CHANGED ABOUT YOUR STYLE OF DRAWING SINCE YOU BEGAN? Now, a message to society dwells somewhere in my work.

288 MANGA: IS IT ART? I do not think in terms of "true art" and "comics." Rather than a public sense of what is art or what it's not, it's a question of personal feelings.

289 WHY IS MANGA SO POPULAR IN THE WESTERN WORLD? Because of the loom for different cultures.

290 WHAT IS THE MOST IMPORTANT LESSON YOU HAVE LEARNED THAT YOU WOULD LIKE TO PASS ON TO OTHERS? More than words, use just simple lines. They can express everything! Like a Paul Klee painting!

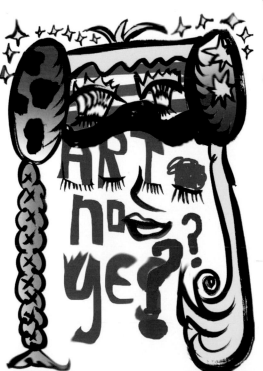

Kaoru Hironaka
http://web.me.com/pinecco

Kaoru Hironaka was born in Kamakura, Japan. She graduated from the paiting department of the Tama Art University. Regardless of genres, she develops artworks in several different medias. Her work ranges from illustrations for magazines, books and CDs to computer graphics, logo and characters design, photography, art, wall painting and live painting. She's also member of the Tokyo Illustrators Society, and has two studios, one in Kobe and the other one in Kamakura, both in Japan.

Karen Rubins

k_rubins@yahoo.com

Karen Rubins was the Comics Artist in Residence at the V&A museum, London, between July and December 2009, and is a multiple award-winning creator of comics and manga. Her work includes *Dark* (self-published), and *Urban Beasts* (Itch). Her story *Tsuchigumo* was published in the *Mammoth Book of Best New Manga 2* (Constable and Robinson). She loves myths and legends, history, and science fiction, and is a lifelong comics reader and creator.

291 WHO ARE YOUR FAVORITE ILLUSTRATORS? ARE YOU TRYING TO FOLLOW IN THEIR FOOTSTEPS? I think it's good to take inspiration from your favorite creators (mine include Wendy Pini, Hiroaki Samura, Rumiko Takahashi), but the only way to get ahead is to make your own footsteps! Don't try to follow someone else.

292 WHAT DOES YOUR WORK DESK LOOK LIKE? WHAT CAN WE COME ACROSS? My desk is normally overflowing with sketchbooks, reference books, paper and pens, and a selection of markers. I have an iMac and a Wacom tablet right in the middle of it. It's hardly ever tidy while I'm working on a project!

293 WHAT ARE YOUR FAVORITE TOOLS OR DRAWING PROGRAMS, AND WHY? I love to use blue mechanical pencils, brush pens or Rotring art pens and fineliners. Pitt artist pens are my absolute favorite brush pens as they have so much variation and a really good drawing texture.

294 WHAT DO YOU LIKE ABOUT MANGA? WHAT DOES MANGA HAVE THAT EUROPEAN OR AMERICAN COMICS DON'T? I love comics from all over the world, but I think what manga has is a real feeling of being inside the characters, rather than watching the action from afar.

295 HOW DO YOU MAKE YOUR DRAWINGS COME TO LIFE? I have a lot of diverse influences—from different types of comics and different media. I don't follow the manga aesthetic slavishly, which helps make my work unique. But all artists are unique in their own way!

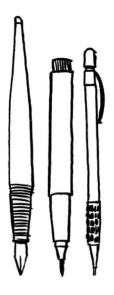

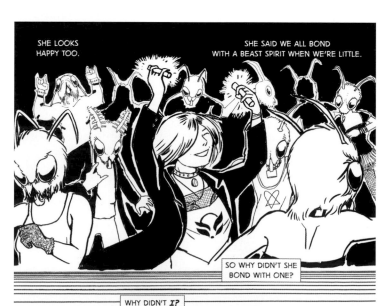

296 WHAT ADVICE WOULD YOU GIVE TO A NOVICE ILLUSTRATOR TRYING TO MAKE A NAME FOR HIMSELF? Entering competitions can be a great way to get yourself known. My advice is to not be shy talking about yourself and your work, and learn to take constructive criticism.

297 DO YOU FEEL THE NEED TO BETTER YOURSELF WHEN IT COMES TO YOUR WORK? TO WHAT EXTENT? I always feel as though I need to improve, but also to experiment. It's only by trying new things that progression really happens. I try not to compare my work with other artists', but it's hard!

298 WHAT HAS CHANGED ABOUT YOUR STYLE OF DRAWING SINCE YOU BEGAN? My style is always changing. It depends on the theme, genre and atmosphere of the story I'm working on. Of course there's something in it that's always recognisably mine (hopefully!)

299 MANGA: IS IT ART? It is as much art as any medium. Like film or novels, some is art, some isn't. If it's creative and shows something new and talks to people — it's art!

300 WHAT IS THE MOST IMPORTANT LESSON YOU HAVE LEARNED THAT YOU WOULD LIKE TO PASS ON TO OTHERS? Don't try to be anyone else — in terms of style or career progression; find your own way of doing things. Work hard, study, and be lucky!

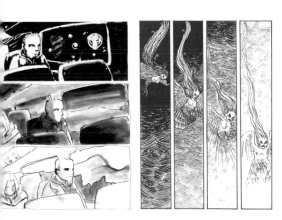

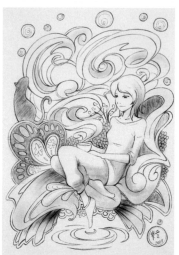

301 Who are your favorite illustrators? Are you trying to follow in their footsteps? There are many artists I favor but Josephine Wall is an artist I look at for inspiration. She creates such fantastical paintings that include all the elements I enjoy drawing: flowers, long hair and lots of color!

302 What does your work desk look like? What can we come across? I don't have my own desk, so depending on what I'm doing I sit and draw anywhere that is comfortable. I suppose my laptop is my work desk as I do most things on it: listening to music whilst working on art projects, writing scripts for my comics, browsing the net...

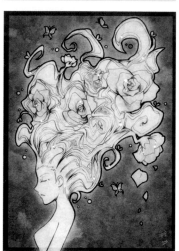

303 What are your favorite tools or drawing programs, and why? I try to use a variety of tools because I tend to get bored of using just one medium. I'm most comfortable with Photoshop, but I like to use Copic markers sometimes. *Mother and Child* was created using a combination of Copics and PS as I couldn't decide what medium to use!

304 What do you like about Manga? What does Manga have that European or American comics don't? I enjoy the dynamic panels and compositions in manga, as well as the exaggerated expressions and humor. When I visualize my pages and characters, I cannot imagine them in any other form but manga.

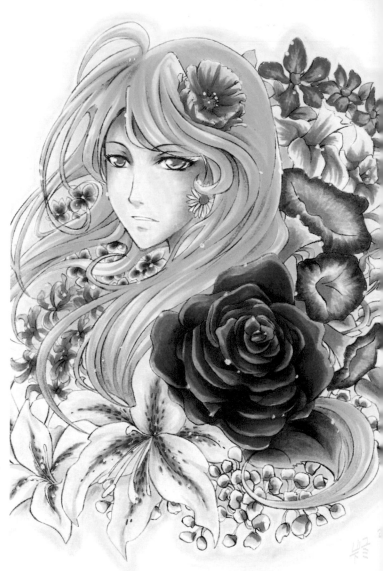

305 What differentiates you from Manga's other illustrators? I suppose what differentiates me from other artists is that I can't seem to stick to one sort of style or medium! I have a certain style that I know people would recognize as my work, but I always like to try something new. At the end of the day I draw what I feel like drawing.

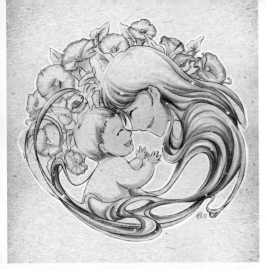

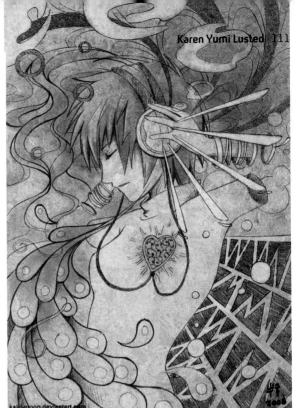

306 WHAT ADVICE WOULD YOU GIVE TO A NOVICE ILLUSTRATOR TRYING TO MAKE A NAME FOR HIMSELF? You need to think realistically but not pesimistically. Don't expect something to land at your feet tomorrow, it may happen but chances are it won't. Work hard towards your goal because by the end of it, you will feel you have deserved the reward.

307 WHAT HAS CHANGED ABOUT YOUR STYLE OF DRAWING SINCE YOU BEGAN? At the beginning, I would try and imitate my favorite artists and get quite annoyed when my work would not reach their standards. Over the years I have accepted that their style is theirs and I have to develop my own. I have allowed my style to grow to what you see now.

308 WHY IS MANGA SO POPULAR IN THE WESTERN WORLD? I think its because it covers a wide range of styles, genres, themes and ages that it can appeal to almost anyone and everyone. Manga is extremely accessible. Anyone can draw it, as long as you have paper, a pen or pencil and an idea.

309 WHAT GOOD HABITS SHOULD A COMIC ILLUSTRATOR HAVE? You need self-motivation, and good organizational skills would help. I think it is also important that you take some time off from your work; you will come back with an open mind and see things that you may want to change or improve. So plan ahead and schedule in those breaks!

310 WHAT IS THE GREATEST ACKNOWLEDGEMENT YOU COULD HOPE TO ACHIEVE FOR YOUR WORK? When I got one of my stories printed as a book, some people who had read it would come to me and say that they enjoyed it, and felt inspired to draw their own. It really touches my heart to hear such nice comments and I hope I can inspire more people with my future works.

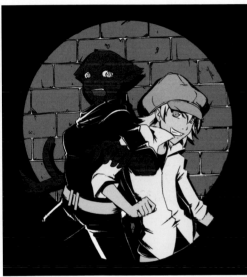

Karen Yumi Lusted

www.moonlightwaltz.com

Karen Yumi Lusted is a promising young manga artist. She started drawing when she was very young and hasn't stopped since, studying art throughout her school years and moving onto animation at university.

At the moment she's working as a teaching assistant, hopefully moving onto a job as an assistant language Teacher in Japan for a year or so. She's learning Japanese in her spare time, although five years of study still hasn't

"got her anywhere", in her own words. She also enjoys playing computer games on her PS3 or DS and watching lots of films, animations, and TV, as well as drawing comics, of course!

漫画

Kate Holden

www.kateholdenart.com

Kate Holden is an illustrator from Cumbria, a county of England famous for its beautiful scenery. She has been totally in love with art, particularly cartoons and illustrations, from a very early age, and no piece of paper has been safe from her since! Clients for her work have included Cumbria County Council, Nacro, The BBC and Nintendo. Kate is typically enthusiastic and energetic and loves learning and discussing new skills or techniques. Outside of drawing and reading comics, she enjoys playing RPGs, rock climbing, martial arts, cosplay and making really awful puns that make people groan. She is a member of the small press comics group IndieManga.

311 WHERE DO THE IDEAS FOR YOUR DRAWINGS COME FROM? HOW DO YOU DO YOUR RESEARCH? I'm often inspired by history, mythology, literature and science. Frequently I hear something interesting from science, politics or culture and think, "hmm, that's interesting."

312 WHAT ARE YOUR FAVORITE TOOLS OR DRAWING PROGRAMS, AND WHY? I have a particular favorite mechanical pencil one of my best friends gave me as an eighteenth birthday present. It's a Parker, so well made, and just the right shape as well as having a certain sentimental value. My first pass of pencils is nearly always with the blue erasable pencils used by animators; it gives me a much cleaner finish.

313 WHAT DO YOU LIKE ABOUT MANGA? WHAT DOES MANGA HAVE THAT EUROPEAN OR AMERICAN COMICS DON'T? The lines between manga and European or American are blurring now. Manga depicts the world with details exaggerated or omitted, and things shown from a subjective perspective. It's less how a camera records the world, and more how your brain remembers and interprets the world.

314 HOW DO YOU MAKE YOUR DRAWINGS COME TO LIFE? The key factor for me is empathy. Languages, culture and politics may be different throughout the world and its history, but human emotion is always the same. If the viewer or reader can connect to the character on a human, emotional level, it doesn't matter how different or crazy the setting is, they will care about the story, I think.

Stage 1:
Animator's blue pencil,
0.5mm HB pencil,
A nice eraser,
Cheap A4 printer paper!
A cup of tea,
A book to lean on

Stage 2:
Manga Studio Debut
Wacom Bamboo A5
graphics tablet,
A cup of tea,
Some good music

Scan and import to manga studio

Export as a .psd and open with Photoshop

Stage 3:
Photoshop,
Wacom Bamboo A5
graphics tablet,
Custom brush plugins
from internet,
A cup of tea,
Plenty of patience!

Also useful:
*Scrap paper for thumbnails and rough sketches,
*A good sized monitor, calibrated to show the colours as truly as possible,
*A reliable computer,
*A tea monkey (friend, partner or family member who will bring tea at intervals),
*Imagination and ingenuity!

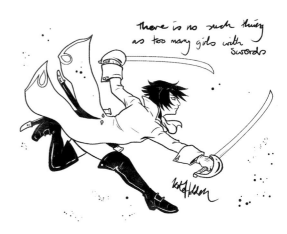

there is no such thing as too many girls with swords

315 WHAT DIFFERENTIATES YOU FROM MANGA'S OTHER ILLUSTRATORS? I would say it's my mixed influences. You can see in my work elements of manga but often with the heavy dark shadows and bold lines of American comics inspired by Jack Kirby, and the loose, elastic postures seen in traditional British cartoons and comics.

MANGAMAN'S RIVAL APPEARS!?

-mortem of a
pped image:

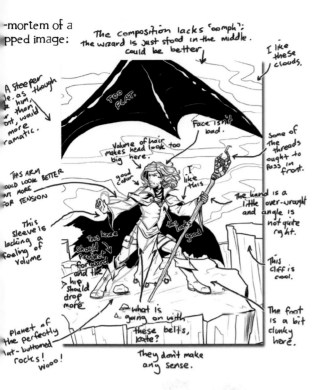

The composition lacks 'oomph':
the wizard is just stood in the middle.
could be better

I like these clouds.

TOO FLAT.

A steeper [...] le as though [...] ont, would more ramatic.

Face isn't bad.

Volume of hair makes head look too big here.

Some of the threads ought to pass in front.

THIS ARM [...] OULD LOOK BETTER [...] NT MORE [...] OR TENSION

good color

I like this

The hand is a little over-wrought and angle is not quite right.

This Sleeve is lacking a feeling of volume

This knee should project forward and the hip should drop more

this looks good

This cliff is cool.

The foot is a bit clunky here.

Planet of the perfectly [...]t-buttoned rocks! Wooo!

what is going on with these belts, Kate?

They don't make any sense.

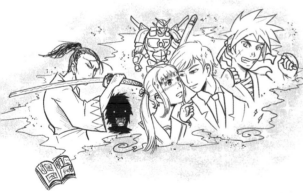

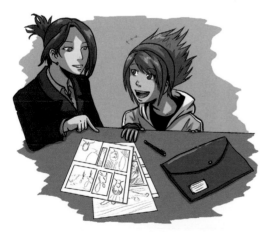

316 DO YOU FEEL THE NEED TO BETTER YOURSELF WHEN IT COMES TO YOUR WORK? TO WHAT EXTENT? I'm extremely critical of my own work, and constantly trying to improve it. Coming from a rural area, I was "the best at drawing" in my little school, which was a bad thing really, I didn't push myself to improve as a teenager because I never needed to try hard to impress my peers. It lead to a steep learning curve in my early twenties trying to get up to professional standards.

317 WHAT HAS CHANGED ABOUT YOUR STYLE OF DRAWING SINCE YOU BEGAN? I began drawing as a baby, so you can imagine a lot has changed there! With regards to manga, I first dabbled in the style in my mid-teens. I drew everybody very angular-looking with huge eyes and tiny, pointed noses, as that was what manga looked like to me then: exotic and different. It took me a lot of practice and experimentation to develop a style that balances what I like about manga with my Western influences.

318 WHY IS MANGA SO POPULAR IN THE WESTERN WORLD? I think it's because manga put emphasis on the characters and embraces a very wide range of genres. One of my pet peeves is hearing manga or anime called a genre; it is not a genre, it's just a style, with comics of practically any genre.

319 WHAT IS THE MOST IMPORTANT LESSON YOU HAVE LEARNED THAT YOU WOULD LIKE TO PASS ON TO OTHERS? Art is like playing an RPG. If you avoid doing things you find difficult, or cheat on them by just copying from other artists, it's like skipping the random monster encounters you have to fight; it denies you valuable experience and skills.

320 WHAT GOOD HABITS SHOULD A COMIC ILLUSTRATOR HAVE? Apart from good motivation and rigorous practice and study, the most important thing is to have an honest and humble attitude. Listen to the criticism of others and try not to make excuses for your shortcomings, pay attention to what your peers are doing and never hesitate to give credit to those you admire.

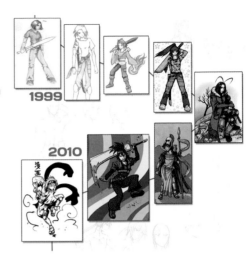

1999

2010

A challenge appears!

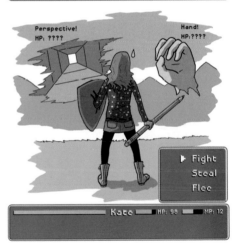

Perspective! HP: ????

Hand! HP:????

▶ Fight
Steal
Flee

Kate HP: 98 MP: 12

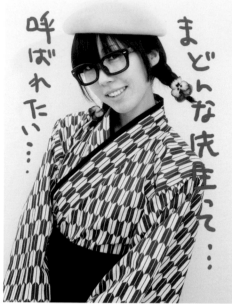

321 Where do the ideas for your drawings come from? How do you do your research? Ideas pop up suddenly in my every day life.

322 Who are your favorite illustrators? Are you trying to follow in their footsteps? They are not illustrators, but I admire Akira Toriyama, Katsuhiro Otomo and Hisashi Eguchi among others.

323 What does your work desk look like? What can we come across? I work on top of my bed.

324 What is the first thing you do before sitting down to draw? I listen out loud to my favorite music to raise my spirits.

325 Do you always use the same tools or do you change depending on the piece you're working on? I change them depending on the work.

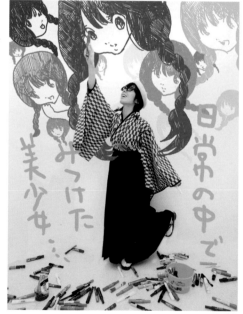

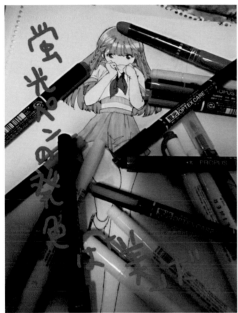

326 WHAT ARE YOUR FAVORITE TOOLS OR DRAWING PROGRAMS, AND WHY? Fluorescent markers. Colors come out well and I always have them with me. Plus, they are easy to use.

327 DO YOU PREFER THE CLASSIC GUIDELINES FROM MANGA OR EXPERIMENTING WITH NEW CHANNELS? I like classic guidelines.

328 WHAT DO YOU LIKE ABOUT MANGA? WHAT DOES MANGA HAVE THAT EUROPEAN OR AMERICAN COMICS DON'T? I like characters. The quality of Japanese manga characters is high. That's why they have fans all over the world.

329 HOW DO YOU MAKE YOUR DRAWINGS COME TO LIFE? I cherish the energy of the drawing line.

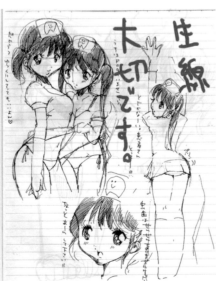

330 WHAT HAS CHANGED ABOUT YOUR STYLE OF DRAWING SINCE YOU BEGAN? I started live painting.

Kato Ai / ai☆madonna

http://ai-madonna.jp/

Kato Ai was born in Tokyo in 1984. Her works include paintings, figures, comics and live painting. She is active both in Japan and abroad, mainly because of her two-dimensional beautiful girls, which she draws as the ultimate motif to express her love. She also gives a humorous touch to her world by adding small phrases to her works. The works of Kato Ai have traveled and been shown internationally in galleries and art centers in Los Angeles, Taipei and even Poland, and also, obviously, in her own country.

Kayo Tamaishi

http://tamaishikayo.blog58.fc2.com

Kayo Tamaishi was born in 1980 and raised in Yokohama, Japan. Kayo's work includes water paintings, book cover designs, magazine illustrations, T-shirts designs, design of CD jackets, advertisements, posters, live paintings and more. The girls' eyes she draws are impressive and attractive. Pleasure, sadness, happiness, solitude and various secrets are hidden in these eyes. All the girls she draws are cute and fashionable. They are always casual, and they do enjoy the fact that they're women.

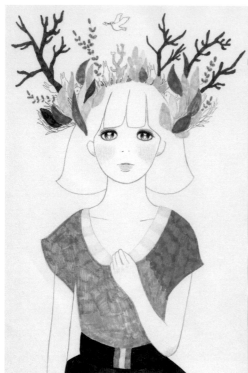

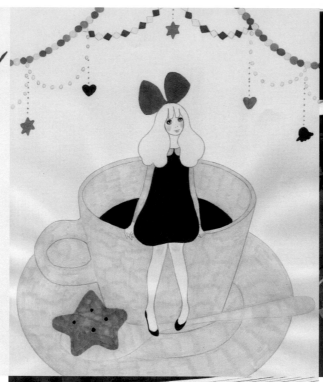

331 WHERE DO THE IDEAS FOR YOUR DRAWINGS COME FROM? HOW DO YOU DO YOUR RESEARCH? I give inspiration to my heart and head unconsciously every day. When I make a drawing, I can take it out naturally.

332 WHAT IS THE FIRST THING YOU DO BEFORE SITTING DOWN TO DRAW? At first I take in some sugar. I like chocolate. And the music is necessary for my drawing, too.

333 DO YOU ALWAYS USE THE SAME TOOLS OR DO YOU CHANGE DEPENDING ON THE PIECE YOU'RE WORKING ON? I usually use a colored pencil and a colored pen for drawing smaller works. I use an oil pastel crayon and the poster color paint when drawing big sizes.

334 WHAT DO YOU LIKE ABOUT MANGA? WHAT DOES MANGA HAVE THAT EUROPEAN OR AMERICAN COMICS DON'T? The characters of Japanese comics have Japanese special prettiness. I feel attached to the characters of Japanese comics.

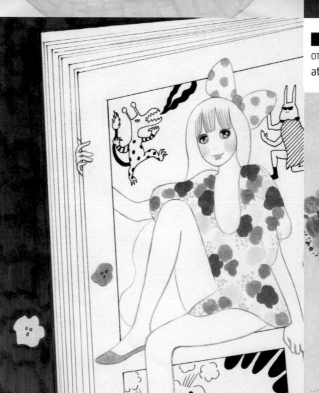

335 WHAT DIFFERENTIATES YOU FROM MANGA'S OTHER ILLUSTRATORS? The girls I draw have a unique atmosphere. Their eyes have a mysterious charm.

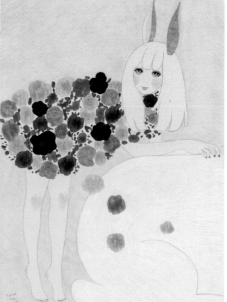

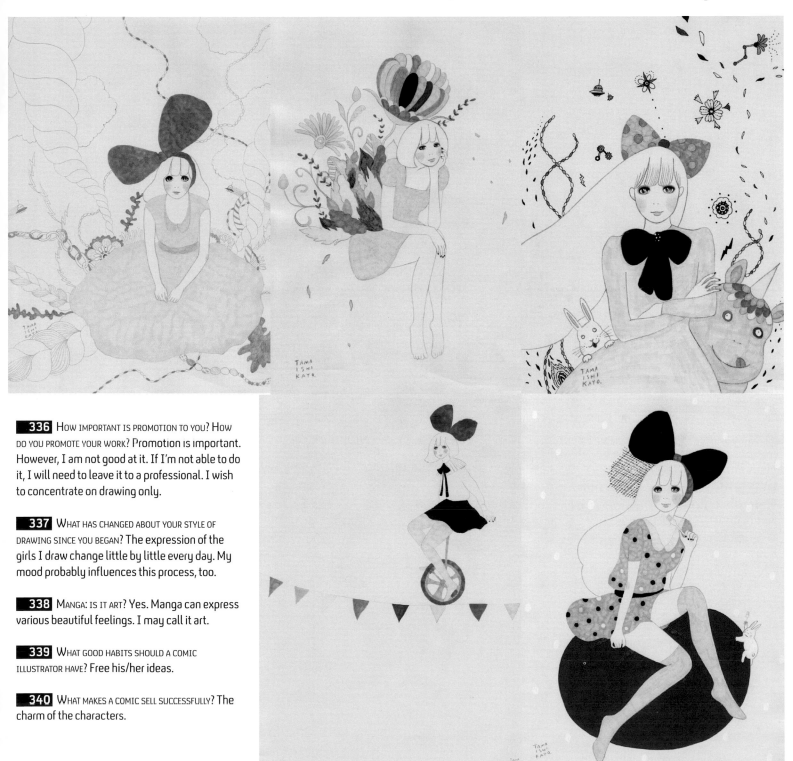

336 How important is promotion to you? How do you promote your work? Promotion is important. However, I am not good at it. If I'm not able to do it, I will need to leave it to a professional. I wish to concentrate on drawing only.

337 What has changed about your style of drawing since you began? The expression of the girls I draw change little by little every day. My mood probably influences this process, too.

338 Manga: is it art? Yes. Manga can express various beautiful feelings. I may call it art.

339 What good habits should a comic illustrator have? Free his/her ideas.

340 What makes a comic sell successfully? The charm of the characters.

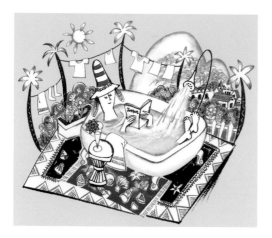

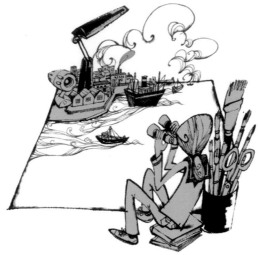

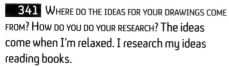

341 WHERE DO THE IDEAS FOR YOUR DRAWINGS COME FROM? HOW DO YOU DO YOUR RESEARCH? The ideas come when I'm relaxed. I research my ideas reading books.

342 WHAT DOES YOUR WORK DESK LOOK LIKE? WHAT CAN WE COME ACROSS? There is a light, a speaker and a container for the brushes and pen.

343 WHAT IS THE FIRST THING YOU DO BEFORE SITTING DOWN TO DRAW? I start my laptop.

344 DO YOU ALWAYS USE THE SAME TOOLS OR DO YOU CHANGE DEPENDING ON THE PIECE YOU'RE WORKING ON? I use mostly brush and pen. Depending on the idea, I use other tools.

345 WHAT ARE YOUR FAVORITE TOOLS OR DRAWING PROGRAMS, AND WHY? The pen is my favorite, because I like the feeling of drawing on paper with the pen.

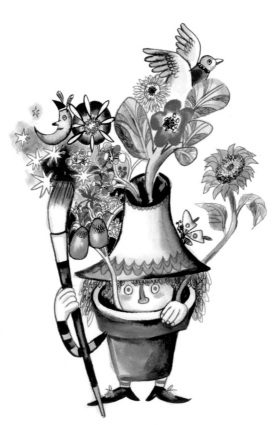

歌舞伎にすと入門

知る観る
KABUKI
100のツボ

辻 和子

東京新聞

346 HOW IMPORTANT IS PROMOTION TO YOU? HOW DO YOU PROMOTE YOUR WORK? It is very important. When I publish a new book, I use it for promotion.

347 WHAT ADVICE WOULD YOU GIVE TO A NOVICE ILLUSTRATOR TRYING TO MAKE A NAME FOR HIMSELF? Focus on your favorite things in the world.

348 WHAT HAS CHANGED ABOUT YOUR STYLE OF DRAWING SINCE YOU BEGAN? It took various trials and errors and some luck. Work is made from tearing papers.

349 WHAT GOOD HABITS SHOULD A COMIC ILLUSTRATOR HAVE? Concentrate in what the work hints, no matter what you see.

350 WHAT DO YOU LIKE ABOUT MANGA? WHAT DOES MANGA HAVE THAT EUROPEAN OR AMERICAN COMICS DON'T? I like Katsushika Hokusai's manga. His work has wit, observation power and deformation. There are also good cartoons in Europe and the U.S.

Kazuko Tsuji
http://ktsuji.com

Kazuko Tsuji was born in Nishinomiya, in Hyogo Prefecture, and studied design and illustration at Kyoto Saga University of Arts. Her work as an illustrator was strongly influenced by *kabuki*, a traditional Japanese drama school that is known for its stylized dramas and the actors' heavy use of garish make-up. Her illustrations are published regularly in Japanese newspapers in a serialized format. Kazuko has also published two books on *kabuki*, as well as a number of travel books.

Keiko Enobi (Atoron)

www.atoron.com

In 1997, Tsukasa Tomoyose and Keiko Enobi started working together on art projects. In the year 2000 they created their own studio, named Atoron, in Okinawa, Japan. Atoron Studio produces art in a variety of mediums, and covers many areas such as illustration, animation, event posters, characters, CD covers, T-shirts, movie clips, TV-advertisements, TV spots and more. In 2003, Atoron studio was awarded the Best In Selection award on the NHK Digital Stadium program (on the national Japanese Broadcasting Corporation- TV network.)

351 WHERE DO THE IDEAS FOR YOUR DRAWINGS COME FROM? HOW DO YOU DO YOUR RESEARCH? I get ideas from everyday life. Unlikely while I'm at my desk, and more so when I'm maybe doing the dishes, while in the bathroom, going shopping, or talking with people. So my inspiration may come from talking to people and then I'll come up with an idea afterwards. Typically, I wouldn't just stay in the studio, but go out instead.

352 WHAT DOES YOUR WORK DESK LOOK LIKE? WHAT CAN WE COME ACROSS? I have a Mac at my desk and my monitor is covered with sticky notes. There are also some snacks, coffee, a planner and some reading material.

353 DO YOU ALWAYS USE THE SAME TOOLS OR DO YOU CHANGE DEPENDING ON THE PIECE YOU'RE WORKING ON? In the last few years, I've been drawing with my favorite watercolor pens on scrap paper. Dissolving the paint on the paper gives the picture its flavor. I like when the outlines become warped. Sometimes I also draw with a glass pen dipped in ink. Lastly, I do my color adjustments on the computer.

354 WHAT DO YOU LIKE ABOUT MANGA? WHAT DOES MANGA HAVE THAT EUROPEAN OR AMERICAN COMICS DON'T? What I like about manga is the different uses of designs when it comes to speech bubbles, fonts or even onomatopoeias. I also like that manga can express different movement or emotions using unique symbols and lines.

355 HOW DO YOU MAKE YOUR DRAWINGS COME TO LIFE? I usually write down my ideas on paper. I make a picture based on a word that sticks out to me the most. Then I look back the next day and see if something catches my eye or whether I still like it.

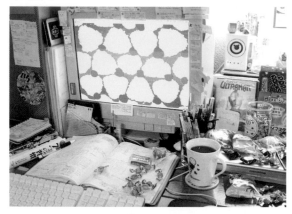
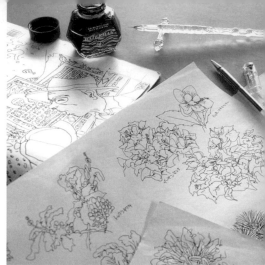

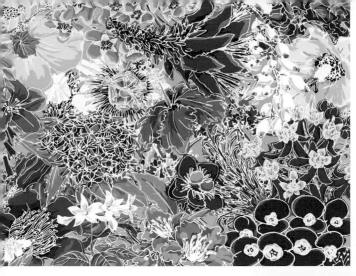

356 WHAT HAS CHANGED ABOUT YOUR STYLE OF DRAWING SINCE YOU BEGAN? At first I used to draw people, but in the last few years, I've been drawing plants, landscapes or inorganic objects (for example, utility poles). Though one thing I've always enjoyed drawing are textile patterns.

357 MANGA: IS IT ART? Manga is clearly art. One picture can't tell the whole story that the author is trying to show. They allow the reader to experience a world and characters that they have created.

358 WHAT GOOD HABITS SHOULD A COMIC ILLUSTRATOR HAVE? Being self-employed, it is important to keep a schedule and try to stick to your own deadlines. Sometimes, if I don't stay focused, I become lazy. So, I believe you have to have a strong will to stay on track.

359 WHAT IS THE GREATEST ACKNOWLEDGEMENT YOU COULD HOPE TO ACHIEVE FOR YOUR WORK? Whether going through a good or bad time, one must have the will to never give up and the effort to accomplish precise goals. Most importantly, one must love the work they do.

360 HOW IMPORTANT IS PROMOTION TO YOU? HOW DO YOU PROMOTE YOUR WORK? Not only is the art important, but the artist's style as well. Doing art shows, you get to see and meet a lot of people. So networking opens up opportunities for work.

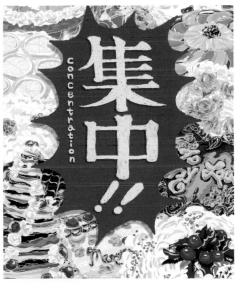

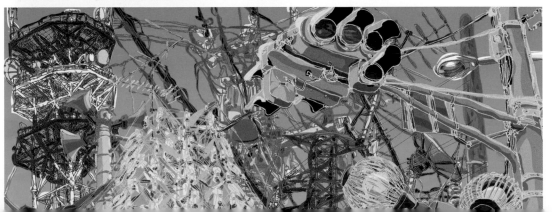

361 WHERE DO THE IDEAS FOR YOUR DRAWINGS COME FROM? HOW DO YOU DO YOUR RESEARCH? When I scribble on my sketchbook, various ideas come out. I also get ideas from taking walks in my town and taking photographs.

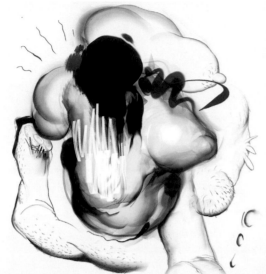

362 WHO ARE YOUR FAVORITE ILLUSTRATORS? ARE YOU TRYING TO FOLLOW IN THEIR FOOTSTEPS? Much of the illustrators that influence me are artists on the Internet. Like Tokiya, GP or Hiroyuki Nisougi for example. When an artist found on the Internet has a fresh and interesting idea, it influences me also.

363 WHAT IS THE FIRST THING YOU DO BEFORE SITTING DOWN TO DRAW? Steady myself.

364 WHAT ARE YOUR FAVORITE TOOLS OR DRAWING PROGRAMS, AND WHY? I like to use pens for analog works, because it's easy to draw lines with them. I like Corel Painter, also, because there are new discoveries every time I use it.

365 WHAT DO YOU LIKE ABOUT MANGA? WHAT DOES MANGA HAVE THAT EUROPEAN OR AMERICAN COMICS DON'T? I think manga is a very excellent art. Manga is superior entertainment, and it easily takes you to out of your daily life. But I also like American comics. I like *X-Men*, *Spawn*, *Hellboy* and etc. I'm very interested in Moebius' work also.

366 WHAT DIFFERENTIATES YOU FROM MANGA'S OTHER ILLUSTRATORS? The way I deform my characters, and my painting-like technique.

367 WHAT HAS CHANGED ABOUT YOUR STYLE OF DRAWING SINCE YOU BEGAN? When I was in my teens I was focused on the design of the picture. Nowadays I'm interested in the feeling, the quality of the art and the freedom of the technique.

368 MANGA: IS IT ART? Yes! I got a lot of knowledge from manga.

369 WHY IS MANGA SO POPULAR IN THE WESTERN WORLD? I think because it comes from the original culture of *kawai* and *moe*, which you don't have in Western countries. In Japan, manga has a long and rich history. I also think the Japanese are masters of the technique of deformation.

370 WHAT GOOD HABITS SHOULD A COMIC ILLUSTRATOR HAVE? They must like to draw, and draw every day. It's important also to have consciousness of oneself as a creator.

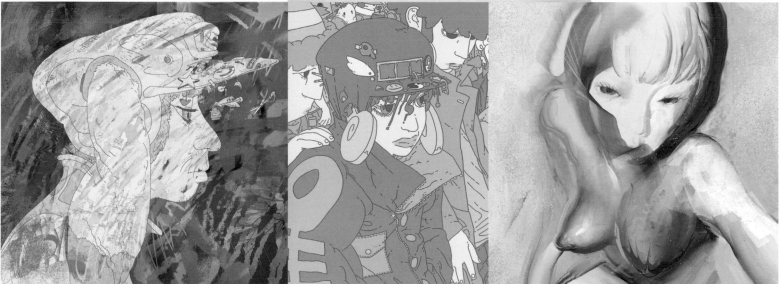

Kenji Urata

www.kenjiurata.com

Kenji Urata started drawing with the computer from an early age, and did announce his work on his website for everyone to know about it. He did study different techniques, including oil painting and digital, at university, where he combined his analogue and digital skills, resulting in his own style. His main themes are the body, the symbols, the eros... The work of Kenji Urata combines illustration, photograph and modern art.

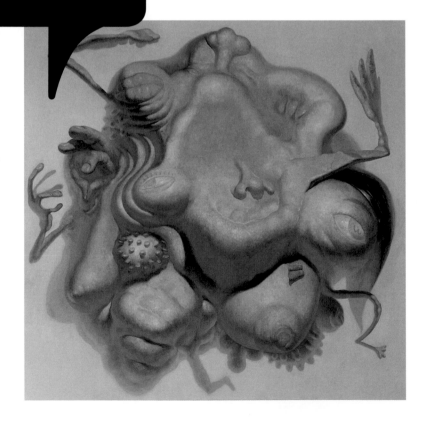

Kentaro Hisa

www17.plala.or.jp/sweet-blossom

Kentaro Hisa (Fukushima Prefecture, Japan, 1977) graduated with a degree in graphic design in 2001, and then set himself up as a freelance illustrator. His usual clients are primarily the news media, advertising agencies, and design studios specializing in the creation of websites, which include names such as Nikkei Home Publishing, Honeys, Look JTB, Sonoko, Universal, Kintetsu Department Store, Marunouti, Orbis, OCN and Shinseido. One of his desires is to work abroad or else, failing that, for foreign clients.

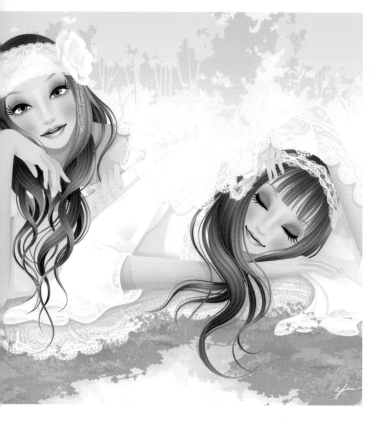

375 How important is promotion to you? How do you promote your work? It is very important. I promote my works mainly on the Web. Some agents promote my works, also.

371 Where do the ideas for your drawings come from? How do you do your research? Lately, I get inspiration from plants and animals.

372 What does your work desk look like? What can we come across? You might think that it's a bleak working desk...

373 Do you always use the same tools or do you change depending on the piece you're working on? I always use Illustrator CS2 on an iMac.

374 How do you make your drawings come to life? When I started to work as illustrator, I introduced my works to design companies and publishers by myself. My style has been built thanks to their advice.

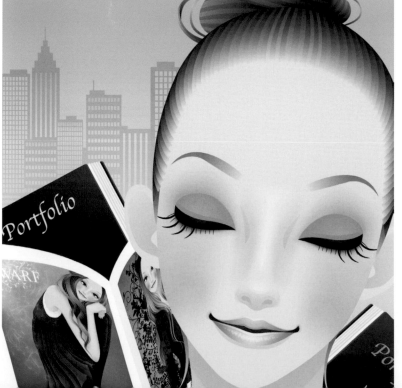

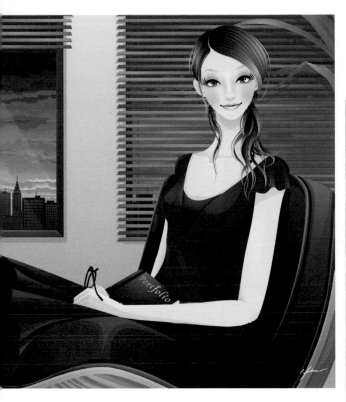

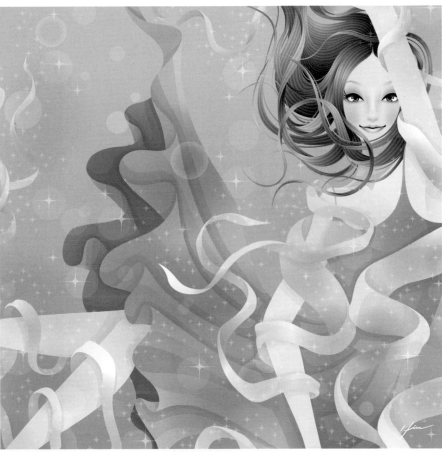

376 WHAT ADVICE WOULD YOU GIVE TO A NOVICE ILLUSTRATOR TRYING TO MAKE A NAME FOR HIMSELF? Believe in your work and show it to a lot of people. And also it is important to show it to design companies and publishers without hesitation.

377 DO YOU FEEL THE NEED TO BETTER YOURSELF WHEN IT COMES TO YOUR WORK? TO WHAT EXTENT? Yes, I feel it. I want not only to improve my skills, but also portray a more stylish view of the world.

378 WHAT HAS CHANGED ABOUT YOUR STYLE OF DRAWING SINCE YOU BEGAN? Basically, my style has not changed. But the facial expressions I draw have gotten softer and more amiable.

379 MANGA: IS IT ART? Admittedly, I don't know. But there are more people now that think this is art.

380 WHAT IS THE GREATEST ACKNOWLEDGEMENT YOU COULD HOPE TO ACHIEVE FOR YOUR WORK? "I was right about requesting you."

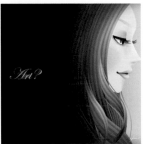

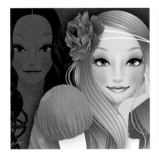

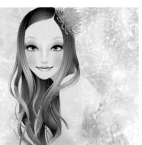

381 WHAT DOES YOUR WORK DESK LOOK LIKE? WHAT CAN WE COME ACROSS? I describe my work area as "controlled chaos" except without the control. So really, it's just a mess. Say! How about I show you a colorful, impressionistic interpretation of my work area and we move on?

382 WHAT IS THE FIRST THING YOU DO BEFORE SITTING DOWN TO DRAW? I'm not averse to typing my own name in a Google search to see what folks are saying about my art. If it's good? Yay! Encouragement! If it's bad, then it gives me something to work on. Feedback is fuel, I say.

383 WHAT ARE YOUR FAVORITE TOOLS OR DRAWING PROGRAMS, AND WHY? I love the Copic Multiliner BS pen. It's a tech pen with a replaceable brush tip, so I get great line variety but with little brush-related mess and I can change the tip when it starts to wear down.

384 HOW DO YOU MAKE YOUR DRAWINGS COME TO LIFE? Make your characters as expressive as possible, both through the face and body language. Using line of action in your drawings will give your characters a lot of life.

385 HOW IMPORTANT IS PROMOTION TO YOU? HOW DO YOU PROMOTE YOUR WORK? You can't make a living off your work if no one sees it. Get out to conventions, art shows, whatever, and don't be afraid to show off your stuff to anyone who's willing to look at it.

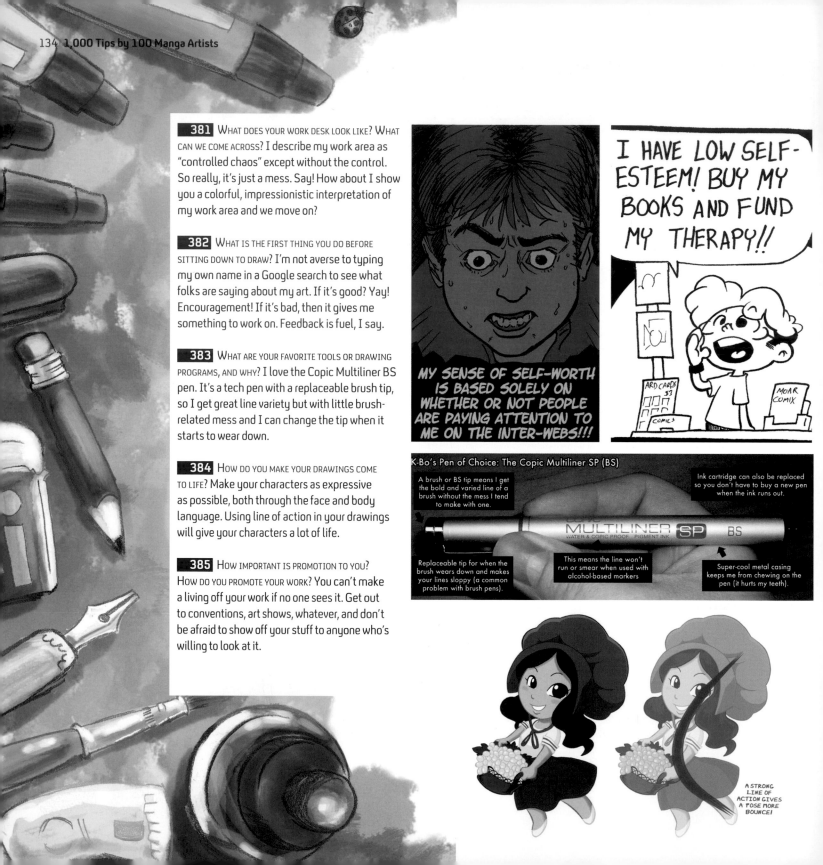

I HAVE LOW SELF-ESTEEM! BUY MY BOOKS AND FUND MY THERAPY!!

MY SENSE OF SELF-WORTH IS BASED SOLELY ON WHETHER OR NOT PEOPLE ARE PAYING ATTENTION TO ME ON THE INTER-WEBS!!!

K-Bo's Pen of Choice: The Copic Multiliner SP (BS)

A brush or BS tip means I get the bold and varied line of a brush without the mess I tend to make with one.

Ink cartridge can also be replaced so you don't have to buy a new pen when the ink runs out.

MULTILINER SP BS
WATER & COPIC PROOF PIGMENT INK.

Replaceable tip for when the brush wears down and makes your lines sloppy (a common problem with brush pens).

This means the line won't run or smear when used with alcohol-based markers.

Super-cool metal casing keeps me from chewing on the pen (it hurts my teeth).

A STRONG LINE OF ACTION GIVES A POSE MORE BOUNCE!

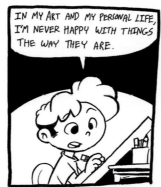

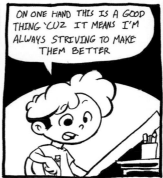

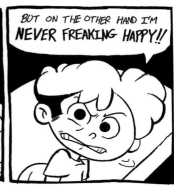

386 WHAT ADVICE WOULD YOU GIVE TO A NOVICE ILLUSTRATOR TRYING TO MAKE A NAME FOR HIMSELF? Get a website (and not just a DeviantArt or Blogspot account). Whether you set it up yourself or get someone to help you, it's an invaluable promotional tool and professionals will not take you seriously without one.

387 DO YOU FEEL THE NEED TO BETTER YOURSELF WHEN IT COMES TO YOUR WORK? TO WHAT EXTENT? The minute you become satisfied with your work is the minute you start to stagnate. I'm constantly learning and improving.

388 WHAT IS THE MOST IMPORTANT LESSON YOU HAVE LEARNED THAT YOU WOULD LIKE TO PASS ON TO OTHERS? Study! Study! Study! Style is not an excuse for shoddy fundamentals, so learn the rules before you break them.

389 WHAT GOOD HABITS SHOULD A COMIC ILLUSTRATOR HAVE? Learn to budget your time effectively, especially if you're even slightly into video games.

390 WHAT MAKES A COMIC SELL SUCCESSFULLY? There's no secret formula for a comic's success. You just have to do your best, get your work out there, and hope the tides of public taste are in your favor. It's one part inspiration, three parts perspiration, and the rest is all luck. Don't try to chase trends or else you'll get left in the dust.

Kevin Bolk

http://www.kevinbolk.com, http://www.interrobangstudios.com

Kevin Bolk (or K-Bo. to his fans) is a freelance cartoonist, illustrator, and proud alumnus of Awesome University, his favorite imaginary alma mater. Although he's done work for Nickelodeon, Tokyopop, Udon Entertainment, Blind Ferret Entertainment, and Voices For, he's best known for his parody webcomics, *It Sucks to be Weegie* and *Ensign Sue Must Die!*, as part of Interrobang Studios' Pot Luck Comics. He's also responsible for the quirky auto-bio comic *I'm My Own Mascot!* as well as the fantasy webcomics send-up *The Last Mystical Legend of the Fantastic Fantasy Trigger Star*, just to name a few. All of these delightful diversions can be conveniently located at the Interrobang Studios website (bookmark or perish!) In his spare time, K-Bo. can be found watching old Saturday morning cartoons or engaging in cage matches with the Rodents of Unusual Size found in the back alley of his Baltimore home. He likes cookies.

Kimiaki Yaegashi

www.okimi.com

Based in Tokyo, Kimiaki Yaegashi is an illustrator and graphic designer. He was born in 1972 in Kitakami, Iwate, Japan. He specialized in art at high school and university, and has worked as a freelance artist in Tokyo since 1998. His ideas are inspired by human relationships, television, music, search engines, traditional culture and pop culture. His works are mainly made using Adobe Photoshop and Illustrator, and his new art is always exhibited on his website as soon as it completed. His style is said to be "colorful, cute, sexy, strange and crazy." Recently, he has been researching information about the traditional Bulgarian ritual Kukeri, and the following work will soon be published as a digital book.

391 Where do the ideas for your drawings come from? How do you do your research? All things do stimulate my senses. It's necessary to search in Google, also.

392 What is the first thing you do before sitting down to draw? I always play good music for relaxing.

393 What are your favorite tools or drawing programs, and why? Photoshop and pen tablet.

394 What do you like about Manga? What does Manga have that European or American comics don't? Manga is easy to transmit, but I love the work of Stan Lee.

395 What differentiates you from Manga's other illustrators? I always include humor in my illustrations.

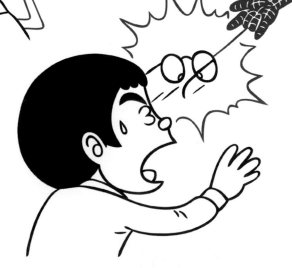

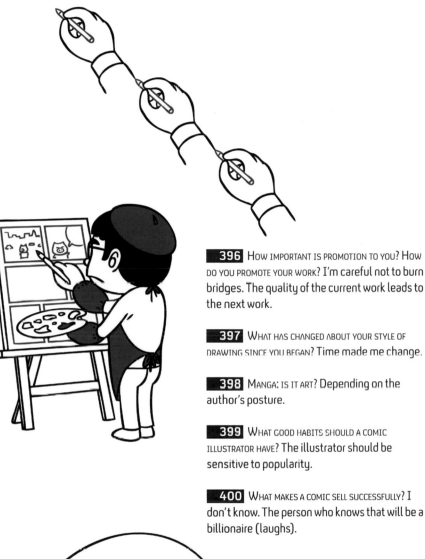

396 How important is promotion to you? How do you promote your work? I'm careful not to burn bridges. The quality of the current work leads to the next work.

397 What has changed about your style of drawing since you began? Time made me change.

398 Manga: is it art? Depending on the author's posture.

399 What good habits should a comic illustrator have? The illustrator should be sensitive to popularity.

400 What makes a comic sell successfully? I don't know. The person who knows that will be a billionaire (laughs).

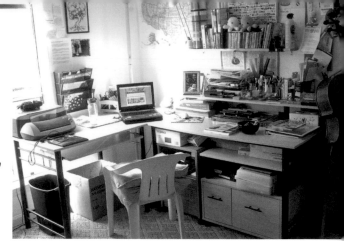

401 WHERE DO THE IDEAS FOR YOUR DRAWINGS COME FROM? HOW DO YOU DO YOUR RESEARCH? I get into the mood for drawing by looking at art from artists that I admire. I will print out and surround myself with images I love, and eventually the ideas will come to me. For researching specific things I use Google Images & books. I always have some new art magazines nearby to browse, too.

402 WHAT DOES YOUR WORK DESK LOOK LIKE? WHAT CAN WE COME ACROSS? My desk is often a place of chaos. I feel like I am constantly having to clean it. You may come across anything from old receipts, dozens of pens, pencils, highlighters, notepads, envelopes, stamps, you name it. I do most of my digital work at my desk in my office, but I enjoy sketching outside.

403 WHAT IS THE FIRST THING YOU DO BEFORE SITTING DOWN TO DRAW? Eat. Make tea. Wear comfy clothes, possibly grab a blanket. Put on good (appropriate) music. Then, typically collect references and print them out. Tape to my page if sketching on paper, or make a folder of reference images to display on an external monitor for inspiration. Drink tea. Draw :)

404 WHAT ARE YOUR FAVORITE TOOLS OR DRAWING PROGRAMS, AND WHY? Digitally I use Paint Tool Sai to sketch. I find it has the smoothest lines and quickest response time on my computer. For textures and effects, I like using Photoshop. I have recently tried a more painterly style in my coloring and am finding that both Sai and Painter are great for blending.

405 WHAT DO YOU LIKE ABOUT MANGA? WHAT DOES MANGA HAVE THAT EUROPEAN OR AMERICAN COMICS DON'T? I love the range of expressions and the limitless freedom in range of detail and color that great manga artists bring. I find it more vibrant and exciting than most American comics. I also love the overall style more. I think manga is usually much more imaginative and creative in story and art.

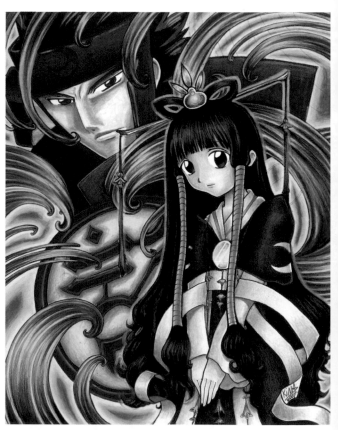

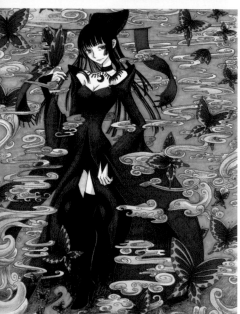

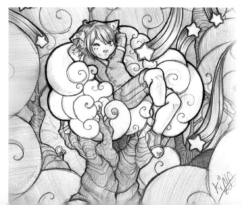

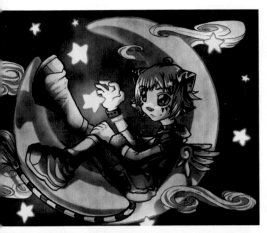

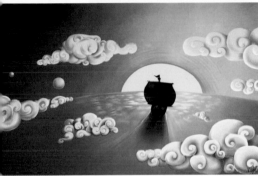

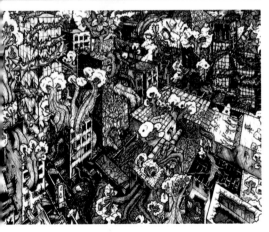

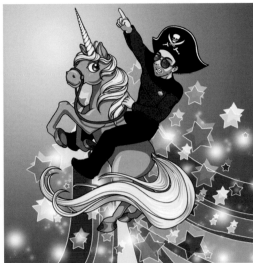

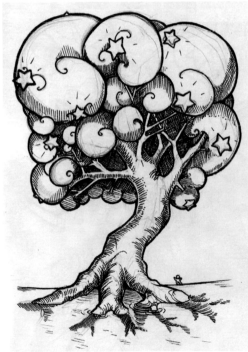

406 How do you make your drawings come to life? I think the key to bringing my own drawings to life lies in the details. The eyes and facial expressions are very important to me. I always draw eyes first, and they "tell" me what to do next. I also find that my more successful pieces usually have large amounts of intricate detail in them.

407 Do you feel the need to better yourself when it comes to your work? To what extent? Even though I have been drawing for over a decade I still don't feel like I am anywhere near where I want to be skill-wise. I am always trying to better myself by studying and trying new things. I think it's really important to always challenge yourself to keep your art fresh and interesting.

408 What has changed about your style of drawing since you began? Many things have changed with my style since I began; namely the technical skill level that shows in my anatomy and character drawings. I have also started trying to do more backgrounds and fully rendered scenes recently. Painting things like rocks and clouds is more challenging than I thought!

409 What is the most important lesson you have learned that you would like to pass on to others? Never try to make your art look like someone else's. Draw from nature, and admire other's art, but find your own style and go with it!

410 What good habits should a comic illustrator have? Draw every day! I have a lot of difficulty doing this but it has helped me through some rough times. I pick up books such as *642 Things To Draw* or participate in daily art challenges. Even if you don't love every drawing it is healthy to draw even for a couple minutes each day to stay in practice.

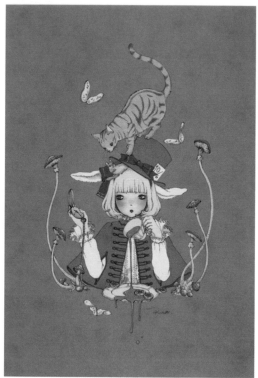

411 WHO ARE YOUR FAVORITE ILLUSTRATORS? ARE YOU TRYING TO FOLLOW IN THEIR FOOTSTEPS? I'm really interested in the illustrations on Victorian cards in Europe. Embracing elements of these illustrations is how I like to express my unique world.

412 WHAT DOES YOUR WORK DESK LOOK LIKE? WHAT CAN WE COME ACROSS? It looks like a cake decorated with lace and frill.

413 DO YOU ALWAYS USE THE SAME TOOLS OR DO YOU CHANGE DEPENDING ON THE PIECE YOU'RE WORKING ON? I change the tools depending on the piece I'm working on.

414 WHAT DO YOU LIKE ABOUT MANGA? WHAT DOES MANGA HAVE THAT EUROPEAN OR AMERICAN COMICS DON'T? I like the illustrations for manga because they are sensitive, beautiful and *kawai*, which makes manga so different from European or American comics.

415 HOW DO YOU MAKE YOUR DRAWINGS COME TO LIFE? I carefully show minute finger movements and feminine-smooth-skin texture.

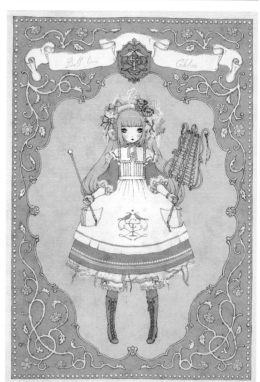

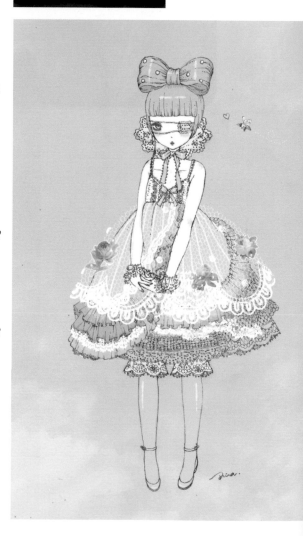

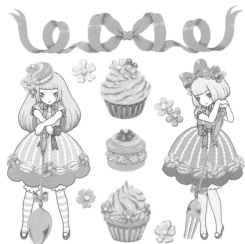

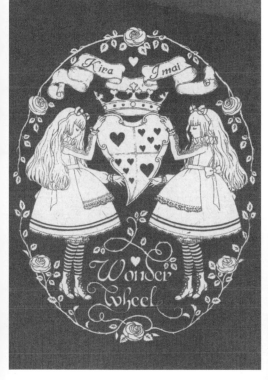

416 What advice would you give to a novice illustrator trying to make a name for himself? Have a strong individuality and be consistent.

417 Do you feel the need to better yourself when it comes to your work? To what extent? Of course, yes. I would like to draw much more in detail and to try new tools and various things related to my work.

418 Why is Manga so popular in the Western world? To what extent? I think it is because of the Japanese unique culture.

419 What is the most important lesson you have learned that you would like to pass on to others? Build in enough time after finishing your work to have another look at your piece.

420 What is the greatest acknowledgement you could hope to achieve for your work? I would love to publish my book and travel around the world holding a private exhibition!

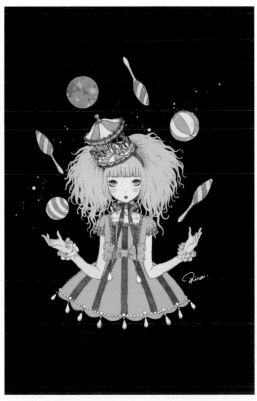

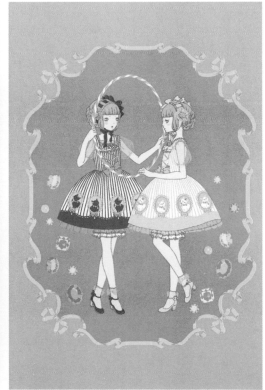

421 Where do the ideas for your drawings come from? How do you do your research? When I draw a picture, the idea for the next picture rises on me.

422 What does your work desk look like? What can we come across? The top of my desk is a mess. It has no style...

423 What are your favorite tools or drawing programs, and why? I like drawing with pencil. I can easily make a delicate tone with it, and delete it afterwards. Besides, pencils are sold anywhere and they're cheap.

424 Do you prefer the classic guidelines from Manga or experimenting with new channels? I like new expression.

425 How do you make your drawings come to life? I take my time. I draw slowly and carefully.

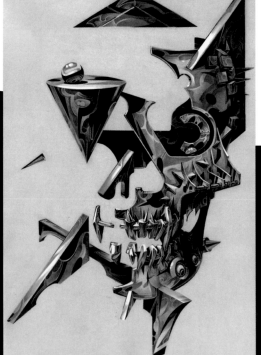

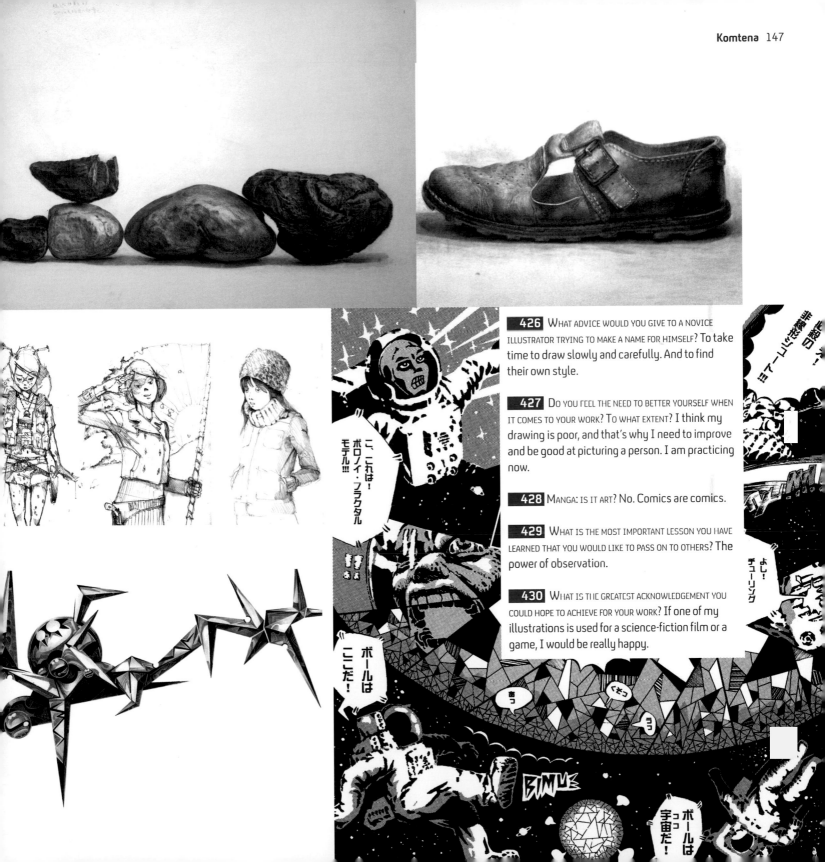

426 WHAT ADVICE WOULD YOU GIVE TO A NOVICE ILLUSTRATOR TRYING TO MAKE A NAME FOR HIMSELF? To take time to draw slowly and carefully. And to find their own style.

427 DO YOU FEEL THE NEED TO BETTER YOURSELF WHEN IT COMES TO YOUR WORK? TO WHAT EXTENT? I think my drawing is poor, and that's why I need to improve and be good at picturing a person. I am practicing now.

428 MANGA: IS IT ART? No. Comics are comics.

429 WHAT IS THE MOST IMPORTANT LESSON YOU HAVE LEARNED THAT YOU WOULD LIKE TO PASS ON TO OTHERS? The power of observation.

430 WHAT IS THE GREATEST ACKNOWLEDGEMENT YOU COULD HOPE TO ACHIEVE FOR YOUR WORK? If one of my illustrations is used for a science-fiction film or a game, I would be really happy.

Komtena
http://komtena.com

Komtena was born in 1978. His parents were working for the oil companies, which meant that when he was two his family moved to the United States. In 2000, Komtena began studying graphic design at Tama Art University. He is currently working as an illustrator, although his work is rooted in graphic design. However, if asked about his hobbies, Komtena is unequivocal: motorbikes and bicycles.

Koya Okada

http://homepage.mac.com/koya_o/index.html

Koya Okada was born in 1969, and graduated from the College of Art at Nihon University in 1992. He is currently working as an illustrator and freelance artist. In 1998, he became the front-page illustrator for the Japanese edition of the magazine *MacPeople*, where he stayed for seven years. He is a great fan of baseball and hot dogs, and is proud of the fact that throughout his life he has visited more than fifty U.S. baseball stadiums.

431 WHERE DO THE IDEAS FOR YOUR DRAWINGS COME FROM? HOW DO YOU DO YOUR RESEARCH? I often draw about sports, so I watch sports games often (right now I'm crazy about football). I went to fifty major league ballparks (or more) when I visited the U.S. Moreover, I receive ideas from the Internet, television and books.

432 WHO ARE YOUR FAVORITE ILLUSTRATORS? ARE YOU TRYING TO FOLLOW IN THEIR FOOTSTEPS? I have a lot of favorite artists, illustrators and cartoonists regardless if they are Japanese or foreign. If I begin to enumerate them, you'll not have enough space!

433 WHAT DOES YOUR WORK DESK LOOK LIKE? WHAT CAN WE COME ACROSS? Look at the picture (right).

434 WHAT IS THE FIRST THING YOU DO BEFORE SITTING DOWN TO DRAW? I collect material according to the theme given by the editor and the designer, and let it sleep. Then, I write my floating ideas on paper.

435 DO YOU ALWAYS USE THE SAME TOOLS OR DO YOU CHANGE DEPENDING ON THE PIECE YOU'RE WORKING ON? I use and have been drawing with acrylic gouache since I was a student at university (twenty years ago). After I became a professional illustrator, I changed the material from canvas into watercolor paper (Arches, made in France).

437 WHAT ARE YOUR FAVORITE TOOLS OR DRAWING PROGRAMS, AND WHY? I use a Mac. However, I also use analogue techniques in many works.

438 WHAT DIFFERENTIATES YOU FROM MANGA'S OTHER ILLUSTRATORS? Extreme perspective.

439 HOW IMPORTANT IS PROMOTION TO YOU? HOW DO YOU PROMOTE YOUR WORK? When I became a professional illustrator, I did show my pictures to publishers, designers, advertising agencies and many more people. This way my work was seen and the clients started to contact me. The website where I publish my work is also effective.

440 WHAT GOOD HABITS SHOULD A COMIC ILLUSTRATOR HAVE? It is necessary to make an effort to obtain information. You need to be interested in pure knowledge.

436 WHAT HAS CHANGED ABOUT YOUR STYLE OF DRAWING SINCE YOU BEGAN? This is the first picture I did (1993).

工場はクビ、時間だけはたっぷりある。
四人の元遠征軍の若者たちは、
鶴岡から東京まで、日本海沿いに歩きだした。
野宿し、風に吹かれ、ブログを綴りつつ──。

岡田航也 画

連載
第三回

明日のマーチ
石田衣良

441 WHERE DO THE IDEAS FOR YOUR DRAWINGS COME FROM? HOW DO YOU DO YOUR RESEARCH? From the mountains, the forests and the trees.

442 WHAT IS THE FIRST THING YOU DO BEFORE SITTING DOWN TO DRAW? I smoke.

443 WHAT ARE YOUR FAVORITE TOOLS OR DRAWING PROGRAMS, AND WHY? Acrylic paints and a ballpoint pen. They're easy to use.

444 DO YOU PREFER THE CLASSIC GUIDELINES FROM MANGA OR EXPERIMENTING WITH NEW CHANNELS? I don't known either of them well.

445 WHAT DIFFERENTIATES YOU FROM MANGA'S OTHER ILLUSTRATORS? My work is useless.

446 How important is promotion to you? How do you promote your work? I take time to promote my work after my deadlines.

447 What has changed about your style of drawing since you began? Space perception. The sense of the Invisible Man.

448 Manga: is it art? Yes!

449 What is the most important lesson you have learned that you would like to pass on to others? Look at things, at invisible things.

450 What makes a comic sell successfully? Consumption society.

451 WHERE DO THE IDEAS FOR YOUR DRAWINGS COME FROM? HOW DO YOU DO YOUR RESEARCH? Inspiration can come from anywhere, so I always carry around a sketchbook to capture random ideas, observations, and doodles. I also have a large collection of art books and movies for reference, and anything I don't have on hand is just a quick Google search away!

452 WHO ARE YOUR FAVORITE ILLUSTRATORS? ARE YOU TRYING TO FOLLOW IN THEIR FOOTSTEPS? When I was young, I loved the work of cartoonists and illustrators like Charles Schulz, Bill Watterston, and Tove Jansson. When I started getting serious about making my own art, I discovered manga and devoured the work of Rumiko Takahashi, Kosuke Fujushima, Masamune Shirow, and Yoshiyuki Sadamoto. These days, I also draw inspiration from a wide range of talents like Ronnie Del Carmen, Chhuy-Ing Ia, Arthur de Pins, Bryan Lee O'Malley, Lewis Trondheim, Anthony Clark and Koji Kumeta.

453 WHAT DOES YOUR WORK DESK LOOK LIKE? WHAT CAN WE COME ACROSS? I have a desktop, but no desk. My laptop is where I do the majority of my work, usually while I'm sitting on my couch. I work almost exclusively digitally, drawing directly in program with a mouse, using nothing more than tiny, rough thumbnails for reference.

454 WHAT IS THE FIRST THING YOU DO BEFORE SITTING DOWN TO DRAW? Procrastinate. I can do this for quite a while, in a variety of ways, like watching movies, playing video games, reading or napping. In all seriousness, it's always valuable to have a bit of time to wrap your head around a drawing before you really need to jump in.

455 WHAT ARE YOUR FAVORITE TOOLS OR DRAWING PROGRAMS, AND WHY? I work almost exclusively in Adobe Illustrator, with a dash of Photoshop. This ensures the art is print-ready, completely resizable, and endlessly configurable for a wide range of uses. It also enables me to quickly test a number of variations on a piece of art, so I can find the approach that will work best. I find it's much easier to take risks in art when you have an "undo" button.

456 WHAT DIFFERENTIATES YOU FROM MANGA'S OTHER ILLUSTRATORS? I trained in graphic design instead of fine art, so my work has a much more iconic quality with bolder contrast and fussier typography than many other manga artists.

457 HOW IMPORTANT IS PROMOTION TO YOU? HOW DO YOU PROMOTE YOUR WORK? Promotion is key. Your work can't sell itself! I make a variety of Web comics, and submit them regularly to online communities, and I'm always looking for opportunities to submit illustrations to shows, competitions and books.

458 MANGA: IS IT ART? It certainly has the potential to be. I consider the work of luminaries like Osamu Tezuka and Hayao Miyazaki to have achieved that level, but the majority is just great entertainment. And there's absolutely nothing wrong with that.

459 WHAT GOOD HABITS SHOULD A COMIC ILLUSTRATOR HAVE? You should always be drawing. Not just the work you need to do for a project or deadline, but little doodles and observational sketches. These are like warmups for an athlete, and the more you stretch those creative muscles, the better your work will be.

460 WHAT IS THE GREATEST ACKNOWLEDGEMENT YOU COULD HOPE TO ACHIEVE FOR YOUR WORK? I'd love to have one of my works adapted into a quality animation. It would be great to see them spring to life with motion and sound. More importantly, I'd then be able to pop over to any toy aisle and pick up one of my characters in action figure form. ^_^

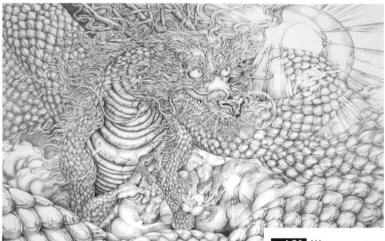

© DYSK

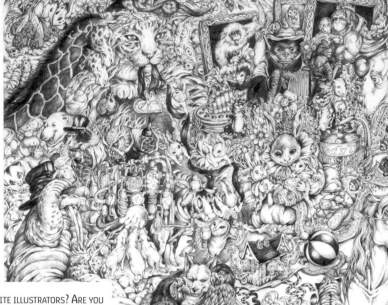

© DYSK

461 WHO ARE YOUR FAVORITE ILLUSTRATORS? ARE YOU TRYING TO FOLLOW IN THEIR FOOTSTEPS? Alan Aldridge. He is the one who illustrated the 1973 version of *The Butterfly's Ball and the Grasshopper's Feast*, a book that influenced me as a girl. I would really like to meet him. He is not an illustrator but I also enjoy animation film director Hayao Miyazaki very much and I would love to meet him, too.

462 WHAT IS THE FIRST THING YOU DO BEFORE SITTING DOWN TO DRAW? I try to visualize the image I want to draw. I determine the direction I want to go with, and stretch its possibilities.

463 DO YOU ALWAYS USE THE SAME TOOLS OR DO YOU CHANGE DEPENDING ON THE PIECE YOU'RE WORKING ON? I mostly use pencils. One HB and one B from Mitsu-Bishi.

464 WHAT DO YOU LIKE ABOUT MANGA? WHAT DOES MANGA HAVE THAT EUROPEAN OR AMERICAN COMICS DON'T? I only like a dozen of mangakas. I don't read much of the others. So I can't really tell about Japanese manga in general, but concerning the artists I like, I would say it is because of their huge magnificent views of the world. The strength of manga is to display the equivalent of a whole movie by the sole work of the hand. It is able to quickly grasp good ideas and information.

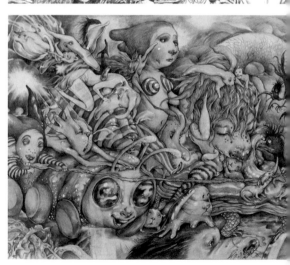

© DYSK

465 WHAT DIFFERENTIATES YOU FROM MANGA'S OTHER ILLUSTRATORS? My drawings move and talk, they are conscious. They are like living creatures.

© DYSK

© DYSK

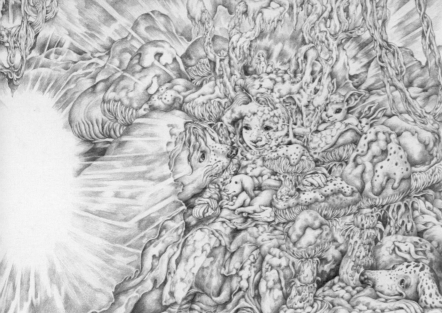

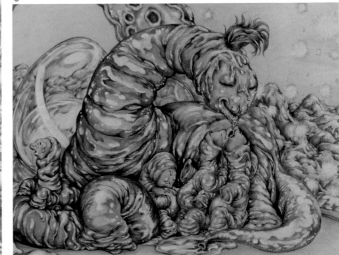

© DYSK

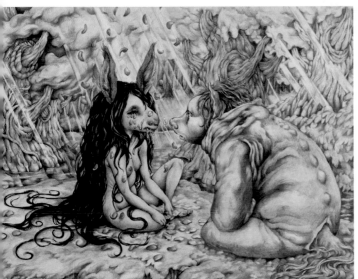

© DYSK

466 Do you feel the need to better yourself when it comes to your work? To what extent? I used to be fond of grotesque stuff, but I got over it. I now rather try to make my art more stylish, to challenge a new, original way of expression. I also want to raise the quality of my work. I want to draw more exaltedly radiant things such as gods.

467 Manga: is it art? I believe it depends on the artists. Some of them might be considered artists, but they might be only a few. Rather than art, I think manga is an independent culture.

468 Why is Manga so popular in the Western world? I think most of literate people eventually become fond of manga. Manga has this huge potential. Its distance is close to people, like films.

469 What is the most important lesson you have learned that you would like to pass on to others? Never to give up. To believe that if you keep faith in something it will eventually be realized sooner or later.

470 What makes a comic sell successfully? Put aside your pride. Study other bestsellers.

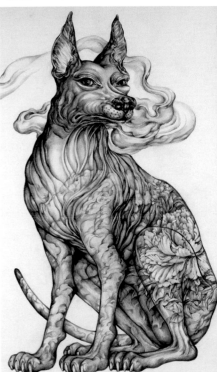

© DYSK

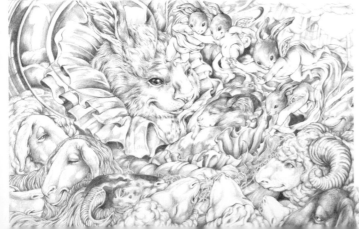

© DYSK

Kyotaro

www.kyotaro.biz

Kyotaro was born in 1978 in Kyoto, Japan. She graduated with a degree in graphic design from the Kyoto Saga University of Arts in 1998, and then moved to Tokyo. In 2004, she published *Baby Shower Story*. In 2006, showed her work in The Armory Show, in New York. In 2007, was part of the collective art exhibition *How to cook Docomodake?* in New York. Several exhibitions followed along the following years, culminating in the I *saw a lot of fairies 2004-2010* solo exhibition at the Mizuma Action Gallery in Tokyo, and the solo exhibition *Heaven's tnip*, held at the Mizuma Action Gallery in Tokyo in 2008.

Laura Watton

www.pinkapplejam.com

Laura Watton is a self-taught comic artist who loves manga and cool illustration. She also loves sewing things too. Some of her favorite things include Gothic Lolita fashion, Rockabilly fashion, energetic music, kittens, video games, beer and cake. She's hugely inspired by Japanese manga style and illustration, and Japanese comics are what inspired her to pick up a pen and draw her own at the age of fifteen. Fifteen years later, it still gives her great motivation. She has been published by several companies, but she also self-publishes her own work. Her day job is as a 2D games artist. She creates comic book and manga-style artwork as a freelance artist outside of her day job. Her admired artists are Alphonse Mucha, Coop, Adam Warren, Johji Manabe, Miwa Ueda, Moyoko Anno, Yayoi Ogawa, Rumiko Takahashi, Kenichi Sonoda, Akemi Takada and many of the 1990's game artists who illustrated the interiors of NES and Super Nintendo instruction booklets.

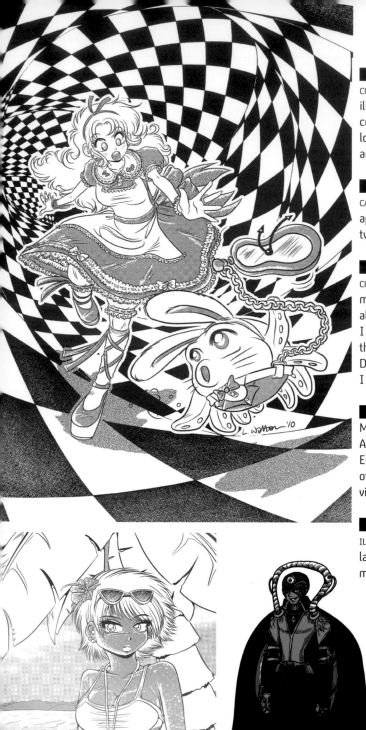

471 WHERE DO THE IDEAS FOR YOUR DRAWINGS COME FROM? HOW DO YOU DO YOUR RESEARCH? Mainly illustration, sometimes fashion, other peoples' comic works, comics I grew up with. I collect a lot of comics and cool images from magazines and the Internet to look at.

472 WHAT DOES YOUR WORK DESK LOOK LIKE? WHAT CAN WE COME ACROSS? The desk is almost falling apart... but here is my old desk from my day job, two monitors, pinboards, pens and cute notelets!

473 DO YOU ALWAYS USE THE SAME TOOLS OR DO YOU CHANGE DEPENDING ON THE PIECE YOU'RE WORKING ON? I mostly use Manga Studio to digitally ink, and I always doodle first-stage pencilwork manually. I color differently depending on each piece, though. To relax, I use natural media, for fun. Digital media helps my work look more polished, I hope!

474 WHAT DO YOU LIKE ABOUT MANGA? WHAT DOES MANGA HAVE THAT EUROPEAN OR AMERICAN COMICS DON'T? Although I feel that Japanese, Western and European comics have been influenced by each other, I also feel Japanese comics can be more visually dynamic, and more emotive.

475 WHAT DIFFERENTIATES YOU FROM MANGA'S OTHER ILLUSTRATORS? I never really lost the influences from late 80's and early 90's manga! I have been told my works have a retro feel to them.

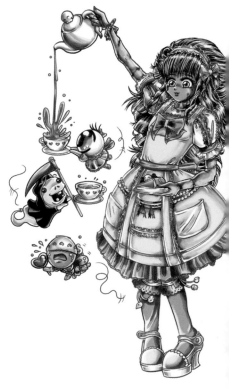

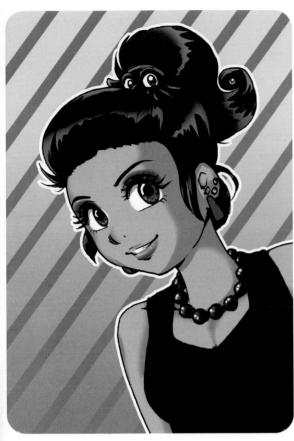

Biomecha character study

477 WHAT HAS CHANGED ABOUT YOUR STYLE OF DRAWING SINCE YOU BEGAN? I grew up reading *shonen* manga, then read a lot of *shojo* manga, as well as other comics. Maybe my storytelling is more influenced by *josei* manga now... but, being inspired by many styles of comics helps hone your own, individual, more unique style.

478 WHY IS MANGA SO POPULAR IN THE WESTERN WORLD? Japanese comics cater to all readers of all ages, whatever gender or interest. The range is vast and broad, like the sea, very exciting!

479 WHAT GOOD HABITS SHOULD A COMIC ILLUSTRATOR HAVE? Use rulers, keep things clean and unfolded, not scruffy; use folders, practice good spelling, take good care of your work, appearances matter!

480 WHAT IS THE GREATEST ACKNOWLEDGEMENT YOU COULD HOPE TO ACHIEVE FOR YOUR WORK? If a person has been the recipient of something that I have made, and it influences them to make something of their own. Thank you for viewing my works!

476 HOW IMPORTANT IS PROMOTION TO YOU? HOW DO YOU PROMOTE YOUR WORK? I have links in my forum and signatures, swap artwork with other artists and have a website, Facebook, Twitter, DeviantArt and so on.

481 WHERE DO THE IDEAS FOR YOUR DRAWINGS COME FROM? HOW DO YOU DO YOUR RESEARCH? (Both): Inspiration can come from anywhere and anything. Life experiences, reading an article, etcetera. For example, our graphic novel series, *Peach Fuzz*, was directly inspired from having two adorable and energetic pet ferrets.

482 WHAT DOES YOUR WORK DESK LOOK LIKE? WHAT CAN WE COME ACROSS? (Lindsay): On my artist desk you'll find: art supplies (pencils, rulers, erasers, paper), a light box for transferring drawings, creating overlays, and checking for mistakes, figurines for three-dimensional reference, artbooks for inspiration, laptop for reference photos, headphones for listening to music, and a sketchbook. I have an additional work desk consisting of my computer and Wacom tablet where I produce my finished color works.

483 WHAT DOES YOUR WORK DESK LOOK LIKE? WHAT CAN WE COME ACROSS? (Jared): I work at an L-shaped computer desk, tucked into my apartment's dining room. The area's crammed with a PC, Cintiq tablet, 11x17 in. scanner, drawing supplies, three thumbtack boards for pinning up notes, and a revolving cache of shelved reference material. Regular desktop residents include anatomy charts, drawing pads, pencils: 0.5 and 0.9 mm with red, blue, and black graphite, artbooks, and magazines. Occasionally, a Nintendo DS drops by for a visit.

484 WHAT IS THE FIRST THING YOU DO BEFORE SITTING DOWN TO DRAW? (Both): The morning process: eat breakfast, shower, straighten up our work areas, compile any reference, and deal with any distractions that would take attention away from the drawing process (business emails, Twitter, bills, etc).

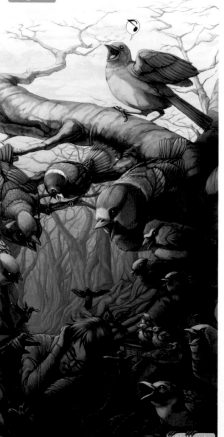

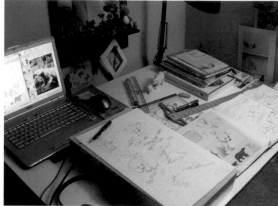

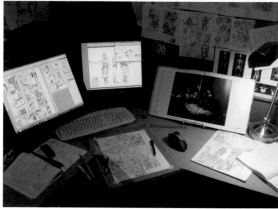

485 WHAT ARE YOUR FAVORITE TOOLS OR DRAWING PROGRAMS, AND WHY? (Both): Our drawing tools: 0.5mm mechanical pencil for drawing. Staedtler Mars plastic eraser for general erasing, Magic rub for large mistakes, Tuff Stuff Eraser Stick for erasing small details. An assortment of rulers for drawing straight lines—good for perspective drawings, creating panel borders, and drawing man-made objects like buildings and tables. Adobe Photoshop CS3 for finishing touches: coloring, screen toning, lettering, and special effects.

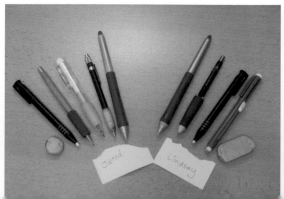

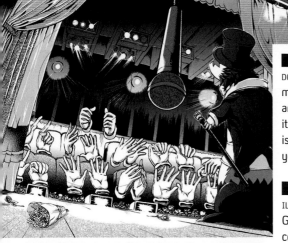

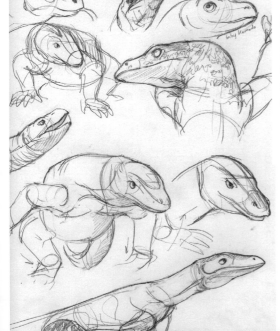

486 How important is promotion to you? How do you promote your work? (Both): You absolutely must promote your work. It doesn't matter how amazing the artwork is—if no one knows it exists, it won't find an audience. (Conversely, if the work is bad, no amount of promotion is going to take you very far. You need both.)

487 What advice would you give to a novice illustrator trying to make a name for himself? (Both): Get on the Internet and show your work! Art communities like DeviantArt are a great way to build an audience, connect with other artists, and get feedback on your work.

488 Do you feel the need to better yourself when it comes to your work? To what extent? (Both): Never stop learning. Satisfaction with your art leads to stagnation. Every day before we begin working on the day's assignments, we do an hour of practice sketching or coloring to strengthen our skills.

489 What is the most important lesson you have learned that you would like to pass on to others? (Both): I'm sure you've heard it before, but it bears repeating: practice, practice, practice. Draw from life, draw from your imagination. Draw, draw, draw.

490 What good habits should a comic illustrator have? (Both): Discipline and dedication are a must. If you aren't self-motivated, you won't last in this profession. You must be willing to sit down every day and focus on your craft. A love of art and storytelling are also essential.

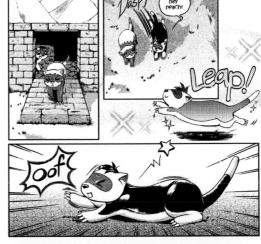

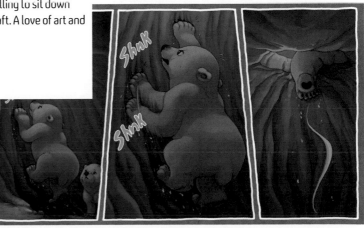

Lindsay Cibos and Jared Hodges

www.jaredandlindsay.com

Lindsay Cibos and Jared Hodges are the creators of the award-winning graphic novel series *Peach Fuzz* (Tokyopop), which has been published internationally and syndicated in newspapers. Lindsay and Jared are also the authors of several art instructional books, including *Digital Manga Workshop* (Harper Design), and *Draw Furries* (Impact Books). Lindsay has also worked as a penciler on various comic titles including *Sabrina the Teenage Witch* (Archie Comics), *Domo: The Manga* (Tokyopop), and *Fraggle Rock* (Archaia Entertainment/Jim Henson Company). They are currently working on a new graphic novel called *The Last of the Polar Bears*, which you can check out on their website at www.lastpolarbears.com.

Mari Mitsumi

http://home.att.ne.jp/green/mari-m

Mari Mitsumi lives in Japan. She has worked as a freelance illustrator and collaborates with various clients in editorial and advertising. Her works are the result of an elaborate process that begins with painting acrylic on canvas, scanning, and finishing up digitally as necessary. Music, films and nature inspire her work. Her work has been recognized by American Illustration, the Society of Illustrators NY and 3x3.

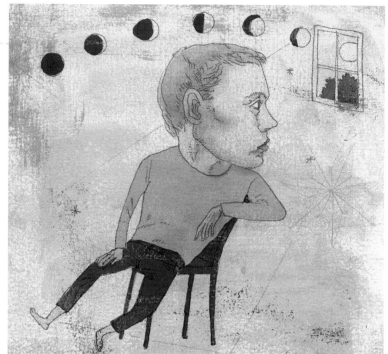

491 WHERE DO THE IDEAS FOR YOUR DRAWINGS COME FROM? HOW DO YOU DO YOUR RESEARCH? They come from movies, music, nature, books, pictures, and TV... When the ideas pop into my head, I make a note immediately and stock it.

492 WHAT DOES YOUR WORK DESK LOOK LIKE? WHAT CAN WE COME ACROSS? My desk is like a window that connects the world of imagination with the real world. It's the place where ideas are connected.

493 WHAT IS THE FIRST THING YOU DO BEFORE SITTING DOWN TO DRAW? Drinking tea or coffee, choosing music that matches the drawings...

494 WHAT ARE YOUR FAVORITE TOOLS OR DRAWING PROGRAMS, AND WHY? I've used carbon ink paper since 1999 because I feel it brings an unique atmosphere to my works.

495 DO YOU PREFER THE CLASSIC GUIDELINES FROM MANGA OR EXPERIMENTING WITH NEW CHANNELS? It's good for me to be able to choose any expression from among many options using digital technology.

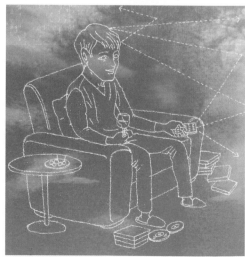

496 How do you make your drawings come to life? I try to connect my works with my interests as freely as possible. So I always gather as much information about the subjects as I can, because knowing what they are leads me to know what I love personally.

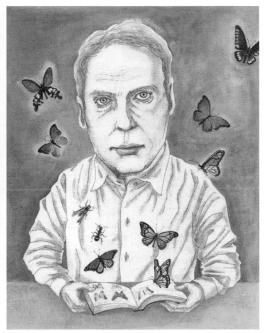

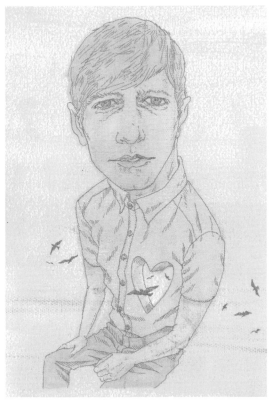

497 How important is promotion to you? How do you promote your work? A website is very important. It allows you to reach people from all around the world.

498 Do you feel the need to better yourself when it comes to your work? To what extent? Yes. I try to improve to exceed the expectations of the client.

499 What has changed about your style of drawing since you began? I changed when I became aware that I was losing passion. I started to search for a new style. This search continues even now, there's no end to it.

500 What is the most important lesson you have learned that you would like to pass on to others? Hearing the voice of your own heart is more important than what people say.

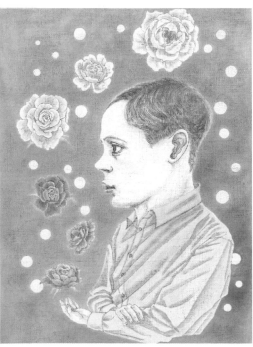

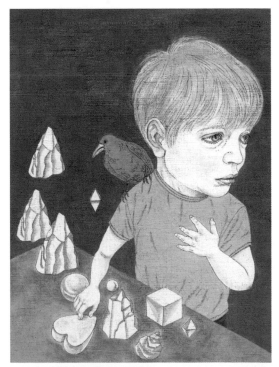

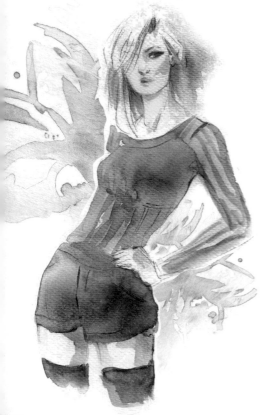

501 WHO ARE YOUR FAVORITE ILLUSTRATORS? ARE YOU TRYING TO FOLLOW IN THEIR FOOTSTEPS? When I began to draw manga figures my favorite artist was Satoshi Urushihara. I loved how he did the eyes and the lights. Now Ashley Wood is one of my favorite artists. He inspires me, but I wouldn't try to copy him.

502 WHAT DOES YOUR WORK DESK LOOK LIKE? WHAT CAN WE COME ACROSS? My work desk is a little adventure. It's not often you'll see it organized, because when I work on it for one minute it's a chaos again. But I like that chaos. And I think I need it to do good work. Of course you will come across a lot of loose paper and pens of different kinds, but often I am working on my laptop, then the chaos is a bit smaller. ;)

503 DO YOU ALWAYS USE THE SAME TOOLS OR DO YOU CHANGE DEPENDING ON THE PIECE YOU'RE WORKING ON? For me it's very important to try a lot of different styles and techniques. Most of my manga-like works are made digitally. But I also draw with pencil, colored pencils, Copic markers, water color and acrylic.

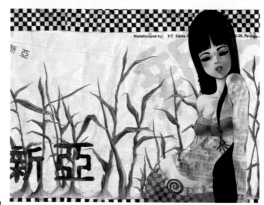

504 WHAT ARE YOUR FAVORITE TOOLS OR DRAWING PROGRAMS, AND WHY? When I am working digitally I use Photoshop. I like this program and I am fascinated with its possibilities. Additionally I am very fascinated in working with water color at the moment, it's very exciting for me.

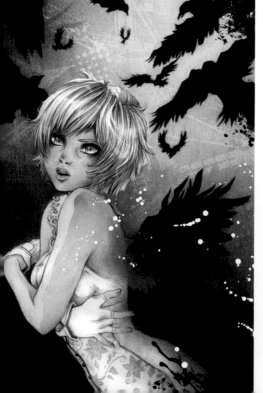

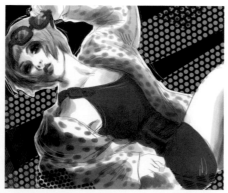

505 WHAT DO YOU LIKE ABOUT MANGA? WHAT DOES MANGA HAVE THAT EUROPEAN OR AMERICAN COMICS DON'T? When I first saw manga it had a special freshness, something very new and exciting for me. I immediately loved the style, the emphatic eyes, the beautiful figures and for the first time I saw strong girls as heroes in the stories. By reading manga I like the feeling of being really close to the figures because there is a lot space for expressing their feelings and often the stories are cinematically narrated.

506 WHAT DIFFERENTIATES YOU FROM MANGA'S OTHER ILLUSTRATORS? At the beginning I copied more than I made by my own ideas. By and by I got more experience and this allowed me to become more free in the style and I tried more different techniques, too.

507 HOW IMPORTANT IS PROMOTION TO YOU? HOW DO YOU PROMOTE YOUR WORK? I have to live from my job as artist and if nobody knows that me and my work exist, I will not get any job. I do a lot on my website and talk constantly about my new projects at my weblog. Furthermore, I try to visit different book fairs and conventions for getting in real contact with people and clients.

508 WHAT ADVICE WOULD YOU GIVE TO A NOVICE ILLUSTRATOR TRYING TO MAKE A NAME FOR HIMSELF? It is important to have a good confidence about one's own work but a realistic sense of its qualities, too. If you have this, go directly under the people, add contests, make your own website, enter communities and visit events where you get in contact with likeminded people or even clients.

509 DO YOU FEEL THE NEED TO BETTER YOURSELF WHEN IT COMES TO YOUR WORK? TO WHAT EXTENT? A constant development in my work is very important to me. I think there is always something to improve or to develop. And I am happy about that. To see that I become better and better by creating is a good feeling and it is one of the things about my work as an artist that I love.

510 WHAT GOOD HABITS SHOULD A COMIC ILLUSTRATOR HAVE? Most important, is, of course, having fun while being creative. But a good comic artist needs a lot of discipline for work, too. He must have an open ear for justifiable critique concerning his own work and open eyes for new inspiration around. He has to be able to work with deadlines and under pressure.

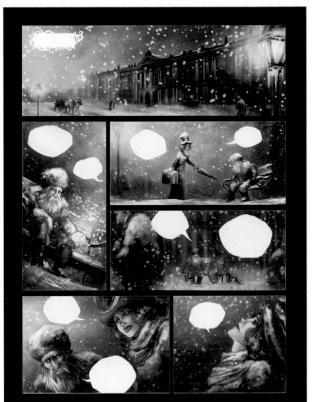

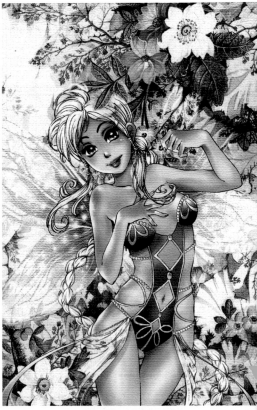

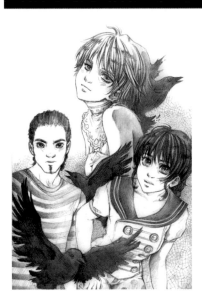

Marie Sann

www.marie-sann.de

Marie Sann was born in November 1986, in Berlin. She has been drawing since she was able to hold a pen. Now she is working as an illustrator and comicartist. Her best known manga publication is *Krähen*, which consists of two books. Currently she is working on a project called *Frostfeuer*, a comic adaption of the fantastic novel by Kai Meyer.

Marumiyan

marumiyan.com

Marumiyan became interested in drawing during his infancy, under the influence of his father. He learned graphic arts and design at university, and started his freelance activities under the name of Marumiyan in 2007. He lives in Fukuoka, Japan, but works for both Japanese and international clients, in different media such as magazines, CD jackets, posters, apparel, Web, etc... His work can be seen in international exhibitions that he organizes regularly, as one of the most well-known Japanese illustrators outside his country.

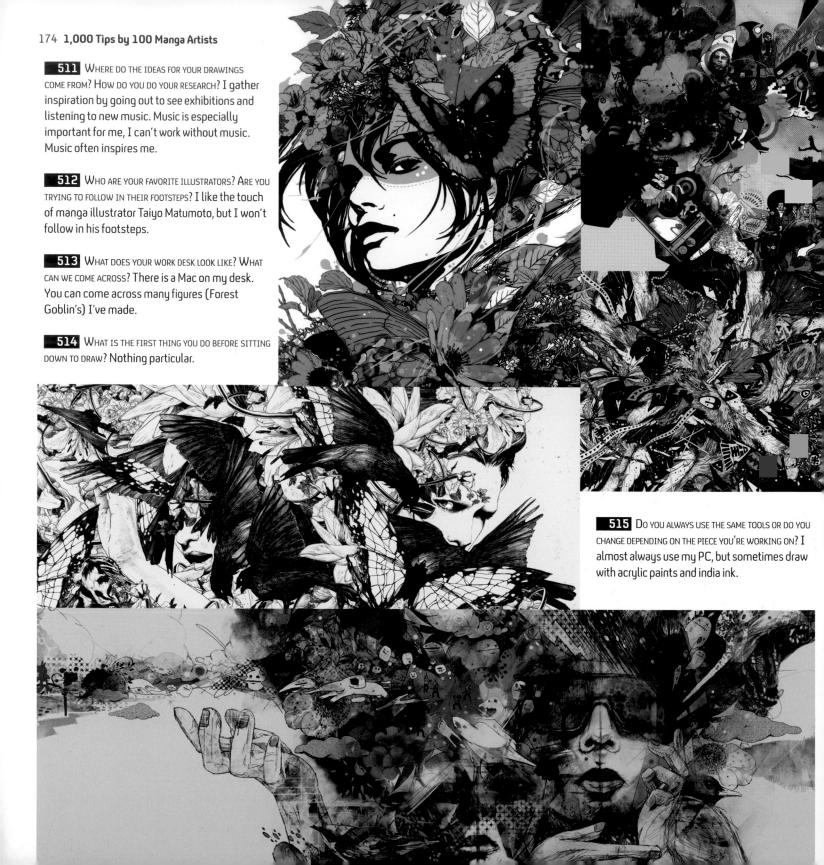

511 WHERE DO THE IDEAS FOR YOUR DRAWINGS COME FROM? HOW DO YOU DO YOUR RESEARCH? I gather inspiration by going out to see exhibitions and listening to new music. Music is especially important for me, I can't work without music. Music often inspires me.

512 WHO ARE YOUR FAVORITE ILLUSTRATORS? ARE YOU TRYING TO FOLLOW IN THEIR FOOTSTEPS? I like the touch of manga illustrator Taiyo Matumoto, but I won't follow in his footsteps.

513 WHAT DOES YOUR WORK DESK LOOK LIKE? WHAT CAN WE COME ACROSS? There is a Mac on my desk. You can come across many figures (Forest Goblin's) I've made.

514 WHAT IS THE FIRST THING YOU DO BEFORE SITTING DOWN TO DRAW? Nothing particular.

515 DO YOU ALWAYS USE THE SAME TOOLS OR DO YOU CHANGE DEPENDING ON THE PIECE YOU'RE WORKING ON? I almost always use my PC, but sometimes draw with acrylic paints and india ink.

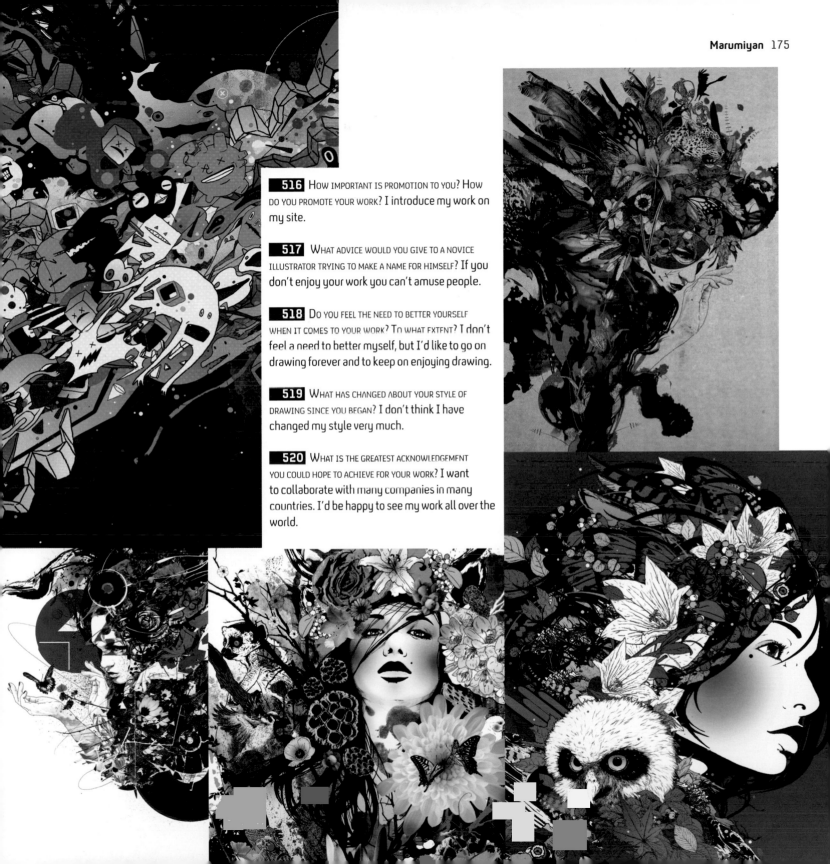

516 How important is promotion to you? How do you promote your work? I introduce my work on my site.

517 What advice would you give to a novice illustrator trying to make a name for himself? If you don't enjoy your work you can't amuse people.

518 Do you feel the need to better yourself when it comes to your work? To what extent? I don't feel a need to better myself, but I'd like to go on drawing forever and to keep on enjoying drawing.

519 What has changed about your style of drawing since you began? I don't think I have changed my style very much.

520 What is the greatest acknowledgement you could hope to achieve for your work? I want to collaborate with many companies in many countries. I'd be happy to see my work all over the world.

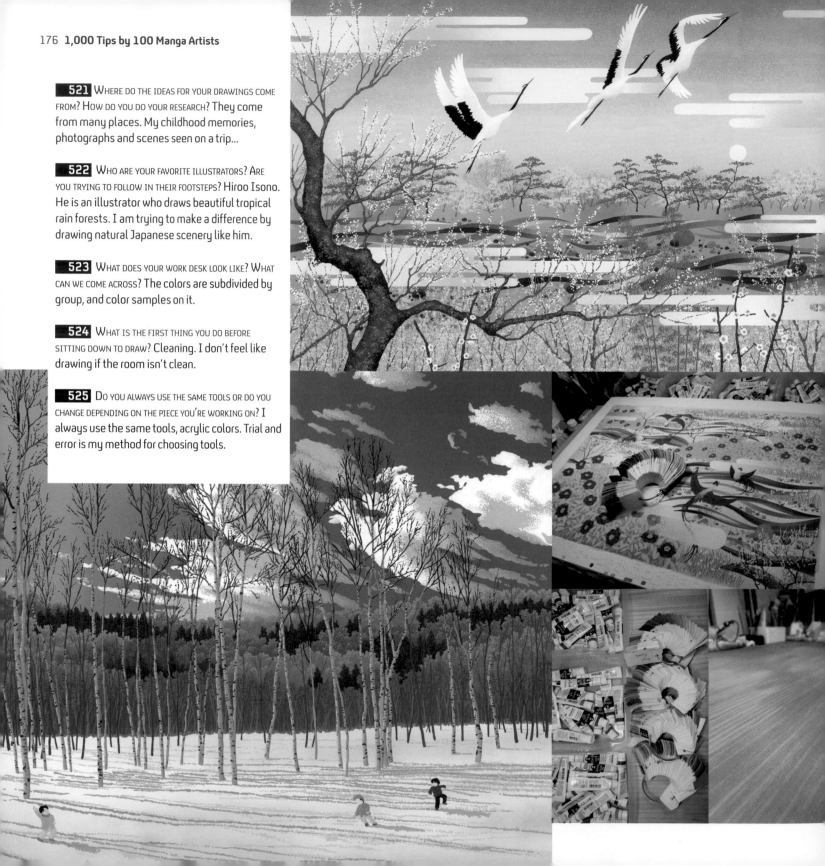

521 WHERE DO THE IDEAS FOR YOUR DRAWINGS COME FROM? HOW DO YOU DO YOUR RESEARCH? They come from many places. My childhood memories, photographs and scenes seen on a trip...

522 WHO ARE YOUR FAVORITE ILLUSTRATORS? ARE YOU TRYING TO FOLLOW IN THEIR FOOTSTEPS? Hiroo Isono. He is an illustrator who draws beautiful tropical rain forests. I am trying to make a difference by drawing natural Japanese scenery like him.

523 WHAT DOES YOUR WORK DESK LOOK LIKE? WHAT CAN WE COME ACROSS? The colors are subdivided by group, and color samples on it.

524 WHAT IS THE FIRST THING YOU DO BEFORE SITTING DOWN TO DRAW? Cleaning. I don't feel like drawing if the room isn't clean.

525 DO YOU ALWAYS USE THE SAME TOOLS OR DO YOU CHANGE DEPENDING ON THE PIECE YOU'RE WORKING ON? I always use the same tools, acrylic colors. Trial and error is my method for choosing tools.

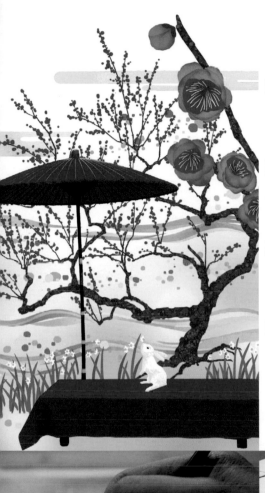

526 WHAT ARE YOUR FAVORITE TOOLS OR DRAWING PROGRAMS, AND WHY? It's acrylic colors. It's easy to use them because they don't dissolve in water when they dry.

527 DO YOU FEEL THE NEED TO BETTER YOURSELF WHEN IT COMES TO YOUR WORK? TO WHAT EXTENT? I always feel the need to better myself. I feel the need to draw pictures that fascinate the people who see them.

528 WHAT HAS CHANGED ABOUT YOUR STYLE OF DRAWING SINCE YOU BEGAN? I draw faster. A big picture could've taken more than one month long ago.

529 WHAT IS THE MOST IMPORTANT LESSON YOU HAVE LEARNED THAT YOU WOULD LIKE TO PASS ON TO OTHERS? There is no special lesson, it's only "draw many illustrations." I was poor long ago. There are many pictures that I don't want to show.

530 WHAT IS THE GREATEST ACKNOWLEDGEMENT YOU COULD HOPE TO ACHIEVE FOR YOUR WORK? I am happy when I receive a prize.

Masayoshi Mizuho

www.m-mizuho.com

Masayoshi Mizuho is a professional illustrator. His approach to work is simple: After observing the mountains, woods and rivers, Masayoshi draws the natural landscapes from memory just as he remembers them. As he puts it: "Japan is brimming with natural beauty. I love painting nature, the passage of the four seasons and the colorful blooming of Japanese nature in all its glory. To do this, I use acrylics. It is not a very efficient way of working, because it means my work can't be reproduced on a massive scale, but I still like the process of working with my hands.

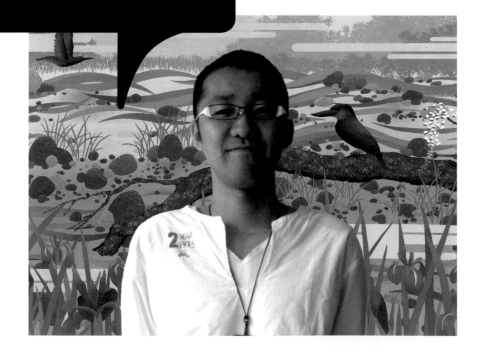

Maximo V. Lorenzo

http://8bitmaximo.com

Maximo V. Lorenzo has been working in comics professionally since 2003. As he says, "it is my mission to master as many walks of art and storytelling as I possibly can, every job I take more steps towards my goal. I love creative challenges and smashing through impossibilities. My areas of strength include: expressing power in art, concept and character design, sequential art, caricature, expression in art, aesthetics, creative thinking, typography, traditional and digital media, iconography, graphic art and adaptability."

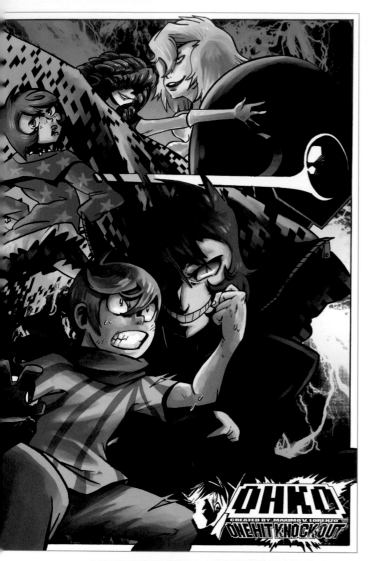

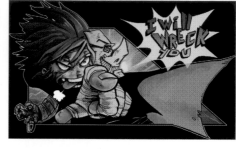

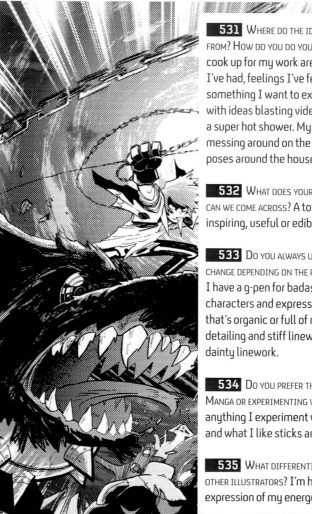

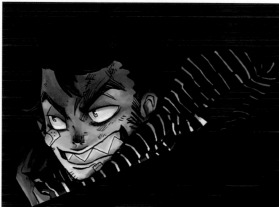

531 WHERE DO THE IDEAS FOR YOUR DRAWINGS COME FROM? HOW DO YOU DO YOUR RESEARCH? The ideas I cook up for my work are a result of experiences I've had, feelings I've felt, things I like to see, or something I want to express. I usually come up with ideas blasting video game music, or taking a super hot shower. My research is equal parts messing around on the Internet and striking cool poses around the house.

532 WHAT DOES YOUR WORK DESK LOOK LIKE? WHAT CAN WE COME ACROSS? A total mess. Anything I find inspiring, useful or edible at the moment.

533 DO YOU ALWAYS USE THE SAME TOOLS OR DO YOU CHANGE DEPENDING ON THE PIECE YOU'RE WORKING ON? I have a g-pen for badass lines that compose characters and expressions, brush for anything that's organic or full of motion, techpens for detailing and stiff linework, and maru pen for dainty linework.

534 DO YOU PREFER THE CLASSIC GUIDELINES FROM MANGA OR EXPERIMENTING WITH NEW CHANNELS? If anything I experiment with manga techniques and what I like sticks around.

535 WHAT DIFFERENTIATES YOU FROM MANGA'S OTHER ILLUSTRATORS? I'm hot-blooded! My art is an expression of my energy and determination!

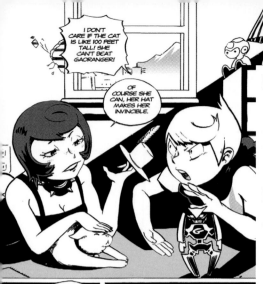

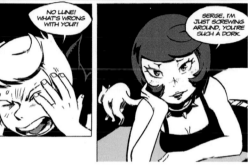

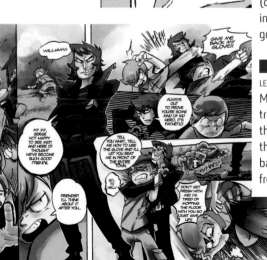

536 WHAT ADVICE WOULD YOU GIVE TO A NOVICE ILLUSTRATOR TRYING TO MAKE A NAME FOR HIMSELF? The ego will keep you productive, but if you don't doubt your methods you won't improve. You don't want to be an extremity of either when presenting your work, the trick is balance.

537 DO YOU FEEL THE NEED TO BETTER YOURSELF WHEN IT COMES TO YOUR WORK? TO WHAT EXTENT? I need to improve in so many areas, but basically my priorities are structure, things like anatomy, panel layout... And getting good at what makes me, me such as fight scenes, linework, facial expressions and badassness.

538 WHY IS MANGA SO POPULAR IN THE WESTERN WORLD? Manga is popular because although we have good published comics on this side of the world, we've more or less pigeonholed who our readers are and what they expect. But when it comes to manga their approach is "comics for everything", which expands readership of comics (or manga) to everyone. Although with our independent and webcomics we're taking that ground back.

539 WHAT IS THE MOST IMPORTANT LESSON YOU HAVE LEARNED THAT YOU WOULD LIKE TO PASS ON TO OTHERS? Manga and comics are the same thing. People try to separate the two for whatever reason but the reality is the more we progress into the future the more we break down cultural and language barriers, and so learn more and become inspired from each other across the planet.

540 WHAT IS THE GREATEST ACKNOWLEDGEMENT YOU COULD HOPE TO ACHIEVE FOR YOUR WORK? Well, hopefully I'd like to make a solid living, as I am a big fan of delicious foods, but really if I can just get people to be intellectually and emotionally swayed by my stories and characters, that's all I could ask for.

545 Do you prefer the classic guidelines from Manga or experimenting with new channels? I prefer the new one.

541 Where do the ideas for your drawings come from? How do you do your research? My ideas come from my dreams. I remember all my dreams.

542 Who are your favorite illustrators? Are you trying to follow in their footsteps? I love Dick Bruna. I got inspired by his technique.

543 Do you always use the same tools or do you change depending on the piece you're working on? I don't always use the same tools. For my comic pieces, I use pens. For my real pictures I use acrylic paint and pencil.

544 What are your favorite tools or drawing programs, and why? My favorite tool is acrylic paint.

546 HOW DO YOU MAKE YOUR DRAWINGS COME TO LIFE? I try to make a story in the picture.

547 MANGA: IS IT ART? Yes. It's a wonderful art.

548 WHY IS MANGA SO POPULAR IN THE WESTERN WORLD? Japanese manga is pretty. There are many beautiful things in the Western world, but pretty things are rare.

549 WHAT GOOD HABITS SHOULD A COMIC ILLUSTRATOR HAVE? It's important to stay keen to my surroundings.

550 WHAT IS THE GREATEST ACKNOWLEDGEMENT YOU COULD HOPE TO ACHIEVE FOR YOUR WORK? Someone that got to know me through my artworks.

Megumi Terada

http://megumi-terada.com

Megumi Terada was born in Japan's Shiga Prefecture in 1982. She graduated from the Image in Stage Art Department at Kyoto University of Art and Design. She works as a freelance artist creating animations, illustration and comics. Her most representative works are serial comic strips for mobile phones, cut illustrations and four-frame cartoons for magazines. Her masterpiece animation, *Room of Love,* is played in the country and also abroad. For this animation, she has won many prizes, such as the *Agency for Cultural Affairs' Media Art Fair* and the *KDDI EZ award.*

Melanie Schober
www.melanie-schober.at

Melanie Schober was born in 1985 in Saalfelden am Steinernen Meer, Austria. The TV series *Sailormoon* created her enthusiasm for mangas and influenced her cartoonish style. In 2005, she won the special prize for Austria at the Connichi competition and won second place at the MangaTalents competition at the book fair in Leipzig 2006. In 2007, she was discovered by the publishing company Carlsen. Since that time she's drawn the mini-manga *Raccoon* and the series *Personal Paradise* in addition to some other short stories.

551 WHERE DO THE IDEAS FOR YOUR DRAWINGS COME FROM? HOW DO YOU DO YOUR RESEARCH? My ideas come to me mostly unexpected, like a flash inside my mind. It's totally inexplicable!

552 WHAT IS THE FIRST THING YOU DO BEFORE SITTING DOWN TO DRAW? I cook some red bush tea. Then I make sure that I have enough toilet paper to clean my drawing pen!

553 WHAT ARE YOUR FAVORITE TOOLS OR DRAWING PROGRAMS, AND WHY? I love traditional drawing pens and ink from Japan for the lines, because manual drawing is like meditation for me. I'm saving money and time with Mangastudio for the screentones.

554 WHAT DO YOU LIKE ABOUT MANGA? WHAT DOES MANGA HAVE THAT EUROPEAN OR AMERICAN COMICS DON'T? I don't exactly know, but I really like that even the most dull subject becomes a thrilling adventure if its told in Manga-style! For me, Manga is is the pure essence of beauty in every line.

555 HOW DO YOU MAKE YOUR DRAWINGS COME TO LIFE? With my full concentration! Only if I pay full attention to my work, the drawings will come to life. I really hate half-heartedness!

556 WHAT ADVICE WOULD YOU GIVE TO A NOVICE ILLUSTRATOR TRYING TO MAKE A NAME FOR HIMSELF? Pay attention to the Internet, because it's the medium of the future. You can join forces with similar young artists all over the world very easily!

557 WHAT HAS CHANGED ABOUT YOUR STYLE OF DRAWING SINCE YOU BEGAN? I pay more attention to the whole composition instead of getting lost in fuzzy details.

558 MANGA: IS IT ART? Definitively! Everything people create from boredom is actually art, I think.

559 WHAT IS THE MOST IMPORTANT LESSON YOU HAVE LEARNED THAT YOU WOULD LIKE TO PASS ON TO OTHERS? Don't try to be someone else! Readers notice it if you try to fool them by just drawing something popular.

560 WHAT MAKES A COMIC SELL SUCCESSFULLY? A well-known arrangement + new ideas + charming characters + great emotions + LUCK = success!

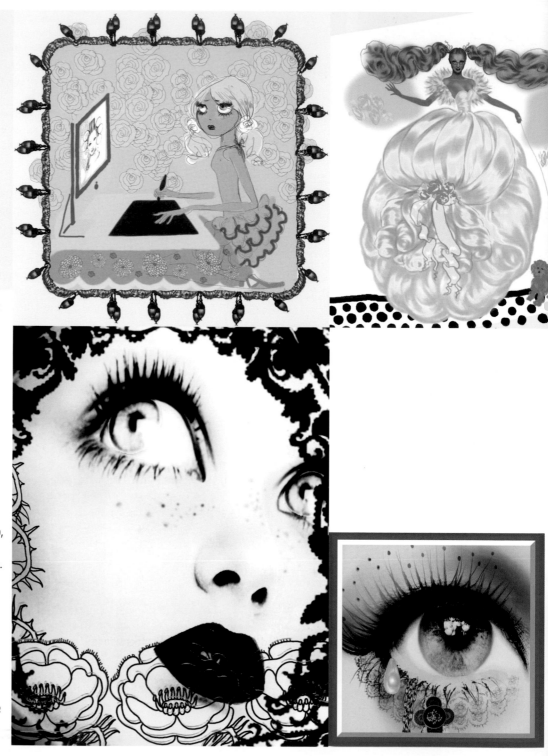

561 WHERE DO THE IDEAS FOR YOUR DRAWINGS COME FROM? HOW DO YOU DO YOUR RESEARCH? I often get my ideas when I'm dressed up with a pair of nice shoes and am riding the subway. The train noise and movement seems to put me in a nice trance, and ideas come to me.

562 WHAT IS THE FIRST THING YOU DO BEFORE SITTING DOWN TO DRAW? I open my PC and say "hello" to my favorite bloggers. I make myself comfortable with a sip of green tea and a foot-warmer.

563 WHAT ARE YOUR FAVORITE TOOLS OR DRAWING PROGRAMS, AND WHY? I depend on Adobe Photoshop, and I'm still only using one percent of that gigantic program, so I have alot to look forward to.

564 DO YOU PREFER THE CLASSIC GUIDELINES FROM MANGA OR EXPERIMENTING WITH NEW CHANNELS? The story line, with its many grades of emotional nuances, tends to be stronger in Japanese manga, and also quite kitsch—which in my view is its strong point.

565 WHAT DIFFERENTIATES YOU FROM MANGA'S OTHER ILLUSTRATORS? Eyes— I always give extra emphasis on drawing eyes. I believe eyes are a channel for energy flow.

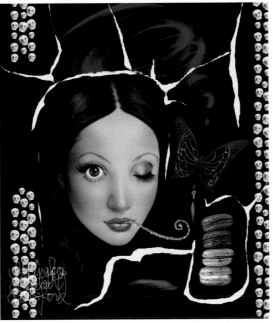

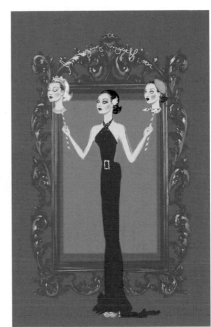

566 WHAT ADVICE WOULD YOU GIVE TO A NOVICE ILLUSTRATOR TRYING TO MAKE A NAME FOR HIMSELF? I suggest putting most of your iconic works on different portal sites, update your blog regularly, and, most of all, don't take "no" for an answer.

567 WHAT HAS CHANGED ABOUT YOUR STYLE OF DRAWING SINCE YOU BEGAN? Those changes in my style over the years which are noticeable have come from reincarnating and interacting with dreams and with the energies of the psyche.

568 MANGA: IS IT ART? I love the word *art*. Whether comics or not, I'm always doing my own art.

569 WHAT IS THE MOST IMPORTANT LESSON YOU HAVE LEARNED THAT YOU WOULD LIKE TO PASS ON TO OTHERS? I try to find the most unexpected juxtapositions.

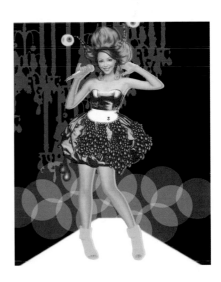

570 WHAT MAKES A COMIC SELL SUCCESSFULLY? Song and dance. And, also… the show must go on.

Minako Saitoh Botsford

http://minakos.com

Minako Saitoh Botsford is a Tokyo-based Japanese illustrator who works widely in fashion, advertising, magazines and package design. She draws digitally over collage/montage.

Her themes are mainly faces of genuine beauty, abundant light, rich laughter, color dreaming and magical fashion.

Mississippi (Takashi Horiguchi)

www.mississippi-kyoto.com

Mississippi is a Japanese manga painter and illustrator. He was born in Osaka in 1972, although he currently lives and works in Kyoto. He studied American literature at the University of Kyoto. Mississippi has shown his work at dozens of individual and collective exhibitions in Japanese galleries and also in Paris (New Galerie de France in Paris), Germany (Druck Dealer, in Hamburg) and The Netherlands (Ars Aemula Naturae, in Leiden).

571 WHERE DO THE IDEAS FOR YOUR DRAWINGS COME FROM? HOW DO YOU DO YOUR RESEARCH? The ideas come from my every day life. But visiting unknown places is also a good way to get new ideas. I love driving alone.

572 WHAT IS THE FIRST THING YOU DO BEFORE SITTING DOWN TO DRAW? Smoke.

573 WHAT ARE YOUR FAVORITE TOOLS OR DRAWING PROGRAMS, AND WHY? Pencil, ink and sumi (Japanese ink). They are easy to get, and I love to mix up them all. I love to see the differences on their surface.

574 DO YOU PREFER THE CLASSIC GUIDELINES FROM MANGA OR EXPERIMENTING WITH NEW CHANNELS? Experimenting. I do manga, and I do fine art as well. Sometimes I feel like using my manga skills on my fine art, and sometimes I feel like using my fine art skills in my manga works.

575 WHAT DIFFERENTIATES YOU FROM MANGA'S OTHER ILLUSTRATORS? In fact, I don't read manga a lot. I learned American literature at university. That's the point, maybe.

576 How important is promotion to you? How do you promote your work? Of course promotion is very important, I often do some artwork for my local community, shop cards or store signs. That's my favorite way to promote my works.

577 What has changed about your style of drawing since you began? At the beginning of my career, I liked only to make drawings of figures, but nowadays I also love to draw scenes.

578 Manga: is it art? Why not? I hope that art fans read more manga, and that manga fans enjoy more art. I'm editing a magazine named *Kyoco* that is a mixture of manga and art.

579 What good habits should a comic illustrator have? Study your town and its people carefully. After you "get" something from them, use some alone time. I think that isolation is necessary to make your imagination grow.

580 What is the greatest acknowledgement you could hope to achieve for your work? I have a few reliable friends in my town. They have a real eye for what's beautiful. Their applause would be the best prize for me.

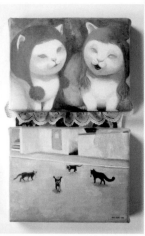

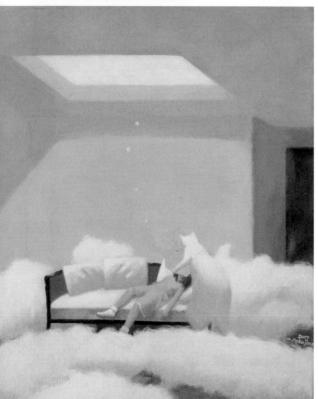

581 WHERE DO THE IDEAS FOR YOUR DRAWINGS COME FROM? HOW DO YOU DO YOUR RESEARCH? Illustration: In books, chose the most impressive subject in the story and re–create it in pictures. Original: Every ordinary thing carry something extraordinary.

582 WHAT DOES YOUR WORK DESK LOOK LIKE? WHAT CAN WE COME ACROSS? Favorite tools, colors, unfinished works and a Macbook. Around them, my cats are sleeping and in heaven.

583 DO YOU ALWAYS USE THE SAME TOOLS OR DO YOU CHANGE DEPENDING ON THE PIECE YOU'RE WORKING ON? Illustration: acrylic on paper and submitted digitally. Original: acrylic or oil on canvas, sometimes patted with textiles to give it an interesting appearance.

584 DO YOU PREFER THE CLASSIC GUIDELINES FROM MANGA OR EXPERIMENTING WITH NEW CHANNELS? My work is not typical manga style. Nevertheless, in my work there is a sense of Japanese cuteness, *kawai*, the essence of manga, I think. So if I had to choose, it would be a kind of new channel, maybe?

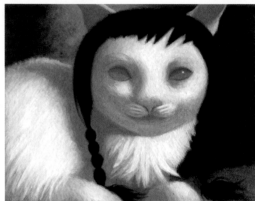

585 HOW DO YOU MAKE YOUR DRAWINGS COME TO LIFE? Some mysterious and strange things are shimmering in this world. I carefully catch them. Elaborate colors and brush works are necessary.

586 HOW IMPORTANT IS PROMOTION TO YOU? HOW DO YOU PROMOTE YOUR WORK? Websites, the *Illustration File* book (an annual of Japanese illustrators), the solo exhibitions and the New Year cards. Honestly, I am not great with it.

587 WHAT HAS CHANGED ABOUT YOUR STYLE OF DRAWING SINCE YOU BEGAN? I started drawing my works monochrome, and gradually changed to colorful acrylics. Now I make them simple again.

588 MANGA: IS IT ART? The spread of manga was only possible when Japanese blood met Western culture. It is not for kids anymore, but also for all kinds of people in the world. Manga deserves to be art.

589 WHAT IS THE MOST IMPORTANT LESSON YOU HAVE LEARNED THAT YOU WOULD LIKE TO PASS ON TO OTHERS? Decide your own philosophy. Make your mirror to reflect the nature of nobody but you. "Art for people" is misleading. In essence, even commercial art isn't a tool for society. It's a tool for you.

590 WHAT IS THE GREATEST ACKNOWLEDGEMENT YOU COULD HOPE TO ACHIEVE FOR YOUR WORK? I've never thought of my works as manga. But in fact I've loved it from childhood and once I was a wannabe manga girl. Does manga live in my works? I'll be excited if my work is known globally as "new manga."

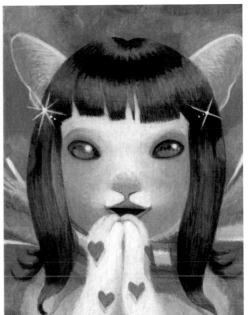

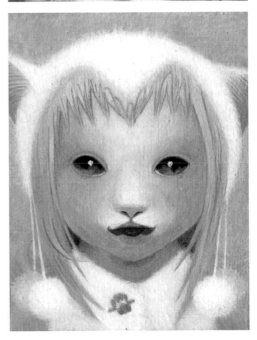

Miya Nakajima
http://nuances.cc

Miya Nakajima was born in Tokyo. She studied drawing and visual communication design at the Tokyo Metropolitan Highschool of Music & Fine Arts and graduated from the Musashino Art University. She began her illustrator career after working as a designer. Her work has appeared in books, promotional brochures, magazines and picture books. She is the author of one of the posters designed to commemorate the fiftieth anniversary of the Universal Declaration of Human Rights in 1998. Since 1988, her work can be admired in solo exhibitions and group shows.

Mizki Yuasa

www.mizdesk.com

Mizki Yuasa is a Japanese graphic designer and illustrator. He began drawing for a living in 2001, going freelance in 2010. Known primarily for his drawings of women and for his strong lines and soft colors, Mizki is able to work in a wide range of styles, from pure manga or comic book to a more realistic style, and finally an illustrative style that is more suited to newspapers and magazines. He works for magazines, newspapers and websites, although he also illustrates all kinds of posters and CD covers. He has also recently decided to do some artistic painting.

591 WHERE DO THE IDEAS FOR YOUR DRAWINGS COME FROM? HOW DO YOU DO YOUR RESEARCH? I am inspired by my past experience and by some books, comics, films and conversations with friends. I imagine a new story from each.

592 WHAT IS THE FIRST THING YOU DO BEFORE SITTING DOWN TO DRAW? I drink coffee. But in some cases, especially at night, I have a beer.

593 DO YOU ALWAYS USE THE SAME TOOLS OR DO YOU CHANGE DEPENDING ON THE PIECE YOU'RE WORKING ON? Basically, I use the same tools every time. I am using the same pens I'm used to, copier paper, a scanner, a Mac and a pen tablet.

594 DO YOU PREFER THE CLASSIC GUIDELINES FROM MANGA OR EXPERIMENTING WITH NEW CHANNELS? The media styles have been changing dramatically whether I like or not. Sometimes I think that I should change my work style and my channels of expression.

595 HOW DO YOU MAKE YOUR DRAWINGS COME TO LIFE? Perhaps like others, my career began by drawing in the corner of my textbooks during my elementary school days. After that, I started copying master's illustrations, which was a big help in determining my own style.

for example: Pen & Pencil Style...

596 HOW IMPORTANT IS PROMOTION TO YOU? HOW DO YOU PROMOTE YOUR WORK? It is very important, almost as important as the drawing process. I always carry my portfolio to show to anybody anywhere. Even to the guys who are drinking next to me in the bar. Perhaps they will become not only bar customers, but also the object of my illustrations.

597 WHAT HAS CHANGED ABOUT YOUR STYLE OF DRAWING SINCE YOU BEGAN? Technically, now I take good care of pen lines before scanning. And I draw more about themes and motifs that make people feel happy.

598 MANGA: IS IT ART? It's difficult to draw a line between art and other forms of expression, isn't it? If art should be able to go on without the attention of anybody, then my work is not "art."

599 WHAT IS THE MOST IMPORTANT LESSON YOU HAVE LEARNED THAT YOU WOULD LIKE TO PASS ON TO OTHERS? Working fast is part of the creative process. Speedy working makes one's quality level improve to the next step.

600 WHAT IS THE GREATEST ACKNOWLEDGEMENT YOU COULD HOPE TO ACHIEVE FOR YOUR WORK? "It's been a great pleasure working with you!"

ART

Manga

Commercial Illustration

Where?

Thank you!!

Mizna Wada

www.hihou.net/mizna

Mizna was born in 1974 in Kumamoto, Japan. She is an illustrator living in Tokyo. She began as a freelance illustrator after completing of an art seminar in Tokyo. She loves horror comics and has a very distinct style based on very clean lines, and she is the creator of a collection of little spooky dolls called, well... Spooky Dolls.

Naoshi

www.nao-shi.com

Naoshi was born in 1979 in Iwate, Japan, and lives in Yokohama, Japan. She is an expert of *sunae*, a Japanese illustration technique that uses shiny colorful sand. She draws unrealistic people living in a real world portraying everyday thoughts and emotions such as joy, happiness, sorrow, and anxiety. When asked, she says "I'd like to tell the whole world about the fun of *sunae*!"

She has exhibited her work in galleries from all around the world, such as Barker Hangar in Santa Monica, USA; Museo Madre in Napoli, Italy; and The streets of Lyon in Lyon, France.

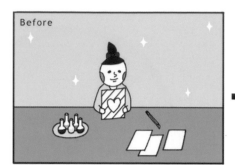

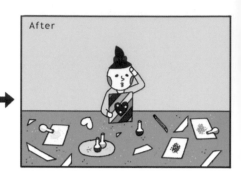

611 Where do the ideas for your drawings come from? How do you do your research? I got inspiration from the picture *Icecream walked*, which I drew at the age of six. That's my favorite character.

612 Who are your favorite illustrators? Are you trying to follow in their footsteps? My favorite illustrator is Kin Shiotani, and I even bought one of his original pictures. I don't think I can follow in his footsteps. I'll try to do it my way with *sunae*.

613 What is the first thing you do before sitting down to draw? I clean my room.

614 Do you always use the same tools or do you change depending on the piece you're working on? When necessary, I draw with Illustrator and Photoshop, but basically I draw with sand.

615 What are your favorite tools or drawing programs, and why? *SUNAE*. I simply love *SUNAE*!!!

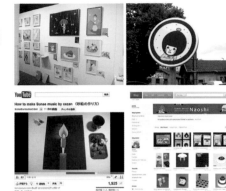

616 How important is promotion to you? How do you promote your work? I promote my work by holding shows and *sunae* workshops, through my website, by selling goods on Etsy, and showing how to make *sunae* using animation.

617 Do you feel the need to better yourself when it comes to your work? To what extent? Of course! I try to pursue works that overwhelm people and give life to sand. I also want to make more pieces that show people how much fun *sunae* can be.

618 What has changed about your style of drawing since you began? My style of drawing hasn't changed very much.

619 What is the most important lesson you have learned that you would like to pass on to others? Keep questioning and creating.

620 What is the greatest acknowledgement you could hope to achieve for your work? I will be very happy if people find my work a lot of fun, original and creative!

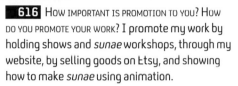

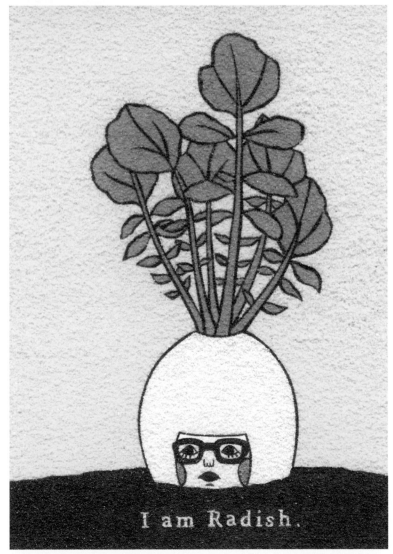

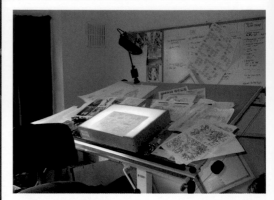

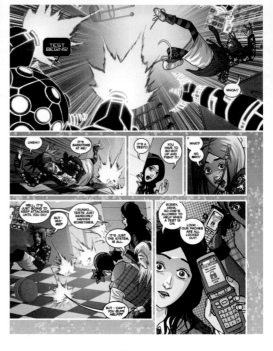

621 WHO ARE YOUR FAVORITE ILLUSTRATORS? ARE YOU TRYING TO FOLLOW IN THEIR FOOTSTEPS? There's so many artists I admire, but the biggest influences will always be the ones whose work I loved as a kid: Alan Davis, Bill Waterson, Rumiko Takahashi...

622 WHAT DOES YOUR WORK DESK LOOK LIKE? WHAT CAN WE COME ACROSS? Cluttered, usually! I always have big piles of reference, scripts, notes, comics, sketches etc. all piled up around me. And toys! For reference. And occasionally for playing with.

623 WHAT ARE YOUR FAVORITE TOOLS OR DRAWING PROGRAMS, AND WHY? I use Manga Studio for inking—it's the closest thing to drawing with pens and paper, but with advantages: you don't have to buy new nibs all the time, and—crucially—there's an undo button.

624 WHAT DO YOU LIKE ABOUT MANGA? WHAT DOES MANGA HAVE THAT EUROPEAN OR AMERICAN COMICS DON'T? It's hard to generalize, but they often have an energy and pace to their storytelling completely unlike what I was used to in comics I read growing up, and that I try to capture in my own work.

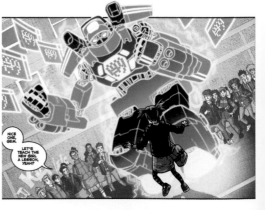

625 WHAT DIFFERENTIATES YOU FROM MANGA'S OTHER ILLUSTRATORS? I think my stuff—particularly on projects like *Mo-Bot High*, my mecha school manga—is a mix of manga influences with very British style and sensibilities. Hopefully this makes the end result a little different.

626 HOW IMPORTANT IS PROMOTION TO YOU? HOW DO YOU PROMOTE YOUR WORK? As a freelancer, promotion is half the job. I try to do things that are fun and cool, like when I drew an A-Z of Awesomeness based on suggestions from Twitter (@neillcameron) and my blog (neillcameron. blogspot.com).

627 DO YOU FEEL THE NEED TO BETTER YOURSELF WHEN IT COMES TO YOUR WORK? TO WHAT EXTENT? I'm always trying to get better with every page I draw. It is possible that I do not manage this every single time.

628 WHAT HAS CHANGED ABOUT YOUR STYLE OF DRAWING SINCE YOU BEGAN? If anything, I've developed the confidence just to be happy drawing in my style, rather than trying to force myself to draw in ways that I think I ought to.

629 WHAT GOOD HABITS SHOULD A COMIC ILLUSTRATOR HAVE? Will power! Force yourself to sit down and draw every day, even if you're not feeling creative, rather than just sitting watching TV/DVDs/playing video games/checking Facebook/Twitter...

630 WHAT IS THE GREATEST ACKNOWLEDGEMENT YOU COULD HOPE TO ACHIEVE FOR YOUR WORK? Getting letters and fan drawings from kids who've read *Mo-Bot High* is pretty much the best feeling in the world, and all the acknowledgement I need. Although an enormous pile of money would be nice, too.

1997 2010

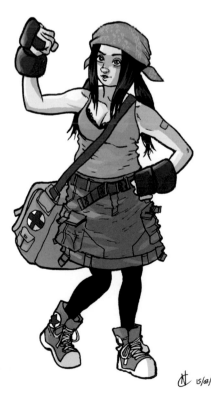

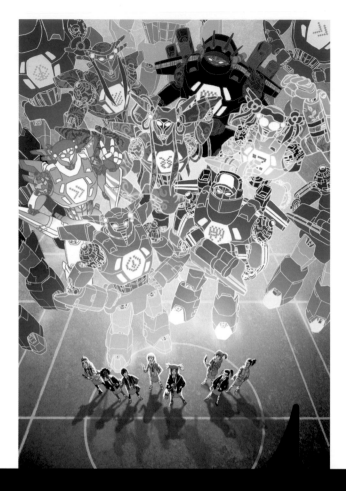

Neill Cameron

www.neillcameron.com

Born and raised in Oxford, England, Neill Cameron has been drawing comics pretty much since he could hold a pencil. For several years Neill was active in the UK small press and independent comics scene. In 2006,

Neill's artwork on *Bulldog: Empire* was featured in the first *Mammoth Book of Best New Manga*, his webcomic *Thumpculture* was shortlisted for an IMAF (International Manga and Anime Festival) award, and

he took the jump into working full-time as a freelance writer and artist. His first graphic novel, the Giant Robot Action Schoolgirl Comedy epic *Mo-Bot High* is out now (www.mobot-high.com).

Noriko Meguro

www.a-circuit.com

Noriko Meguro is one of Japan's finest digital print artists and illustrators; her use of texture and color is of great subtlety and expression. Her treatments of the subject matter, especially those of a figurative nature, illustrate a negotiation between the realms of the tradicional and the technological. Her images of boys and girls are said to be received favorably among people of any age, from juniors to adults. She works mainly doing book covers. Her works have received favorable comments because of her mastery of movement, transparencies and vitality, expressed through dozens of little drawing details.

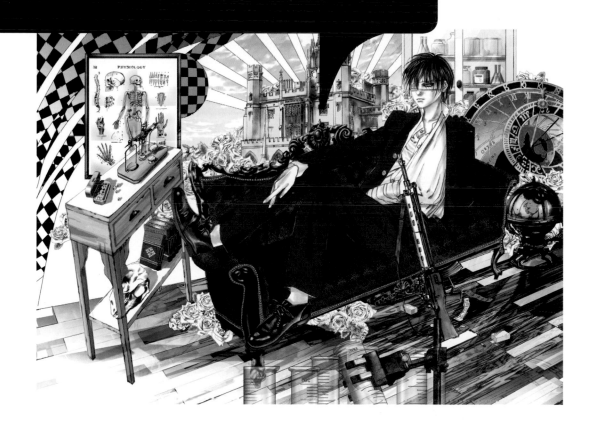

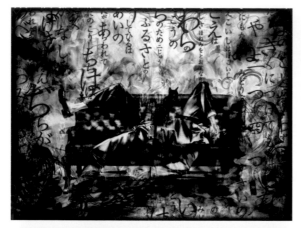

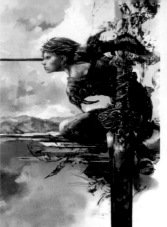

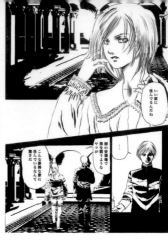

631 How important is promotion to you? How do you promote your work? I take the illustration to the publisher. Then, the editor sees my picture. The picture talks.

632 What does your work desk look like? What can we come across? I have a lot of material on my desk. It's becoming like a mountain. I visit libraries for more material, and material increases more.

633 Do you always use the same tools or do you change depending on the piece you're working on? I always use the same tools. I'm familiar with them, so I can work faster. However, to draw a comic I must prepare to use new software.

634 Do you prefer the classic guidelines from Manga or experimenting with new channels? I want to draw things that only I can draw. I want to make people pleased by a technique that didn't exist before. For example, I want to draw pictures in black and white that feel like color.

635 How do you make your drawings come to life? I draw lots of croquis. As a result, I'm able to draw spontaneous lines.

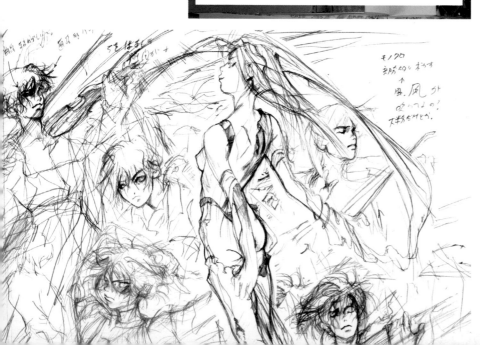

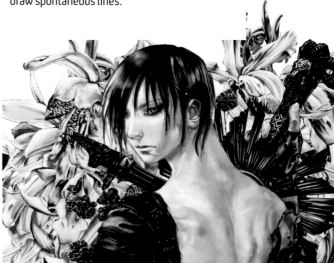

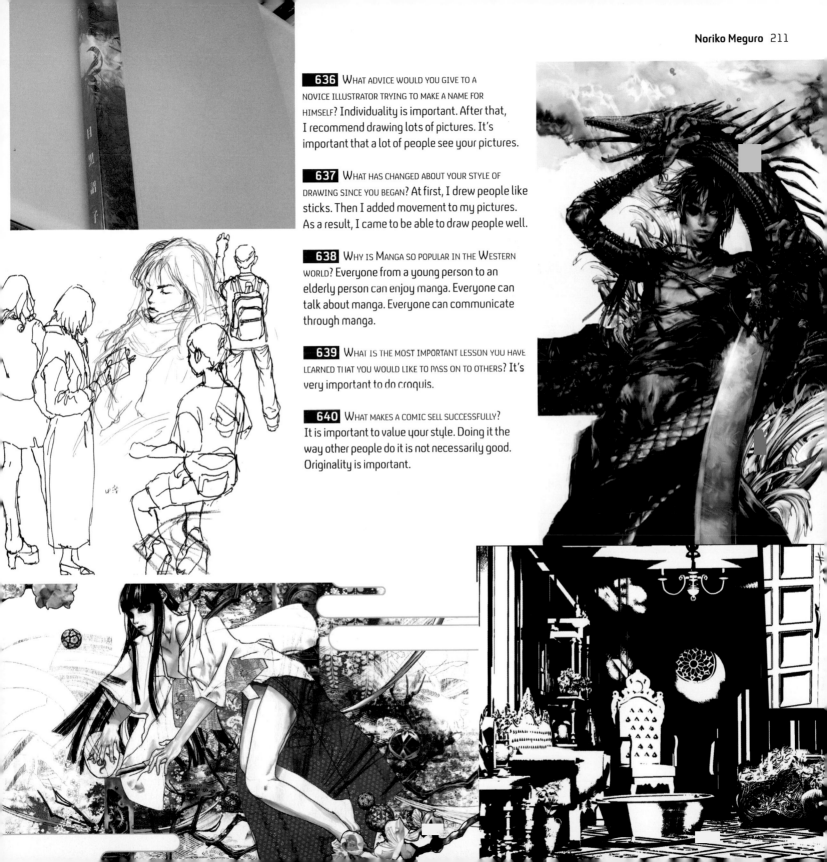

636 WHAT ADVICE WOULD YOU GIVE TO A NOVICE ILLUSTRATOR TRYING TO MAKE A NAME FOR HIMSELF? Individuality is important. After that, I recommend drawing lots of pictures. It's important that a lot of people see your pictures.

637 WHAT HAS CHANGED ABOUT YOUR STYLE OF DRAWING SINCE YOU BEGAN? At first, I drew people like sticks. Then I added movement to my pictures. As a result, I came to be able to draw people well.

638 WHY IS MANGA SO POPULAR IN THE WESTERN WORLD? Everyone from a young person to an elderly person can enjoy manga. Everyone can talk about manga. Everyone can communicate through manga.

639 WHAT IS THE MOST IMPORTANT LESSON YOU HAVE LEARNED THAT YOU WOULD LIKE TO PASS ON TO OTHERS? It's very important to do croquis.

640 WHAT MAKES A COMIC SELL SUCCESSFULLY? It is important to value your style. Doing it the way other people do it is not necessarily good. Originality is important.

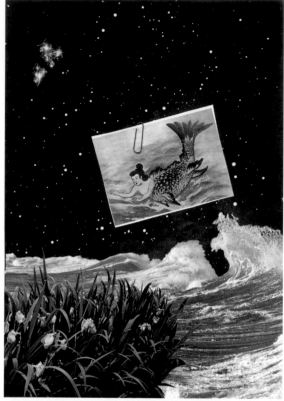

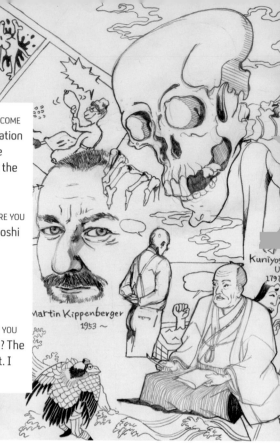

641 WHERE DO THE IDEAS FOR YOUR DRAWINGS COME FROM? HOW DO YOU DO YOUR RESEARCH? The inspiration comes from the flowers, the trees and nature when strolling. I research on the Internet, at the library...

642 WHO ARE YOUR FAVORITE ILLUSTRATORS? ARE YOU TRYING TO FOLLOW IN THEIR FOOTSTEPS? I like Kuniyoshi Utagawa and Martin Kippenberger.

643 WHAT IS THE FIRST THING YOU DO BEFORE SITTING DOWN TO DRAW? I pray.

644 DO YOU ALWAYS USE THE SAME TOOLS OR DO YOU CHANGE DEPENDING ON THE PIECE YOU'RE WORKING ON? The tool changes according to the work's content. I use collage, acrylic gouache, I draw...

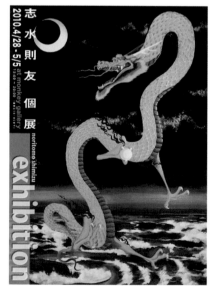

645 HOW IMPORTANT IS PROMOTION TO YOU? HOW DO YOU PROMOTE YOUR WORK? I organize exhibitions of my work, and buy advertising spaces in magazines.

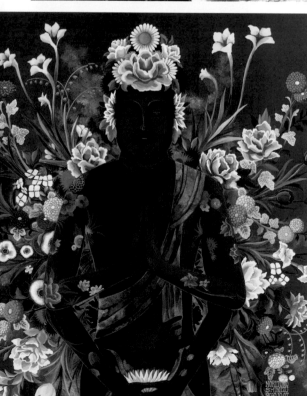

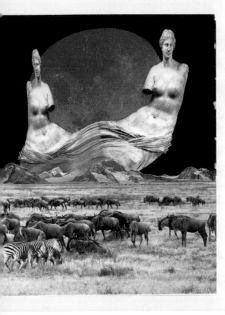

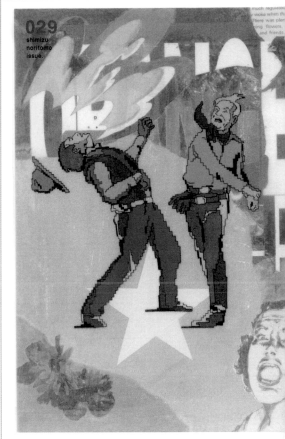

646 WHAT ADVICE WOULD YOU GIVE TO A NOVICE ILLUSTRATOR TRYING TO MAKE A NAME FOR HIMSELF? Repeat, destruct and create.

647 DO YOU FEEL THE NEED TO BETTER YOURSELF WHEN IT COMES TO YOUR WORK? TO WHAT EXTENT? When a client requests a higher quality and I need more inspiration, I study the subject even more. (God, nature, the universe...)

648 WHAT HAS CHANGED ABOUT YOUR STYLE OF DRAWING SINCE YOU BEGAN? The mind is more free when you're old.

649 WHAT IS THE MOST IMPORTANT LESSON YOU HAVE LEARNED THAT YOU WOULD LIKE TO PASS ON TO OTHERS? Reality of God. Importance of myth.

650 WHAT GOOD HABITS SHOULD A COMIC ILLUSTRATOR HAVE? It is necessary to observe carefully.

10 YEARS AGO

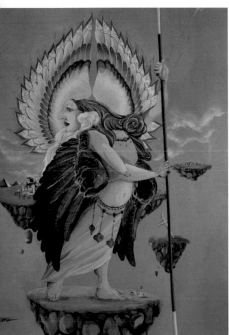

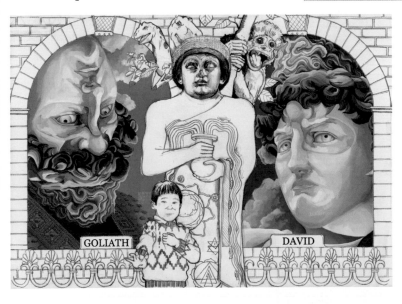

Noritomo Shimizu

www1.odn.ne.jp/noritomo_shimizu/shimizu/index.html

Noritomo Shimizu (1974) began work as an illustrator in 1999, primarily for magazines and the advertising industry. Barely two years later, in 2011, he staged his first individual exhibition. A further two years later, in 2004, he took part in Japan Week organized by the Welsh city of Cardiff. A book has come out recently in Japan featuring a large part of his most recent work.

Ponto Ponta

www.as-amid.com

The artist Ponto is a graduate of the Japanese Style Painting Department of Tama University of Arts. His work amazes the reader because of its versatility and its cross-cultural blend. He's the owner of the Japanese illustration company As-Amid Inc. Ponta has worked with advertising agencies and done illustrations for Warner Brothers Japan. His artwork has been exhibited every year since 2005 in a group exhibition in New York, USA.

His hope is for you to enjoy and personally connect with the characters he creates. He works also as a painter and is member of the International ukiyo-e Society.

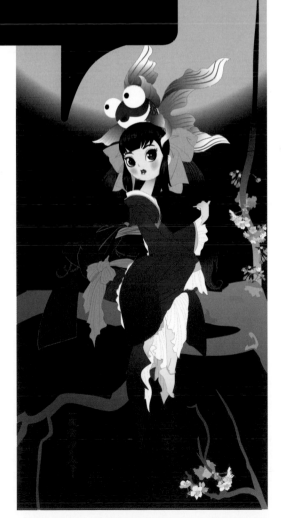

651 WHERE DO THE IDEAS FOR YOUR DRAWINGS COME FROM? HOW DO YOU DO YOUR RESEARCH? I get ideas from the scent of flowers, by listening to nature, by the feeling of the wind across my skin and by prayers drawn up to the moon. I research things from nonchalant daily life.

652 WHAT IS THE FIRST THING YOU DO BEFORE SITTING DOWN TO DRAW? First I clear my mind so I can concentrate on an image, feeling and idea that I want to create before I draw.

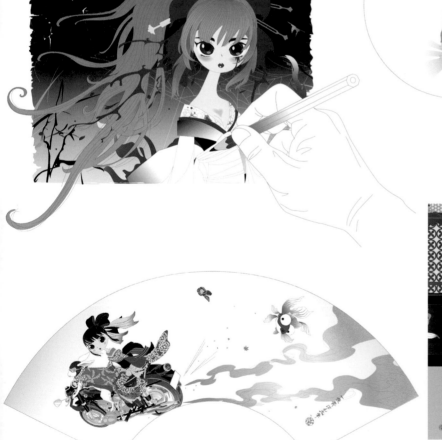

653 WHAT ARE YOUR FAVORITE TOOLS OR DRAWING PROGRAMS, AND WHY? My favorite program is Adobe Illustrator 8.0 because the pen-style tool gives me a realistic sense when I paint or draw. It also has a large palette of colors, which is useful for the artwork I do.

654 DO YOU PREFER THE CLASSIC GUIDELINES FROM MANGA OR EXPERIMENTING WITH NEW CHANNELS? I have a deep appreciation of classic guidelines from manga and enjoy them. But I think it is important to aim one step ahead.

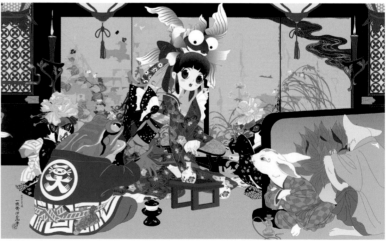

655 WHAT DIFFERENTIATES YOU FROM MANGA'S OTHER ILLUSTRATORS? My dress-up doll characters are unique and have versatility. The innocence in my art represents a cross-cultural blend.

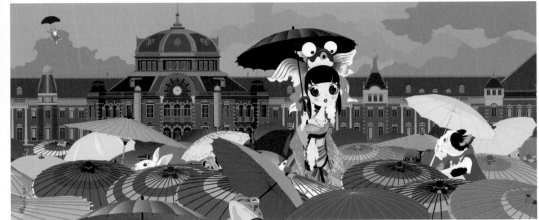

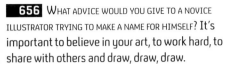

656 WHAT ADVICE WOULD YOU GIVE TO A NOVICE ILLUSTRATOR TRYING TO MAKE A NAME FOR HIMSELF? It's important to believe in your art, to work hard, to share with others and draw, draw, draw.

657 WHAT HAS CHANGED ABOUT YOUR STYLE OF DRAWING SINCE YOU BEGAN? Maybe I have not changed greatly in my style but the growing of my characters shows my steady growth as an artist.

658 MANGA: IS IT ART? Yes, it's art! Manga may not be for everyone's liking. However, for those who love manga, it can be better than Picasso's works.

659 WHAT GOOD HABITS SHOULD A COMIC ILLUSTRATOR HAVE? A flexible mind. A good habit is to have a delicate sense that allows you to laugh, cry and get enjoyment out of even the smallest events in life so they inspire you to draw.

660 WHAT IS THE GREATEST ACKNOWLEDGEMENT YOU COULD HOPE TO ACHIEVE FOR YOUR WORK? To receive love from other people. To keep love and faith in my art and in the characters I make. I wish they had an everlasting appeal.

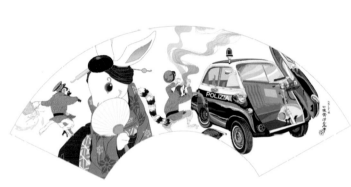

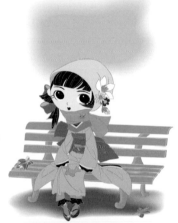

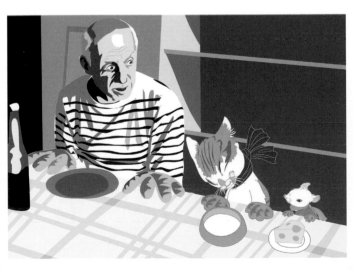

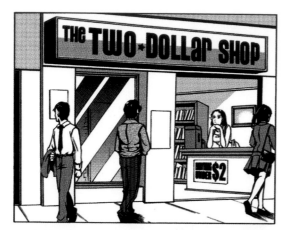

661 WHERE DO THE IDEAS FOR YOUR DRAWINGS COME FROM? HOW DO YOU DO YOUR RESEARCH? I get my ideas from ordinary everyday things. For example, a co-worker used to bring odd little trinkets to work. I later found out she worked at a two-dollar store, so that gave me an idea for a short story called *The Two-Dollar Deal*.

662 WHO ARE YOUR FAVORITE ILLUSTRATORS? ARE YOU TRYING TO FOLLOW IN THEIR FOOTSTEPS? I have many favorite artists, and I sometimes follow them in art-style; other times in writing and story-telling. Takeshi Obata of *Death Note* and Kentarou Miura of *Berserk* are two artists I've tried to emulate. You can see a few influences in my designs.

663 WHAT DOES YOUR WORK DESK LOOK LIKE? WHAT CAN WE COME ACROSS? My working area is very small, it's really two desks (one a computer desk) with a propped up drawing board. My laptop, with a second monitor, attached is more important since I surf the net a lot while I draw. You can see how small the area is in this picture (right).

664 DO YOU ALWAYS USE THE SAME TOOLS OR DO YOU CHANGE DEPENDING ON THE PIECE YOU'RE WORKING ON? I usually use the same tools, and change the way I lay pen strokes to create a different look. I've always used the G-pen, the nikko pen and Sakura microns. I alternate between the three of them, though I sometimes also use brush pens.

665 WHAT ARE YOUR FAVORITE TOOLS OR DRAWING PROGRAMS, AND WHY? I think the nikko pen is still my favorite. I don't use it much these days because my current work requires a different style of art, but no other tool can create such thin, fine lines. It can create a very unique kind of look, like this picture (right).

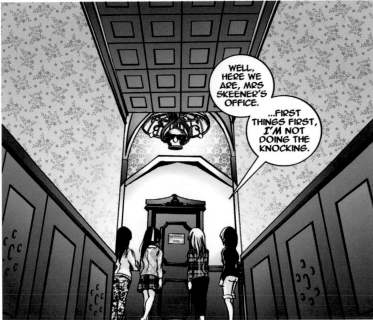

666 DO YOU PREFER THE CLASSIC GUIDELINES FROM MANGA OR EXPERIMENTING WITH NEW CHANNELS? I always jump at the chance to experiment, but I rarely ever get these opportunities. I've mixed prose with comics, and in this picture (above), I drew a short fan-comic with a half-page format instead of a full-page one. It was fun, and the results were great.

667 WHAT DO YOU LIKE ABOUT MANGA? WHAT DOES MANGA HAVE THAT EUROPEAN OR AMERICAN COMICS DON'T? The iconic character designs, which emphasize the expressiveness of the character. I also love the cinematic style of storytelling. I'm a big fan of cinema, and often apply movie techniques to my manga storytelling.

668 HOW IMPORTANT IS PROMOTION TO YOU? HOW DO YOU PROMOTE YOUR WORK? I think promotion is extremely important, but I rarely find the time to do it. I have a blog, and a website with lots of short manga for readers to browse. However, I think drawing more stories is still the best way to promote yourself.

669 WHAT HAS CHANGED ABOUT YOUR STYLE OF DRAWING SINCE YOU BEGAN? I've gotten better at drawing people. I always like drawing backgrounds, but in the past few years, I've gotten better at character designs. I used to draw very plain faces, but my faces now have a lot more variation.

670 WHAT IS THE GREATEST ACKNOWLEDGEMENT YOU COULD HOPE TO ACHIEVE FOR YOUR WORK? Having people buy and enjoy my work is enough. I do mostly longer stories, but I think it would be a great compliment if people would purchase my short story collections. Since these short stories are free, you must be a real fan if you buy it!

Queenie Chan

www.queeniechan.com

Queenie Chan was born in 1980 in Hong Kong, and migrated to Australia when she was six years old. In 2004, she began drawing a three-volume mystery-horror series called *The Dreaming* for LA-based manga publisher Tokyopop. To date, it has been translated into multiple languages. She has since collaborated on several single-volume graphic novels with best-selling author Dean Koontz. As prequels to his *Odd Thomas* series of novels, they are called *In Odd We Trust* and *Odd Is On Our Side*, the latter becoming #1 on the *New York Times* best-seller list the week it came out. A third book is coming in 2011. In 2009, she also provided art for the *Boys Book of Positive Quotations*, by best-selling inspirational author Steve Deger. Apart from her professional work, she also draws a number of online comic strips on her personal site.

Robert Deas
www.rdcomics.co.uk

The professional comic career of Robert Deas began after coming second in the 2006 IMAF competition in the Print/Comic category with a spin off from his long running webcomic *Instrument of War*. His first published work was his self-penned sci-fi espionage tale *November*. Since then he has gone on to produce the artwork for *Shakespeare: Macbeth* for SelfMadeHero, *The Golden Tiger & Nemesis* for Rubicon Canada, an issue of *Transformers: All Hail Megatron* for IDW and an animated webcomic for the online multiplayer game, *Code of Everand*. He lives and works in Lincolnshire and operates a completely digital workflow, using a combination of AutoDesk Sketchbook Pro, Adobe Photoshop CS4 and a Wacom Cintiq 21UX, running on a 21.5" iMac. He's currently producing the artwork for an adaptation of *Pride and Prejudice* for SelfMadeHero.

671 WHERE DO THE IDEAS FOR YOUR DRAWINGS COME FROM? HOW DO YOU DO YOUR RESEARCH? My ideas come from a variety of sources, of course there's other manga and comics but also TV, film, video games, books. When it comes to research it depends on the project. When writing *November*, my espionage manga set in Russia, I bought lots of books, Moscow and St. Petersburg travel books, books on Russian history and politics and of course nowadays there's the Internet.

672 WHAT DOES YOUR WORK DESK LOOK LIKE? WHAT CAN WE COME ACROSS? I have an office in one of the bedrooms in my home. In there you'll find my desk with my iMac and Wacom Cintiq 21UX digital drawing tablet.

673 WHAT ARE YOUR FAVORITE TOOLS OR DRAWING PROGRAMS, AND WHY? I work completely digitally and for the last year and a half I have drawn on nothing else other than my Wacom Cintiq 21UX digital drawing tablet. It's a fantastic piece, very expensive, but without question the best investment I've ever made.

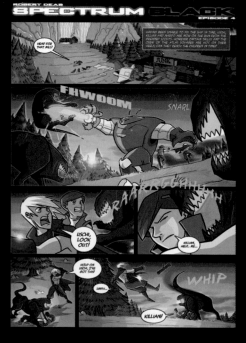

674 WHAT DO YOU LIKE ABOUT MANGA? WHAT DOES MANGA HAVE THAT EUROPEAN OR AMERICAN COMICS DON'T? I prefer the pacing of manga books. Western comics are often presented as mini series or big series and are divided into small volumes and collections, with notable exceptions like *The Walking Dead*. Manga series are often huge in scale with seemingly no restriction on page count and this gives the writers and artists a chance to let their creation breathe and take their time with their story.

675 WHAT DIFFERENTIATES YOU FROM MANGA'S OTHER ILLUSTRATORS? I think you can see both manga and Western influences in my work. I think you can tell I grew up reading a lot of 90s Marvel books and on the other hand reading a lot of manga and watching a lot of anime. I'm not sure how different this makes me from other creators but the influences are definitely there in my work.

Spectrum Black © 2009, Random House

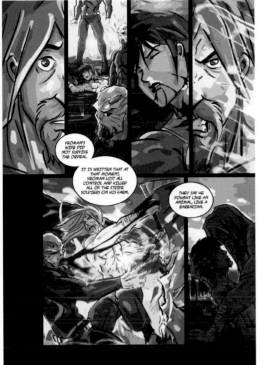

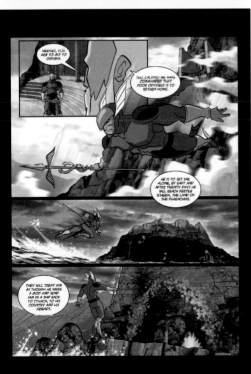

676 WHAT ADVICE WOULD YOU GIVE TO A NOVICE ILLUSTRATOR TRYING TO MAKE A NAME FOR HIMSELF? Never give up. It wasn't until I was in my late twenties that I got my big break but I always believed it would happen one day. Enter your work in competitions, that's how I got noticed. Go to conventions, meet some other creators and editors and show your work to anyone who will give you five minutes of their time to look over your portfolio. Don't take a negative critique badly, learn from it and make your stuff better.

677 DO YOU FEEL THE NEED TO BETTER YOURSELF WHEN IT COMES TO YOUR WORK? TO WHAT EXTENT? Always! Not many artists are happy with their work once it's in print in a similar way to actors that can't watch themselves on screen. I'm a perfectionist but also take deadlines very seriously so sometimes you have to let things slide to keep the project on time, it's a compromise and a balance. At the moment I'm working on an adaptation of *Pride and Prejudice*, which is really pushing my art to a new level as it's way outside of my comfort zone of science fiction and action genres.

678 MANGA: IS IT ART? Of course, just as much as any medium. Anyone who says otherwise is ignorant.

679 WHAT GOOD HABITS SHOULD A COMIC ILLUSTRATOR HAVE? Good time management. The ability to keep to a deadline and deliver quality work on time is something I have tried to build my reputation on.

680 WHAT MAKES A COMIC SELL SUCCESSFULLY? A good story and good art help but outside of that it's anyone's guess.

Pride and Prejudice reproduced with permission © 2011, SelfMadeHero

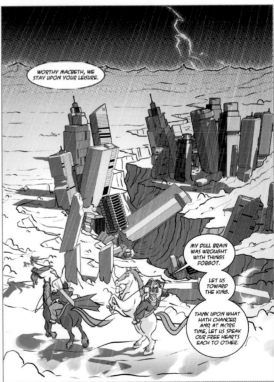

Manga Shakespeare: Macbeth reproduced with permission © 2008, SelfMadeHero

681 WHERE DO THE IDEAS FOR YOUR DRAWINGS COME FROM? HOW DO YOU DO YOUR RESEARCH? I take photos everywhere. Also, sometimes I get ideas from photographers, fashion designers, films...

682 WHAT IS THE FIRST THING YOU DO BEFORE SITTING DOWN TO DRAW? I think about a composition.

683 DO YOU ALWAYS USE THE SAME TOOLS OR DO YOU CHANGE DEPENDING ON THE PIECE YOU'RE WORKING ON? I use acrylic colors. But I also like to use different tools on the same work.

684 DO YOU PREFER THE CLASSIC GUIDELINES FROM MANGA OR EXPERIMENTING WITH NEW CHANNELS? Experimenting with new channels.

685 HOW DO YOU MAKE YOUR DRAWINGS COME TO LIFE? Happy.

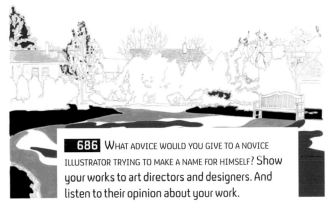

686 WHAT ADVICE WOULD YOU GIVE TO A NOVICE ILLUSTRATOR TRYING TO MAKE A NAME FOR HIMSELF? Show your works to art directors and designers. And listen to their opinion about your work.

687 WHAT HAS CHANGED ABOUT YOUR STYLE OF DRAWING SINCE YOU BEGAN? I used to use magic markers and color pencils at first, but then I changed to acrylic colors.

688 WHY IS MANGA SO POPULAR IN THE WESTERN WORLD? Because it's a very original Japanese cultural product.

689 WHAT IS THE MOST IMPORTANT LESSON YOU HAVE LEARNED THAT YOU WOULD LIKE TO PASS ON TO OTHERS? I think it's important to know how much I love to do it.

690 WHAT GOOD HABITS SHOULD A COMIC ILLUSTRATOR HAVE? Curiosity.

Romi Watanabe

http://romiwatanabe.com

Romi Watanabe lives in Tokyo. She graduated from the Setsumodo Seminar and studied as an exchange student at the St. Martins College in London. She worked for the apparel industry and then became a freelance illustrator. She creates illustrations for editorials, CD covers, textiles and advertisements. She has shown her works in solo exhibitions in many galleries, such as the Harayuku Rocket, the So-Net and the Gaien-Mae Sign, all of which are located in Tokyo.

Rose Besch

http://barachan.com

Born in 1982, Rose Besch is
a self-taught illustrator from
Atlanta who has worked for
American Greetings, RSA Films
and SlugFest Games. In her
spare time, she enjoys cooking,
baking, sleeping, and fawning
over her two rabbits.

691 WHERE DO THE IDEAS FOR YOUR DRAWINGS COME FROM? HOW DO YOU DO YOUR RESEARCH? Inspiration comes to me from a variety of sources — fashion, music, other artwork, etc. If possible, I like to read up a bit on the history or background of something (usually via Google or Wikipedia) before I draw it, and hopefully achieve more substance in the finished product that way.

692 WHO ARE YOUR FAVORITE ILLUSTRATORS? ARE YOU TRYING TO FOLLOW IN THEIR FOOTSTEPS? I love Alphonse Mucha's style, but also the way his commercial art brought beautiful, unique imagery to people's everyday lives. I'm also a big fan of Adam Hughes's marriage of comic art storytelling with wonderfully crafted illustration, and the fact that he never went to art school gives me a lot of hope!

693 WHAT DOES YOUR WORK DESK LOOK LIKE? WHAT CAN WE COME ACROSS? My laptop, monitor, and tablet, of course. An empty soda can or two (it's my worst habit). Godzilla figures. Nail polish bottles. A small potted plant that's currently in wretched shape because my boyfriend's cat keeps eating it!

694 DO YOU ALWAYS USE THE SAME TOOLS OR DO YOU CHANGE DEPENDING ON THE PIECE YOU'RE WORKING ON? It changes a bit. I'm perhaps most efficient at working digitally, so that's how I complete most of my art. But for some pieces, nothing replaces the look and feel of real media.

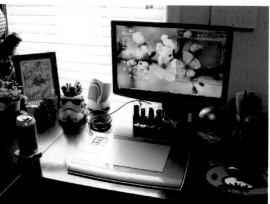

AKAIBARA
赤い薔薇
barazhand.com

695 WHAT DIFFERENTIATES YOU FROM MANGA'S OTHER ILLUSTRATORS? Rather than trying to parrot any one style, I'd like to think that my work incorporates elements from a multitude of sources, Eastern and Western, old and new.

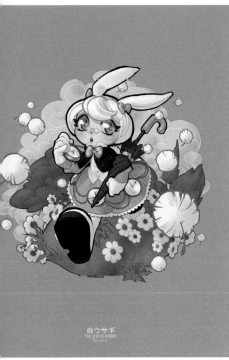

696 How important is promotion to you? How do you promote your work? I think promotion is essential; your work needs to be solid, of course, but how will anyone know of it if you don't get yourself out there? I try to post my work in many places and (sort of) keep up with social media trends, and post new content semi-consistently.

697 Do you feel the need to better yourself when it comes to your work? To what extent? Absolutely! I don't think I'll ever be completely satisfied with my work, but hopefully that means I'll keep striving to improve, too.

698 What has changed about your style of drawing since you began? In some ways, I feel like my actual style has not changed so much as my technical ability (better anatomy, improved grasp of color, and so on) but I suppose it started out looking very *shojo*—esque and has moved closer to pop-art territory.

699 Why is Manga so popular in the Western world? I think the styles seem exotic to many. The characters are often very visually appealing, too. And, the wide selection of genres available in manga are quite different from the usual Western mindset that cartoons and comic books are mainly for children.

700 What is the most important lesson you have learned that you would like to pass on to others? Don't ever get discouraged by a lack of talent. I think motivation is everything, not talent! It may seem like great artists do their work with ease, but they all had to start somewhere. Don't give up!

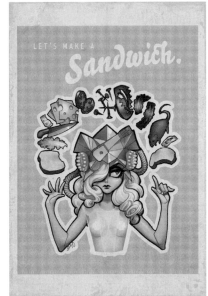

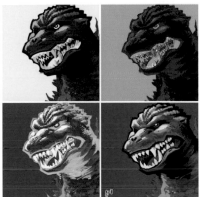

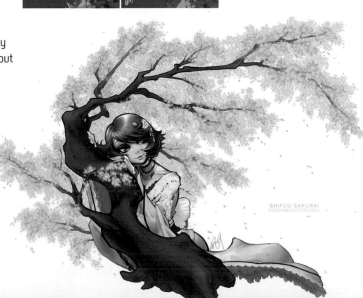

701 Where do the ideas for your drawings come from? How do you do your research? I like finding out about real-life technology and applying it to more outlandish fictional designs. Physics and technology can capture my imagination.

702 What does your work desk look like? What can we come across? I'm constantly moving my work place. Whether in my living room, a noodle shop, or a late night snack bar, all I need is a good chair, headphones, and electrical power to get productive. A lot of my work was developed late at night in one odd place or another.

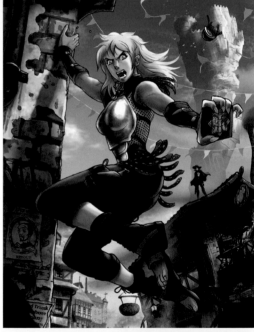

703 Do you prefer the classic guidelines from Manga or experimenting with new channels? I don't believe in any strict art style orthodoxy, or that almost taxonomic labeling sometimes used to describe art styles. Catering to current fashion has its place, but new influences should always be explored.

704 How do you make your drawings come to life? I like putting emotional impact into my work, even if the result isn't particularly happy or nice.

705 What advice would you give to a novice illustrator trying to make a name for himself? Don't avoid outside influences to stay "original." Originality comes from knowing what's out there and knowing what gaps can be filled in.

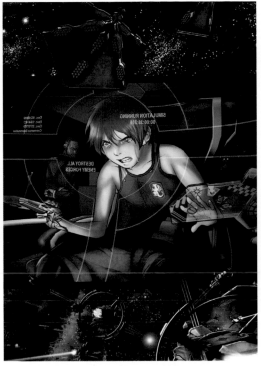

706 Do you feel the need to better yourself when it comes to your work? To what extent? I never want to end up satisfied with my current quality of work. There are always ways to get better, or at least explore new abilities.

707 What has changed about your style of drawing since you began? I've been less obsessed about the little details and more focused on the final emotional reaction.

708 What is the most important lesson you have learned that you would like to pass on to others? Be flexible. Be willing to change and be open to new influences and direction. The alternative is stagnation.

709 What good habits should a comic illustrator have? Thinking like a student open to learning, studying the market, being on time, doing the research, and communicating clearly with the clients.

710 What makes a comic sell successfully? If I change someone's mind!

Ruben de Vela

rubendevela.deviantart.com

Ruben is a twenty-nine-year-old illustrator from Manila. Shifting to industrial design from applied physics, he ended up in Toei Animation's background department for *One Piece* and *Pretty Cure*.

Currently a freelancer, his past projects have involved Namco (UFS *Tekken 6*), Blizzard and Tokyopop (*Starcraft Frontline*), with various media such as comic penciling and coloring, and

digital painting. In parallel with his interest with video games, he is currently working on art for portable game development.

Ryuji Shishido

http://shishidoryuji.net

Ryuji Shishido was born in 1972, and became a freelance illustrator in 2002. He lives in Odawara City, Kanagawa (Japan). His works are pure simplicity characterized by flat surfaces and the texture of cloth. He feels the need to draw familiar scenery of the nostalgia felt in childhood. His illustrations are made digitally using Adobe Illustrator. His first exhibition was in Fujisawa (Japan) in 2004. Followed by, among others, the *Art Fair Tokyo* 2009 exhibition.

711 Do you prefer the classic guidelines from Manga or experimenting with new channels? I like classic and simple techniques. Additionally, I'm always looking for an original technique that only I can do.

712 Where do the ideas for your drawings come from? How do you do your research? I recall my childhood when I take a walk in my vicinity in the middle of the night, and I see the dark, and I see different scenes from daytime. The ideas arise there.

713 What does your work desk look like? What can we come across? I always keep the room tidy and clean, because the disorder weakens the production desire.

714 Do you always use the same tools or do you change depending on the piece you're working on? For my official work, I use a Mac. For personal works I use painting materials such as paints and cloths.

715 What are your favorite tools or drawing programs, and why? I like hand-drawing the line. And I like the fact that it doesn't depend on the resolution.

716 HOW DO YOU MAKE YOUR DRAWINGS COME TO LIFE? See the pictures.

717 HOW IMPORTANT IS PROMOTION TO YOU? HOW DO YOU PROMOTE YOUR WORK? Work is worthless if you draw a very wonderful picture but it doesn't reach any other person's eyes. I directly contact readers and meet them, or send promotional e-mails to invite them to see my website.

718 WHAT ADVICE WOULD YOU GIVE TO A NOVICE ILLUSTRATOR TRYING TO MAKE A NAME FOR HIMSELF? I'm sure I'm able to express myself even in the most tedious work.

719 MANGA: IS IT ART? I think some cartoons are sublime art.

720 WHAT IS THE GREATEST ACKNOWLEDGEMENT YOU COULD HOPE TO ACHIEVE FOR YOUR WORK? My works connect you to other works. It's as important as the pecuniary reward.

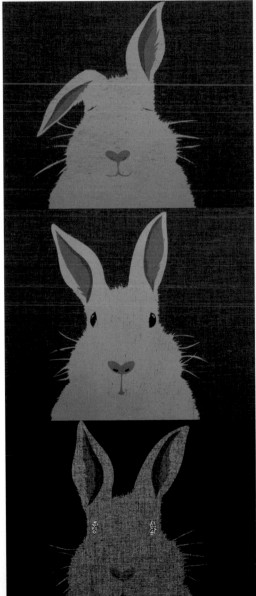

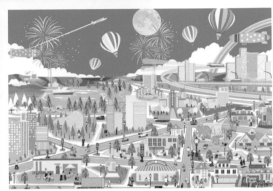

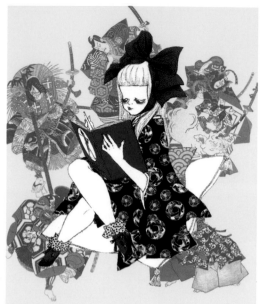

721 WHERE DO THE IDEAS FOR YOUR DRAWINGS COME FROM? HOW DO YOU DO YOUR RESEARCH? I feel stimulated by the beauty of Japanese traditional art and the kabuki. I'm also influenced by the cruel fairy tales, as I read them in large quantities when I was a child. When I was a junior high school student, I was impacted also by a book featuring a photographic collection of the work of doll designer and artist Katan Amano.

722 WHO ARE YOUR FAVORITE ILLUSTRATORS? ARE YOU TRYING TO FOLLOW IN THEIR FOOTSTEPS? I like authors who draw, like Edward Gorey or Henry Dagger. I would like to be like them. I also like *ukiyo-e* artists.

723 WHAT IS THE FIRST THING YOU DO BEFORE SITTING DOWN TO DRAW? I drink black coffee and play the music I like.

724 DO YOU ALWAYS USE THE SAME TOOLS OR DO YOU CHANGE DEPENDING ON THE PIECE YOU'RE WORKING ON? I draw with a mechanical pencil, depending on my feelings, and then I color the work with paints. Then I take the work to the personal computer and adjust the color.

725 HOW DO YOU MAKE YOUR DRAWINGS COME TO LIFE? Stimulus comes from the outside. Until this instant comes, I move my hand simply, freely and instantaneously.

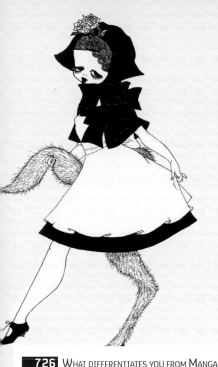

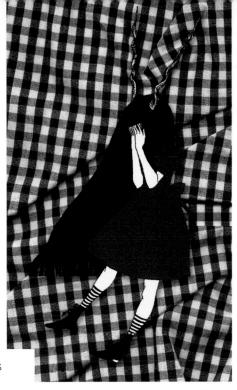

730 What is the greatest acknowledgement you could hope to achieve for your work? It's delightful when the people who look at my work feel a piercing feeling inside.

726 What differentiates you from Manga's other illustrators? I mix beauty and fear.

727 Do you feel the need to better yourself when it comes to your work? To what extent? I need to investigate my own psyche more and more deeply. It allows me to sharpen my art.

728 What has changed about your style of drawing since you began? I became stranger with time.

729 What is the most important lesson you have learned that you would like to pass on to others? I have learned the art of making ball-jointed dolls. The fact that I'm doing three-dimensional work makes me conscious of the three-dimensional depth of pictures.

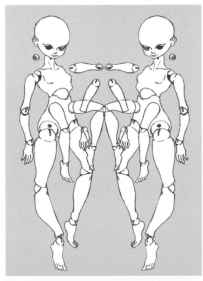

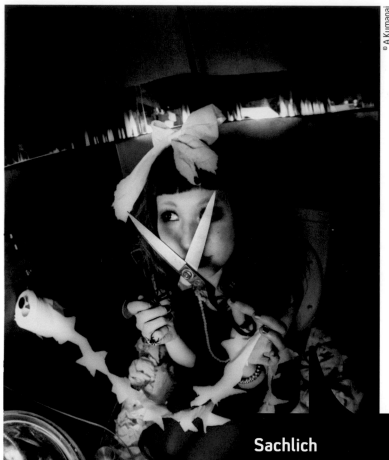

© A.Kumagai

Sachlich

www.sachlich.net

Sachlich is a complete and utter mystery. Little is known of her other than that she is an illustrator, and her drawings use Japanese *kawai* and manga cartoons as a starting point to transport the viewer to disturbing, troubling places where girls are not as innocent as they seem at first sight. A visit to her blog means crossing the threshold of everyday reality to reach a world that is closer to David Lynch than to Katsuhiro Otomo. Sachlich, who also works as a writer and photographer as well as an illustrator, hopes soon to turn her hand to animation.

Sai Tamiya

www.asahi-net.or.jp/˜bv9s-tmy/sai

Sai Tamiya is a Japanese illustrator. He was born in 1970 and graduated from the Faculty of Fine Art at Nihon University. He does book cover designs, Web design and CD covers, and he works for fashion magazines and advertisement agencies. His work has appeared in several international publications. He has received prizes such as the *Pater Award* from the Pater Sato Illustration Competition. All his work is drawn using Photoshop and Painter.

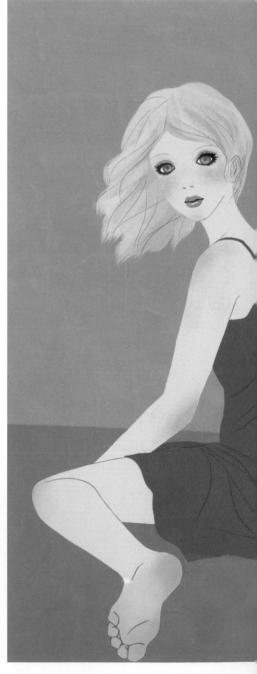

731 Where do the ideas for your drawings come from? How do you do your research? I watch people, shops and advertisements in my town.

732 What is the first thing you do before sitting down to draw? I drink a coffee and read information about the illustration.

733 What are your favorite tools or drawing programs, and why? I used to use acrylic paints before, but now I usually use Painter11 and Photoshop CS5. It allows you to redraw the illustrations easily and data management is very convenient with them. I now think that digital tools are better.

734 What do you like about Manga? What does Manga have that European or American comics don't? I like *Peanuts* by Charles M. Schulz. I have got not only the comics, but also the cartoon's soundtrack.

735 How do you make your drawings come to life? I think that the most important things are the eyes and the expression of the body (especially the fingers).

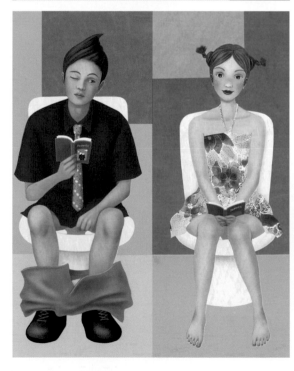

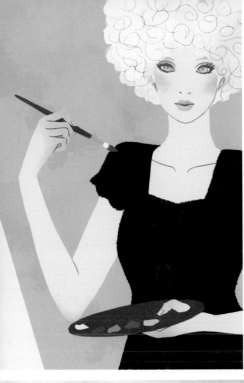

736 WHAT ADVICE WOULD YOU GIVE TO A NOVICE ILLUSTRATOR TRYING TO MAKE A NAME FOR HIMSELF? Draw a lot and show your work to someone.

737 WHAT HAS CHANGED ABOUT YOUR STYLE OF DRAWING SINCE YOU BEGAN? I wanted to be a picture book artist at first, but right now I'm mainly drawing illustrations for book covers and fashion magazines.

738 MANGA: IS IT ART? It depends on the comic. I think that there are several comics that can be art.

739 WHAT GOOD HABITS SHOULD A COMIC ILLUSTRATOR HAVE? Curiosity for your favorite thing. Be positive.

740 WHAT MAKES A COMIC SELL SUCCESSFULLY? An attractive character and story.

741 WHERE DO THE IDEAS FOR YOUR DRAWINGS COME FROM? HOW DO YOU DO YOUR RESEARCH? It is usually the figure manufacturer that orders me to make a figure model of a manga character, first of all. Then I check the original manga and anime or play the game to research the character's looks, personality and behavior. Finally, I imagine and draw the pose that it will become.

742 WHAT DOES YOUR WORK DESK LOOK LIKE? WHAT CAN WE COME ACROSS? It's a little chaotic. There are various tools and materials for figure modeling.

743 DO YOU ALWAYS USE THE SAME TOOLS OR DO YOU CHANGE DEPENDING ON THE PIECE YOU'RE WORKING ON? I basically use the same tools (polyester putty and box cutter) for making any kind of model. But I always search for something new and useful for my work.

744 WHAT DO YOU LIKE ABOUT MANGA? WHAT DOES MANGA HAVE THAT EUROPEAN OR AMERICAN COMICS DON'T? I don't know much about European and American comics. But I can say that I like manga's absorbing stories, vivid characters and exquisite tempos produced from frames and words.

745 HOW DO YOU MAKE YOUR DRAWINGS COME TO LIFE? I sculpt the hand parts with extreme care so that the character looks expressive.

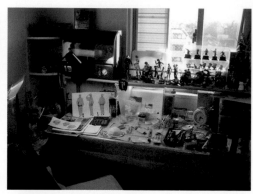
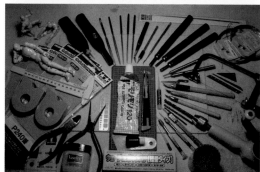

746 How important is promotion to you? How do you promote your work? It's very important. I started my career as an exhibitor at Wonder Festival. Now, it is my commercial figure products that promote my name most effectively.

747 Do you feel the need to better yourself when it comes to your work? To what extent? Yes, I do. To a great extent.

748 Manga: is it art? It's a very difficult question! Anyway, I think that manga should be always a pleasure close to us.

749 What is the most important lesson you have learned that you would like to pass on to others? Trial and error.

750 What is the greatest acknowledgement you could hope to achieve for your work? "This figure is true to the original character!" I hope to be a figure sculptor who can represent any world view.

Saki Asada

http://atf.cocolog-nifty.com

Saki Asada is a figure sculptor in Tokyo, born in Paris in 1976. She moved to Kyoto in 1982. She began exhibiting and selling figure kits at Wonder Festival (a bi-annual event of figures in Japan) in 2005. Since 2006, she's been a freelance figure sculptor, making models for Kotobukiya (an old manufacturer of figures and plastic models in Japan). Her first commercial work, the school uniform version of Shinji and Kaworu of *Neon Genesis Evangelion*, was noticed due to the rarity of handsome boy figures at the time. Her latest new releases are Hajime Saito and Toshizo Hijikata of *Hakuouki Shinsengumi Kitan* (1/10 scale, produced by Kotobukiya and distributed by Movic).

Sally Jane Thompson

www.sallyjanethompson.co.uk

Originally South African, Sally moved to England after several years in Canada and is now involved in the U.K. comics scene. Because of her love for all aspects of the medium, her projects are varied, including commissioned works, self-published projects, workshops, exhibitions and drawing events. Her style is quirky but gentle. She is inspired by comics, juxtapositions, art nouveau, too many books and movies to list, sketching and taking in the world around her, and all the little moments that give us pause because something important is happening underneath the apparently mundane.

751 WHERE DO THE IDEAS FOR YOUR DRAWINGS COME FROM? HOW DO YOU DO YOUR RESEARCH? All the things I see and experience in daily life get stirred together really. Sometimes two things will connect and the combination of those things becomes some new thing of its own to explore.

752 WHAT IS THE FIRST THING YOU DO BEFORE SITTING DOWN TO DRAW? A cup of tea or coffee helps get me going!

753 DO YOU ALWAYS USE THE SAME TOOLS OR DO YOU CHANGE DEPENDING ON THE PIECE YOU'RE WORKING ON? A lot of my work is blue pencil, then ink, then digital finishing, so it's important I vary that to avoid getting stale. Plus sometimes a different media is the right fit for the content of a piece.

754 WHAT DO YOU LIKE ABOUT MANGA? WHAT DOES MANGA HAVE THAT EUROPEAN OR AMERICAN COMICS DON'T? One of the things manga has influenced is the building of atmosphere and a sense of place, through both large environment shots and multiple small details.

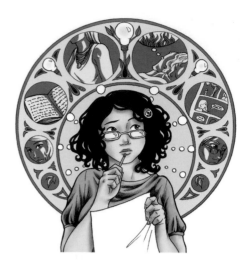

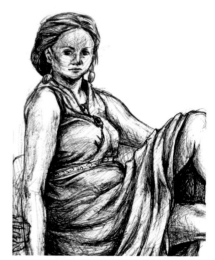

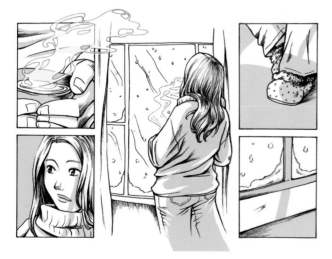

755 HOW DO YOU MAKE YOUR DRAWINGS COME TO LIFE? Life drawing practice helps an artist to draw loose, expressive and natural poses. I also feel more organic lines, not rulered or fixed width, can bring a lot of life to a work.

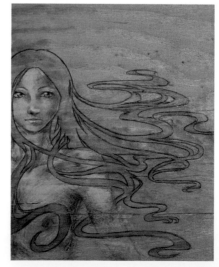

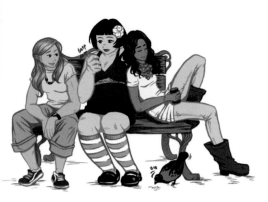

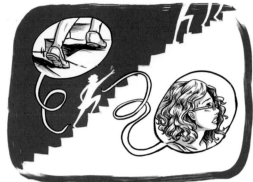

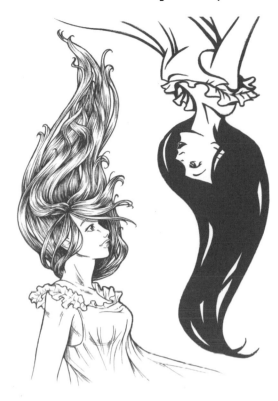

756 WHAT DIFFERENTIATES YOU FROM MANGA'S OTHER ILLUSTRATORS? I try to have a spark of reality that people can relate to. One example is drawing people in a variety of shapes and sizes, the beauty of the real rather than one fixed ideal.

757 DO YOU FEEL THE NEED TO BETTER YOURSELF WHEN IT COMES TO YOUR WORK? TO WHAT EXTENT? Surrounding myself with the work of accomplished artists gives me a real sense of urgency to improve. But I enjoy my achievements along the way as well; that helps avoid discouragement.

758 WHAT HAS CHANGED ABOUT YOUR STYLE OF DRAWING SINCE YOU BEGAN? I've found myself turning to simpler lines for greater expression, and being influenced by inky brushwork and the strong shapes of retro animation.

759 WHAT GOOD HABITS SHOULD A COMIC ILLUSTRATOR HAVE? As well as practicing drawing, they should also practice looking. Look at everything around you, what is it shaped like? How does it move? How is the light hitting it?

760 WHAT IS THE GREATEST ACKNOWLEDGEMENT YOU COULD HOPE TO ACHIEVE FOR YOUR WORK? When I think about the impact certain books had on me, treasured children's books, influential novels, inspiring comics, I think how amazing it would be if one of my books could be that to someone.

761 WHERE DO THE IDEAS FOR YOUR DRAWINGS COME FROM? HOW DO YOU DO YOUR RESEARCH? Many ideas come from mixing up some images from the past. For example, I draw an ancient castle with a touch of a gundam robot suit, give a poisonous taste to a girlish motif, or add a silly joke to a tender drawing. I adjust these combinations in accordance with how buoyant I feel.

762 WHAT IS THE FIRST THING YOU DO BEFORE SITTING DOWN TO DRAW? I start by having coffee and something sweet. I take a look at photos and pictures in magazines, illustrated reference books, and websites. Then, such images come to my mind and I usually think it would be fun to see the next development of the scene. Meanwhile, I begin to scribble images, and then I get focused on work.

763 DO YOU ALWAYS USE THE SAME TOOLS OR DO YOU CHANGE DEPENDING ON THE PIECE YOU'RE WORKING ON? When I draw an inorganic and mechanical line, I use Rotring. It can draw a uniform line. When I draw a hand-written taste of line, I use a brush pen. Then I scan the line drawing and paint it with Photoshop. If I want to draw an even more inorganic line, I trace a pencil-drawn draft with Illustrator (software).

764 DO YOU PREFER THE CLASSIC GUIDELINES FROM MANGA OR EXPERIMENTING WITH NEW CHANNELS? I am in love with so many manga, from the classic to the modern. However, when I create a drawing, I keep distant from my favorites. I would rather draw something interesting by using expressive approaches of morphology and syntax commonly used in manga.

765 HOW DO YOU MAKE YOUR DRAWINGS COME TO LIFE? Many of my drawings are static in terms of movement, and I would feel uncomfortable if my drawings came to life. I believe that a drawing attracts the attention of the reader and becomes a vivid work when it provokes disharmony as a combination of color, shape, material, time, situation and face expression.

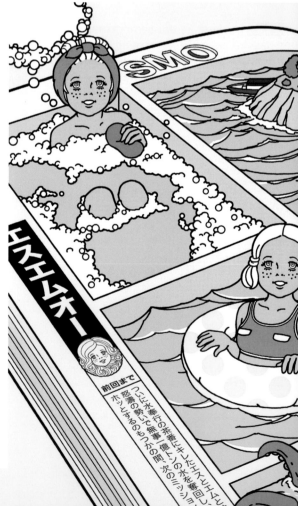

766 How important is promotion to you? How do you promote your work? Regardless of the type of media, it is important to create opportunities to get people to see my drawings. My original postcards of season's greetings or my direct mails created new opportunities, much more than I expected.

767 Do you feel the need to better yourself when it comes to your work? To what extent? It is always an issue for me to improve my skills, patience, efficiency, and speed to put ideas into drawing. Nowadays more and more people read manga through mobile phones, smartphones, and tablet computers, and I would like to create interesting works that incorporate animation, which cannot be realized though the paper medium.

768 Manga: is it art? What a great invention manga is! This is how I often feel about manga. Manga allows one to express the emotion of a character with the background motif or pattern, to deform the face of a character in a peculiar manner to show an exact emotion, to draw an impossible hairstyle, to characterize a high school delinquent boy fighting on a nationwide scale, and to illustrate a strong delinquent boy of two meters and a half (6½ feet) tall. When I see a manga illustrating any of the above that is when I feel manga is art.

769 What good habits should a comic illustrator have? Exploring places where I am a complete stranger is a great opportunity to get an unexpected inspiration. My mother used to collect books on gardening and plants. I took a look at the books for no reason and realized how fun the design of gardens is, how beautiful the shape and color of the plant is.

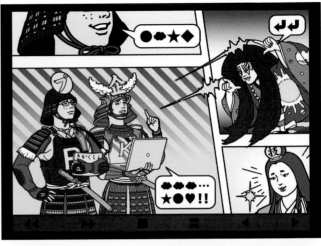

770 What is the greatest acknowledgement you could hope to achieve for your work? I am particularly delighted when a person feels happy about my work. I also would be absolutely happy if people in the future liked my works, because I value things that remain attractive over the lapse of time.

Sayuri Maeda (SMO)

www.smosmo.com

Sayuri Maeda was born in 1966. She earned a bachelor of art in industrial, interior and craft design from Musashino Art University, Tokyo. While at University, she started the Tokyo Kosaku Club, that lasted from 1986 to 2001. SMO is the solo project that illustrator Sayuri Maeda started in 2001. SMO stands for "Sayuri Maeda Office." Her activity ranges from covers to advertisements, books, magazines and websites. The style of her work is usually colorful with an inorganic touch. However, it sometimes expands to a broader variety of tastes.

Shoko Shimizu

www.geocities.jp/shoshoartist

Shoko Simizu was born in Japan, but lived in France for nine years (from 1988 to 1997). She studied painting with master painter Jean-Pierre Ceytaire, and worked on the collection *Zipang* by porcelaine company Porcelaine de Paris. In 1997, she returned to Japan, where she started to work as painter, illustrator and graphic designer. Her works have been used mainly in books and posters.

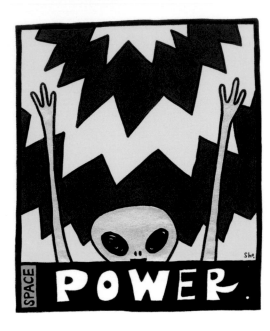

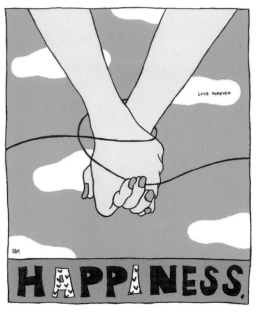

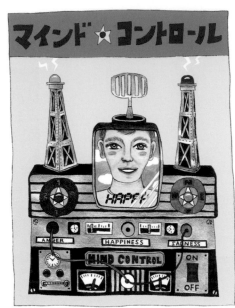

771 WHERE DO THE IDEAS FOR YOUR DRAWINGS COME FROM? HOW DO YOU DO YOUR RESEARCH? Prophets.

772 WHAT IS THE FIRST THING YOU DO BEFORE SITTING DOWN TO DRAW? Nothing. Just feel passion and happiness. What do you do?

773 WHAT ARE YOUR FAVOURITE TOOLS OR DRAWING PROGRAMS, AND WHY? My hands. Because God creates these perfect tools!

774 WHAT DO YOU LIKE ABOUT MANGA? WHAT DOES MANGA HAVE THAT EUROPEAN OR AMERICAN COMICS DON'T? Hokusai. If you look at *hokusai* manga, that is the answer.

775 HOW DO YOU MAKE YOUR DRAWINGS COME TO LIFE? Only God knows!

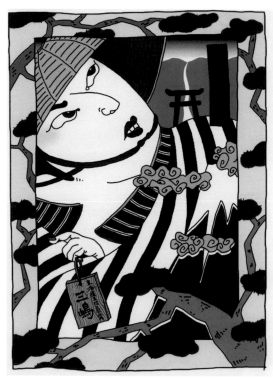

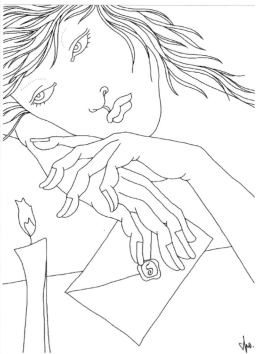

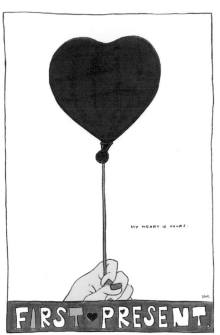

776 How important is promotion to you? How do you promote your work? It is not an artist's work. An artist floats in another world.

777 What has changed about your style of drawing since you began? Love.

778 Manga: is it art? If you think so...

779 What good habits should a comic illustrator have? Say "wow!" Be emotional!

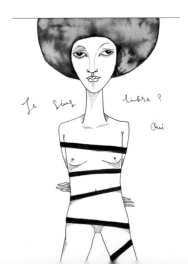

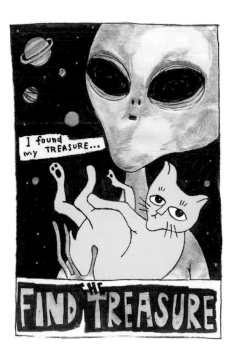

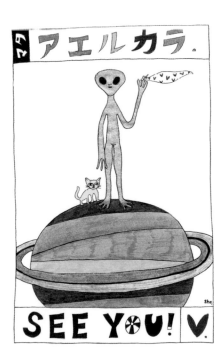

780 What makes a comic sell successfully? You know much better, don't you? See you!

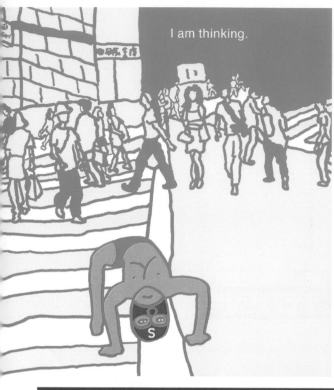

I am thinking.

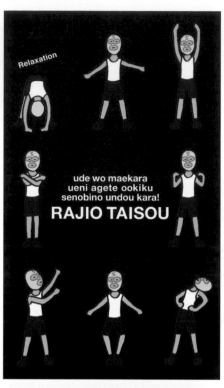

Relaxation

ude wo maekara
ueni agete ookiku
senobino undou kara!

RAJIO TAISOU

781 WHERE DO THE IDEAS FOR YOUR DRAWINGS COME FROM? HOW DO YOU DO YOUR RESEARCH? I stroll in the town. I take a train. I enjoy talking to my friends. I play with my daughter. My ideas come from my wonderful daily life.

782 WHAT IS THE FIRST THING YOU DO BEFORE SITTING DOWN TO DRAW? I first clear my head, and concentrate on drawing the picture. I try to relax my mind and body.

783 DO YOU ALWAYS USE THE SAME TOOLS OR DO YOU CHANGE DEPENDING ON THE PIECE YOU'RE WORKING ON? I prefer to use a felt-tipped marker, which is only one dollar. But sometimes I use a crayon. Because I can't control the crayon very much, there are so many interesting drawing lines that can appear.

784 DO YOU PREFER THE CLASSIC GUIDELINES FROM MANGA OR EXPERIMENTING WITH NEW CHANNELS? I always try to find new ways for manga. Manga is the present and the future.

785 WHAT DIFFERENTIATES YOU FROM MANGA'S OTHER ILLUSTRATORS? I believe that my illustrations have warmth, loveliness and a little bit of humour.

5 seconds 30 seconds 45 seconds 2 minutes

a TRAPEZE
tobe tobe tobunda!
maware maware mawarunda!
Soshite oreno motohi
egaode kurunda!

a circus
troupe

minna ni yume wo otodoke shimasu yo

Challenge

SHOUDAN
SHIYOU!
SOUSHIYOU!

Meishi koukan wa
Fukumen man no kihon desu.
※ Fukumen koukan wa shimasen.

786 HOW IMPORTANT IS PROMOTION TO YOU? HOW DO YOU PROMOTE YOUR WORK? I meet many people, show them my work and listen to their opinions and advice. Meeting many people gives you more chances to succeed. Because manga is part of my business, I work with many people.

787 WHAT HAS CHANGED ABOUT YOUR STYLE OF DRAWING SINCE YOU BEGAN? I use to draw for myself, but now I draw for myself and for the people who see my work. I want to make these people as happy as I can.

788 MANGA: IS IT ART? I think artists make the art that they want, then people who see the art sympathize with it. But manga needs more communication with the audience than art. Manga is very entertaining!

789 WHAT GOOD HABITS SHOULD A COMIC ILLUSTRATOR HAVE? I try to think that every day is new. I try to do new things.

790 WHAT MAKES A COMIC SELL SUCCESSFULLY? Do not give up the aggressive target. Work hard with the aggressive target. Have 100 dreams. Then, the road will open!

Like Ballroom Dancing

Success Story

Say hello to Mr. Big Boy!!
HIGH! He is only 171 centimeters.
But he can jump higher than whom!
How nice! How wonderful!

Shuhei Tabuchi

www.520gou.jp

Shuhei Tabuchi was born in Tokyo in 1975. He liked drawing and writing since childhood, but his qualifications in art class were very average. His only accolade was a writing contest' prize he got in first grade. The title of the writing was *My head is a shaven head*. After spending almost all of his time in high school playing baseball, he entered Colorado State University (USA). It was the time he started to grow his beard. Now, sixteen years later, he still loves beards. After coming back to Japan, he pursued a career as an illustrator. For a while, his earnings as an illustrator were not enough to make a living, so he got a part-time job cleaning up the building of a crammed school. He aspired to wipe the blackboard perfectly. He was also good at mopping. Then, gradually, he got more opportunities to work as an illustrator. Now he's doing illustrations for advertisement agencies, books, magazines and others. He will continue creating humorous illustrations and try to make people smile!

Sonia Leong

http://fyredrake.net

Sonia first rose to fame during the 2005 *Tokyopop Rising Stars of Manga* (UK & Ireland) competition. Since then her popular *Manga Shakespeare: Romeo and Juliet* (SelfMadeHero) has had numerous global editions. Her work appears in *DOMO: The Manga* (Tokyopop), *Comic Book Tattoo* (Image) and the *I, Hero* series (Hachettes). She's geekily proud of her art being part of the set of British TV sitcom, *The I.T. Crowd* (Channel 4). She's a member of Sweatdrop Studios. She also loves clothes.

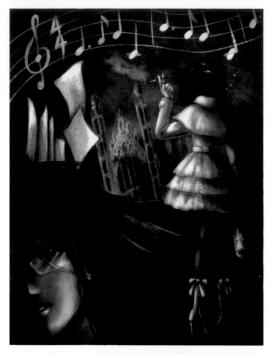

791 WHERE DO THE IDEAS FOR YOUR DRAWINGS COME FROM? HOW DO YOU DO YOUR RESEARCH? All music is programmatic to me, I see characters or scenery when I listen. I love gothic architecture and fashion. Being drunk helps me write too!

792 WHAT IS THE FIRST THING YOU DO BEFORE SITTING DOWN TO DRAW? I need a hot cup of tea, very strong with three sugars in the morning, decreasing to one sugar by night. Then I have to hold my breath, particularly when inking!

793 DO YOU ALWAYS USE THE SAME TOOLS OR DO YOU CHANGE DEPENDING ON THE PIECE YOU'RE WORKING ON? I always change! Partly from work, I had to be very flexible to get more commissions, so now I like changing my tools to get different looks to my work.

794 WHAT DO YOU LIKE ABOUT MANGA? WHAT DOES MANGA HAVE THAT EUROPEAN OR AMERICAN COMICS DON'T? My favorite manga has the perfect blend between realism and style, with more expression—it's so emotionally strong and so pretty at the same time!

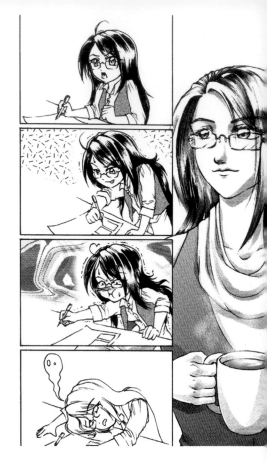

795 WHAT DIFFERENTIATES YOU FROM MANGA'S OTHER ILLUSTRATORS? Some people recognize my eyes and hair, some say it's my clean lines—they can't tell if it's by hand or computer traced.

SEXY MAN

SEXY MAN↑
+SPARKLE

796 HOW IMPORTANT IS PROMOTION TO YOU? HOW DO YOU PROMOTE YOUR WORK? I have a website, lots of online portfolios and I chat on forums. I also go to many events to socialize with fans and colleagues.

797 WHAT HAS CHANGED ABOUT YOUR STYLE OF DRAWING SINCE YOU BEGAN? My men are sexier. And I'm putting more sparkly details into my pics!

798 MANGA: IS IT ART? Most are commercial, so it's eye-candy: bright and frivolous. But some pieces speak to your soul. That is art, even if it wasn't meant to be.

799 WHAT IS THE MOST IMPORTANT LESSON YOU HAVE LEARNED THAT YOU WOULD LIKE TO PASS ON TO OTHERS? Never reason away your vision. For years, I thought I couldn't do this, I held myself back. When I started believing in myself, I became successful.

800 WHAT IS THE GREATEST ACKNOWLEDGEMENT YOU COULD HOPE TO ACHIEVE FOR YOUR WORK? A big animation deal for one of my comics! I'd love to see my original characters on the TV screens or lots of cosplayers and plushies at conventions.

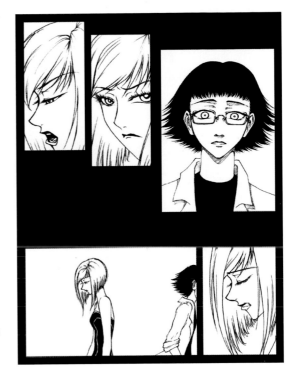

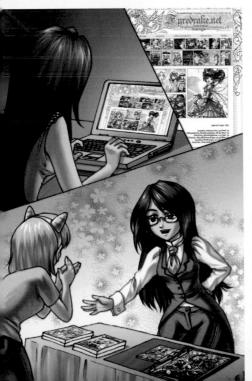

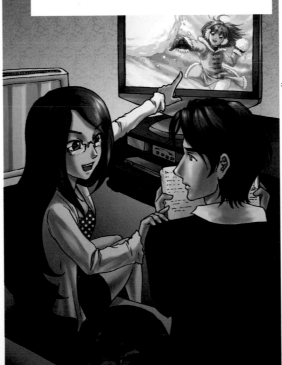

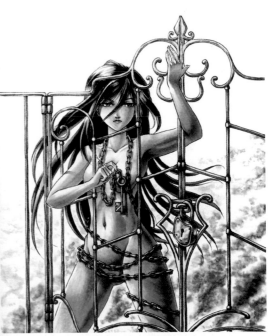

801 WHO ARE YOUR FAVORITE ILLUSTRATORS? ARE YOU TRYING TO FOLLOW IN THEIR FOOTSTEPS? Hmm, there are so many to name! Although I want to do my own thing, I suppose I follow them in some ways. Some of my all-time favorites include Akira Toriyama, Shinkiro, all of Capcom's art staff, and Rumiko Takahashi. I also admire many of the artists from Disney and Pixar, along with artists from older eras of American comic books, too.

802 WHAT IS THE FIRST THING YOU DO BEFORE SITTING DOWN TO DRAW? The first thing I do is run through a mental or literal checklist of tips I make for myself, such as "don't draw too quickly" or "concentrate on the shapes."

803 WHAT ARE YOUR FAVORITE TOOLS OR DRAWING PROGRAMS, AND WHY? I use a very large Wacom tablet because I like to make large, comfortable strokes when I draw. Although I love usual programs like Photoshop and Flash, my favorite is probably Paint Tool Sai. It features many of the most important elements from other illustration software and it captures your strokes much more gracefully.

804 WHAT DO YOU LIKE ABOUT MANGA? WHAT DOES MANGA HAVE THAT EUROPEAN OR AMERICAN COMICS DON'T? I like manga because there is a great deal of diversity in both visual style and narrative. There is something for everyone. Also, there seems to be a primary focus on interesting characters, which is really what matters in a story.

805 HOW DO YOU MAKE YOUR DRAWINGS COME TO LIFE? I focus on the character's personality or current emotion. I also try to capture a realistic, believable pose or very natural shapes.

806 WHAT ADVICE WOULD YOU GIVE TO A NOVICE ILLUSTRATOR TRYING TO MAKE A NAME FOR HIMSELF? Your primary focus should be getting better at creating art. If you continue to do this every day and display your work on the Internet and in galleries, you will begin to attract attention. Make lots of art and lots of friends! Then, you should start actively looking for job openings and take whatever you can, no matter how small. It will be very difficult to get by at times, but if you believe you've been given a gift then you should have faith in it! God would not have given you talent without the intention to let you use it.

807 WHY IS MANGA SO POPULAR IN THE WESTERN WORLD? Comics in the Western world started to stagnate as the entire industry became driven by superhero comics. All other genres began dwindling and eventually you could only find them "underground." The only variety was which type of superhero you liked. People noticed manga because it was so different, and exposed us to new ideas and stories.

808 WHAT IS THE MOST IMPORTANT LESSON YOU HAVE LEARNED THAT YOU WOULD LIKE TO PASS ON TO OTHERS? Beyond everything else, you can't just make art for yourself. There is nothing wrong with that, but you should try to enrich other peoples lives. You should try to give your audience something, even if it's just a little laugh.

809 WHAT GOOD HABITS SHOULD A COMIC ILLUSTRATOR HAVE? You should always be doing your best to understand what you're doing better. If you can learn to think critically about what you're doing and exactly what is happening as you create and display your art, then you can recognize mistakes and correct them.

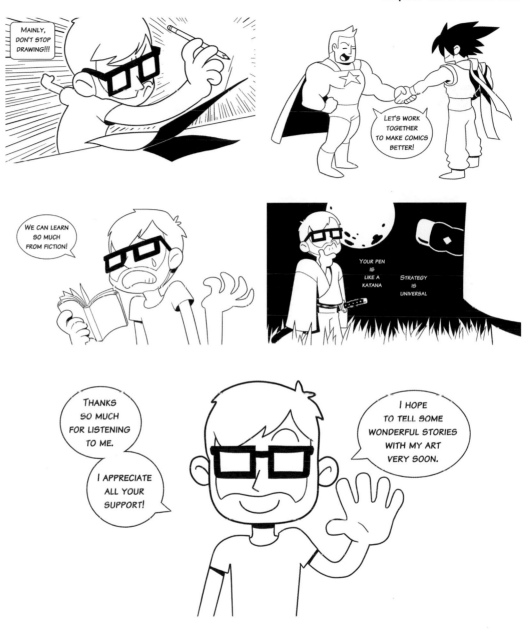

810 WHAT IS THE GREATEST ACKNOWLEDGEMENT YOU COULD HOPE TO ACHIEVE FOR YOUR WORK? There are certain stories that I've read growing up that mean a lot to me, even today. If I can give this experience to younger kids and then they grow up loving and remembering the characters and stories I told, then that would be the greatest compliment I could receive as far as being an artist goes. Also, as a Christian, it would be a major compliment to me to know that I have brought some of that to my audience.

Stephen 'Teben' Hetrick

www.theawesomeevery.com

Stephen was born in Pensacola, Florida. He began drawing at a very early age and his interest in art only grew as he got older. Always a fan of video games, comics, and films, he pursued work among these things from youth into adulthood. He began his professional career as a caricature artist at Bush Gardens in Tampa, and also as a storyboard artist on animated films, such as the *Angel Wars* DVD series. Afterwards he was employed by Gorilla Systems Corp. as a 2-D artist on a variety of video game projects. Since his time there, he has become a freelance artist, contributing his time to all manner of professional and personal projects, including comics, video games, and animation.

Steven Cummings (SC)

www.sc-shiki.com

Steven Cummings is a creator of manga and comic books. He got his start in the industry in 2002 doing some inventory book work for DC Comics. Since then he has moved on to work for Marvel Entertainment, Image/top Cow, Devil's Due, Kenzer and Co., Tokyopop, Humanoids and Udon Entertainment. Titles he has worked on include *Batman: Legends of the Dark Knight*, the *Deadshot* miniseries, *Wolverine: First Class, New Excalibur, Elektra, The Darkness, Street Fighter* from Udon, and the Humanoids Graphic Novel line *Les Armee Des Anges*. At Tokyopop he co-created the graphic novel series *Pantheon High* and also illustrated *CSI: the manga* for Tokyopop. On top of that he has drawn numerous covers and illustrations for too many people to remember.

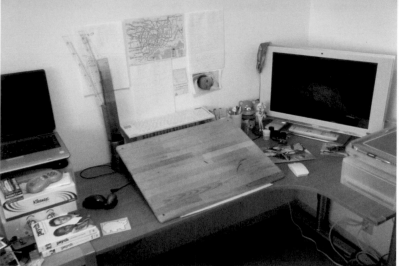

811 What does your work desk look like? What can we come across? My desk is a little crowded. Two computers and various art materials covered in paper and pencils, a phaser here or there.

812 Do you always use the same tools or do you change depending on the piece you're working on? I buy a lot of new art supplies to try out for different pieces/mediums but I always seem to end up using the same old pencils, pens, brushes, and toning knives.

813 What are your favorite tools or drawing programs, and why? I have this set of Staedler .3 and .5 mm mechanical pencils I have been using for the past decade. The grip near the tip of the pencil has been worn almost smooth in places I have used them so much. They are pretty nasty after all these years but I can't bring myself to replace them. They are kind of like a sixth finger at this point.

814 What do you like about Manga? What does Manga have that European or American comics don't? I like the range of manga. With American comics you are pretty much stuck with superheros or some variation on that theme, but with manga anything goes story wise. That variety makes for interesting stories.

815 How do you make your drawings come to life? I look to life to bring my drawing to life. There are a lot of good reference books I have picked up along the way to help me keep the art as natural as possible.

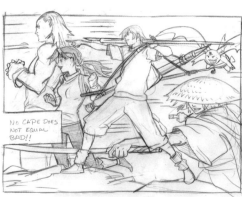

NO CAPE DOES NOT EQUAL BAD!!

816 How important is promotion to you? How do you promote your work? I usually let my publishers do the lion's work of promotion. As important as pushing my books is I would honestly rather just sit at home and draw, draw, draw!

817 What has changed about your style of drawing since you began? I used to overdraw everything. Lots of lines and more lines. I eventually learned to relax a little while drawing and now I keep it simple(r). I probably still have some work to do in this area

818 Why is Manga so popular in the Western world? Manga is popular in the West for the radically different way it expresses the world to the reader. Unlike American superhero comics where you have to be special in order to be the hero, manga deals with normal people doing normal things.

819 What is the most important lesson you have learned that you would like to pass on to others? I think the most important lesson I learned is that there is no "correct" way to do something in art. It is all about self-expression and that can be accomplished almost anyway with any tools on any medium.

820 What good habits should a comic illustrator have? The best habit for an illustrator to have is a set work schedule, starting the same time every day and not stopping until the particular piece you are working on is done.

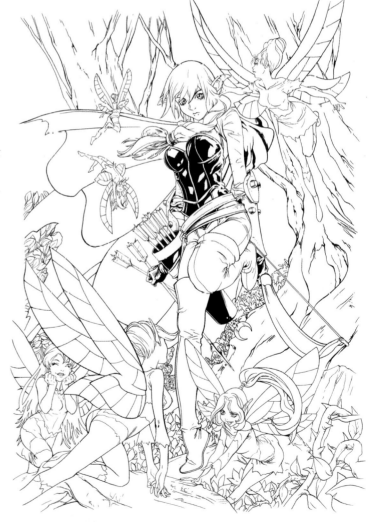

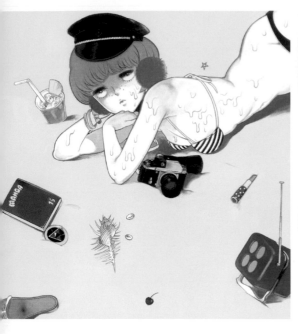

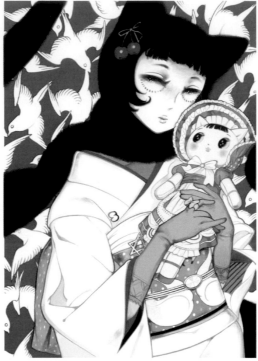

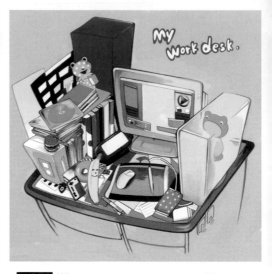

821 Where do the ideas for your drawings come from? How do you do your research? I think that there are ideas in daily life.

822 Who are your favorite illustrators? Are you trying to follow in their footsteps? Junichi Nakahara, Akira Uno, Suehiro Maruo and Henry J. Darger.

823 What does your work desk look like? What can we come across? PC, many books, data disk, a clock that looks like a frog, a toy... It overflows with lots of colors.

824 What is the first thing you do before sitting down to draw? I write a letter to the thing that I want to draw. I collect these documents.

825 Do you always use the same tools or do you change depending on the piece you're working on? No. A PC is my main tool for both color and monochrome works.

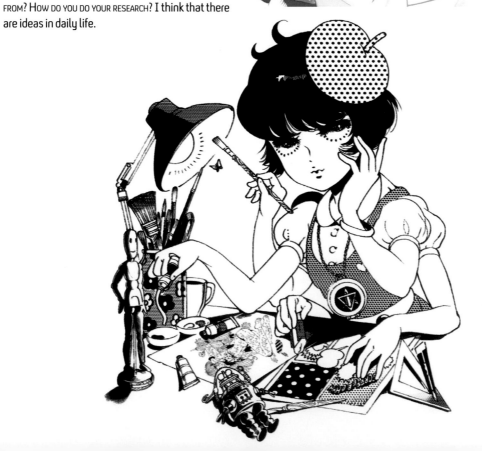

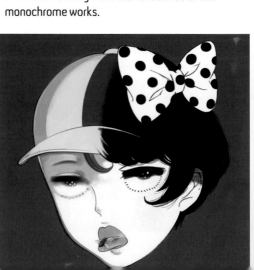

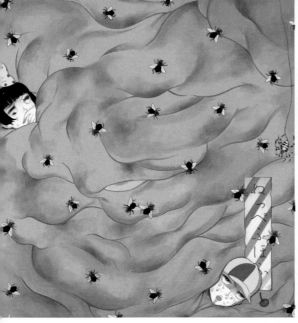

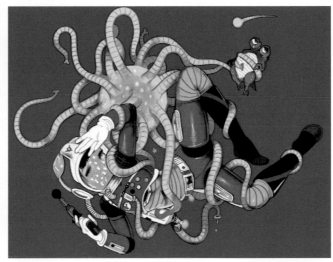

 826 WHAT ARE YOUR FAVORITE TOOLS OR DRAWING PROGRAMS, AND WHY? Painter 6. It allows you to express an interesting feel of materials.

 827 WHAT DIFFERENTIATES YOU FROM MANGA'S OTHER ILLUSTRATORS? Nothing.

 828 WHAT ADVICE WOULD YOU GIVE TO A NOVICE ILLUSTRATOR TRYING TO MAKE A NAME FOR HIMSELF? Even if you run into pains and difficulties, please do not give up.

 829 WHAT HAS CHANGED ABOUT YOUR STYLE OF DRAWING SINCE YOU BEGAN? I have changed a lot.

830 MANGA: IS IT ART? I think manga is more immediate than art.

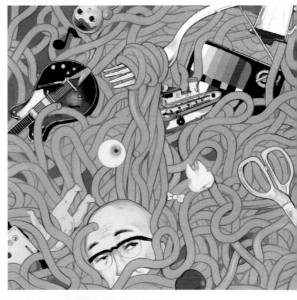

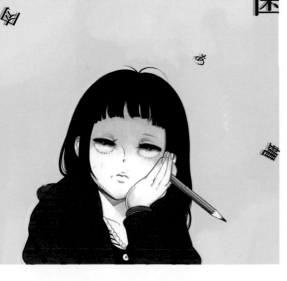

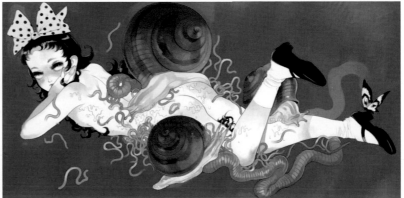

Syujyutu Karasuba

http://killer.versus.jp

Syujyutu Karasuba is a well-known Japanese illustrator, and a regular in various magazines and manga publications in his home country, such as *Cobalt*, for instance, a bimonthly published by Shueisha, which specializes in serializing stories for teenage girls in a lighthearted tone. Or the magazine *SS*, specializing in manga illustrations, to which Syujyutu contributes on a regular basis.

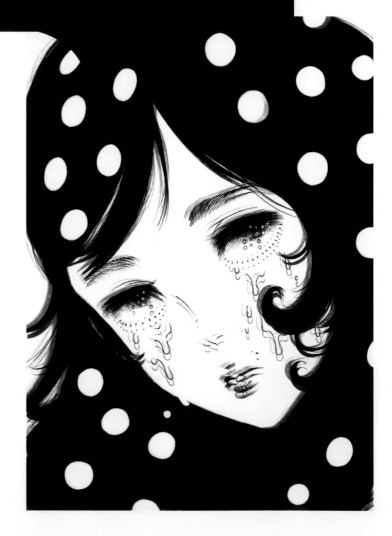

T. Birdman

http://magatu.karakasa.com

T. Birdman was born in 1988. He always uses a mechanical pencil, and draws Birdman's miniatures with it. The birds are a symbol, his ideal. Ideal face and ideal body. Birdman is he.

Project Birdman will continue until T. Birdman becomes a perfect birdman.

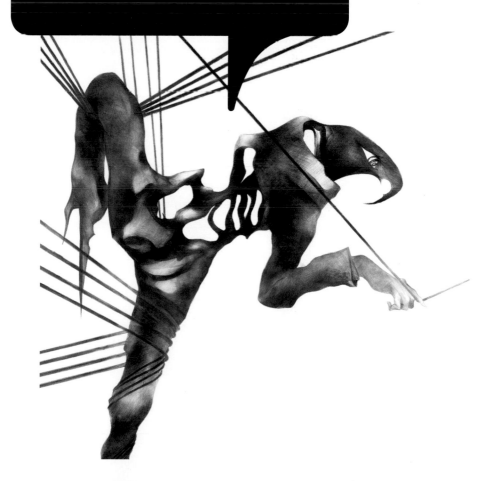

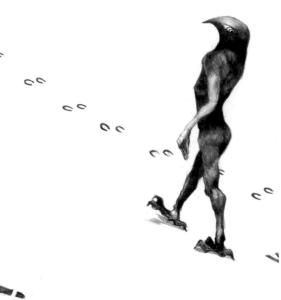

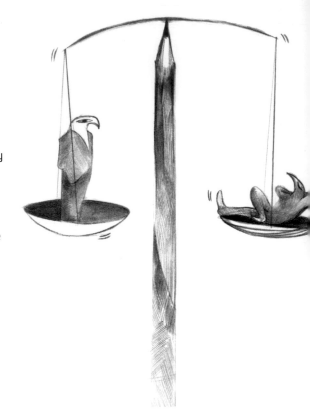

831 WHO ARE YOUR FAVORITE ILLUSTRATORS? ARE YOU TRYING TO FOLLOW IN THEIR FOOTSTEPS? I have many illustrators I like, but I don't think I follow them.

832 WHAT IS THE FIRST THING YOU DO BEFORE SITTING DOWN TO DRAW? First, I make tea with my Japanese yunomi. (Yunomi is a cup for Japanese tea.)

833 DO YOU ALWAYS USE THE SAME TOOLS OR DO YOU CHANGE DEPENDING ON THE PIECE YOU'RE WORKING ON? I always use my mechanical pencil.

834 DO YOU PREFER THE CLASSIC GUIDELINES FROM MANGA OR EXPERIMENTING WITH NEW CHANNELS? I like both. But I dislike noncommittal and commonplace works.

835 HOW DO YOU MAKE YOUR DRAWINGS COME TO LIFE? I shape my ideas by drawings. So, drawings are my way of communication.

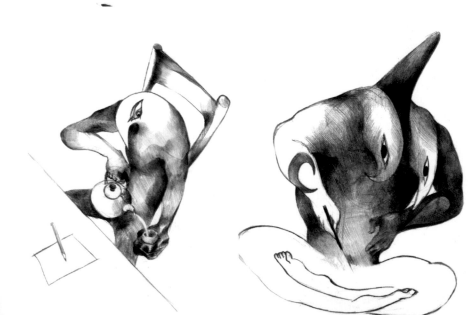

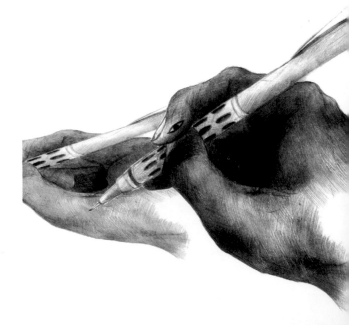

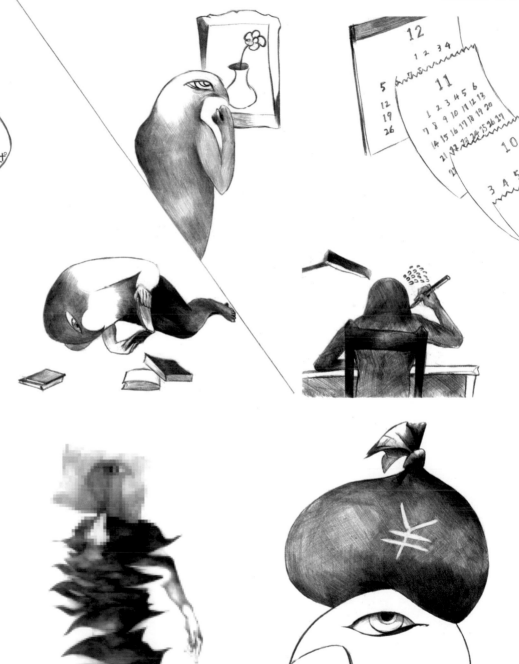

私の名前は
ゅげむじゅげむごこうのす
りきれかいじゃりすいぎょのす
いぎょうまつうんらいまつふうら
まつくうねるところにすむところや
ぶらこうじのぶらこうじぱいぽ
ぽぱいぽのしゅーりんがん
がんのぐーりんだい

836 WHAT ADVICE WOULD YOU GIVE TO A NOVICE ILLUSTRATOR TRYING TO MAKE A NAME FOR HIMSELF? Having a simple and easy to remember name is good. It helps you when people talk about you and your works.

837 DO YOU FEEL THE NEED TO BETTER YOURSELF WHEN IT COMES TO YOUR WORK? TO WHAT EXTENT? I want to draw more delicate works.

838 MANGA: IS IT ART? Manga is manga. We don't need to compare manga to art.

839 WHAT IS THE MOST IMPORTANT LESSON YOU HAVE LEARNED THAT YOU WOULD LIKE TO PASS ON TO OTHERS? The most important thing is constancy.

840 WHAT IS THE GREATEST ACKNOWLEDGEMENT YOU COULD HOPE TO ACHIEVE FOR YOUR WORK? I want to earn a living with my drawing.

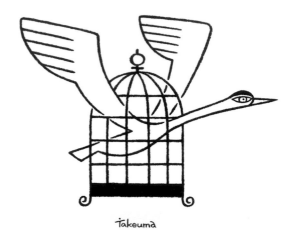

Takeuma

Takeuma

841 Where do the ideas for your drawings come from? How do you do your research? Internet, zoo, cafe, and so on. To start drawing anyway is the most important.

842 What is the first thing you do before sitting down to draw? I drink hot coffee.

843 What are your favorite tools or drawing programs, and why? HB Pencils and a sketchbook.

844 What do you like about Manga? What does Manga have that European or American comics don't? A lovable finisher, like ka-me-ha-me-ha!

845 How do you make your drawings come to life? With my passion for surprising people.

Takeuma

Takeuma

Takeuma

846 HOW IMPORTANT IS PROMOTION TO YOU? HOW DO YOU PROMOTE YOUR WORK? I keep on drawing.

847 WHAT HAS CHANGED ABOUT YOUR STYLE OF DRAWING SINCE YOU BEGAN? My drawings got much simpler.

848 WHY IS MANGA SO POPULAR IN THE WESTERN WORLD? Because it is enjoyable.

849 WHAT GOOD HABITS SHOULD A COMIC ILLUSTRATOR HAVE? To experience various things.

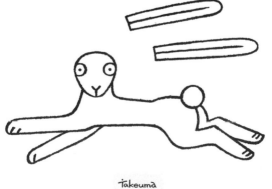

850 WHAT IS THE GREATEST ACKNOWLEDGEMENT YOU COULD HOPE TO ACHIEVE FOR YOUR WORK? To astonish other Illustrators.

Takeuma
www.k5.dion.ne.jp/˜s-tkm231

Takeuma, who now lives in Kyoto, was born in Osaka, Japan, in 1981. In 2004, he graduated from the Faculty of Industrial Art and Textile, at Kyoto University.

Takeuma works primarily in the publishing industry, illustrating books, and for other companies in the same sector, such as newspapers and magazines. His artistic

style, which is very simple and somewhat minimalist, with clean, precise lines, has made him one of the best-known illustrators in Japan.

Taruto Aoyama

www.aoyamataruto.com

Illustrator and designer Taruto Aoyama was born in the Yamagata prefecture of Japan. Her work, which has been described as dynamic and spacious, is characterized by sharp lines and a sense of energy. Her artwork has appeared in advertisements, magazines, and books, and has been featured on limited-edition products.

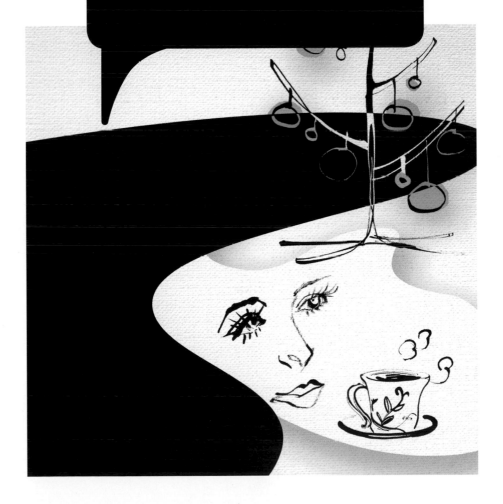

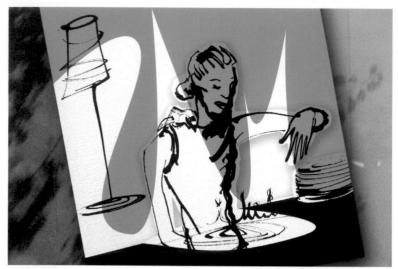

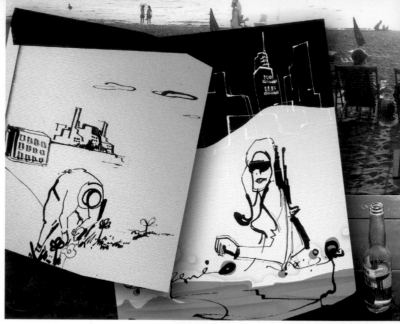

852 WHO ARE YOUR FAVORITE ILLUSTRATORS? ARE YOU TRYING TO FOLLOW IN THEIR FOOTSTEPS? Tadanori Yokoo.

853 WHAT IS THE FIRST THING YOU DO BEFORE SITTING DOWN TO DRAW? I read as many applicable materials and get as many ideas as I can. Then I write down my ideas and put them aside. I want to re-set my mind before I start drawing, similar to a computer re-boot.

854 WHAT ARE YOUR FAVORITE TOOLS OR DRAWING PROGRAMS, AND WHY? I like to use a natural reed pen and *sumi* (Japanese ink) and a personal computer.

855 WHAT DO YOU LIKE ABOUT MANGA? WHAT DOES MANGA HAVE THAT EUROPEAN OR AMERICAN COMICS DON'T? We can read manga anywhere and it takes me everywhere. It is a visual novel. Manga is not only for entertainment, but also it creates a new world for me. It takes me beyond this reality plane.

851 WHERE DO THE IDEAS FOR YOUR DRAWINGS COME FROM? HOW DO YOU DO YOUR RESEARCH? Walking around Tokyo inspires me a lot.

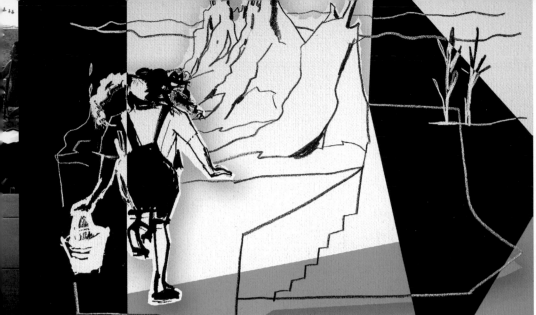

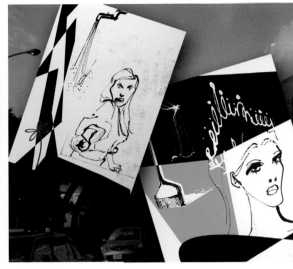

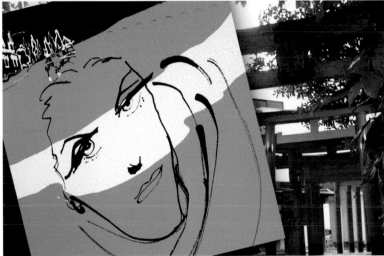

856 WHAT HAS CHANGED ABOUT YOUR STYLE OF DRAWING SINCE YOU BEGAN? I draw more abstractly now.

857 MANGA: IS IT ART? Absolutely!

858 WHY IS MANGA SO POPULAR IN THE WESTERN WORLD? Manga's visual nature impacts your imagination.

859 WHAT IS THE MOST IMPORTANT LESSON YOU HAVE LEARNED THAT YOU WOULD LIKE TO PASS ON TO OTHERS? Listen to your voice.

860 WHAT GOOD HABITS SHOULD A COMIC ILLUSTRATOR HAVE? An illustrator should have curiosity about everything. Don't sit at a desk all the time, go out! Don't go out all the time, sit at a desk!

861 WHERE DO THE IDEAS FOR YOUR DRAWINGS COME FROM? HOW DO YOU DO YOUR RESEARCH? They all come from my own life, so I keep focused on the environment that I feel most comfortable in. What/how I felt through experiences in everyday life turns out to be the best material for my drawings.

862 WHAT IS THE FIRST THING YOU DO BEFORE SITTING DOWN TO DRAW? Let things settle down over some coffee, tea, and something to nibble on, which results in a pile of cups and dishes on the desk once I've started.

863 DO YOU ALWAYS USE THE SAME TOOLS OR DO YOU CHANGE DEPENDING ON THE PIECE YOU'RE WORKING ON? Mainly acrylic paints but occasionally color inks and color pencils, too. It depends on what works and the clients require.

864 DO YOU PREFER THE CLASSIC GUIDELINES FROM MANGA OR EXPERIMENTING WITH NEW CHANNELS? Classic guidelines from the aspect of drawing. I also find later works quite interesting because they deal with wider range of themes than the old ones.

865 HOW DO YOU MAKE YOUR DRAWINGS COME TO LIFE? I keep drawing until I get confident. This apparently makes it a lot easier for the audience to feel my drawings come to life. But it often happens that I see people show interest in the ones that are NOT exactly my favorite, or vice versa as well...

Output

866 HOW IMPORTANT IS PROMOTION TO YOU? HOW DO YOU PROMOTE YOUR WORK? Very important. But above that, drawing to inspire people is crucial. Laying too much emphasis on selling would just not bear fruit. I often approach potential business partners (because that way they're likely to have an interest in my drawings as well).

867 DO YOU FEEL THE NEED TO BETTER YOURSELF WHEN IT COMES TO YOUR WORK? TO WHAT EXTENT? Yes. I would like to work on more than the drawings ordered (from my client) so that it reinforces my expression skills through drawings. I'd like to use methods that take more time that I cannot use because of the limited period of time.

868 MANGA: IS IT ART? No. Japanese mangas are just like some ready-made meals in the supermarket. They present you with the benefit of low price, convenience, or sometimes an amazing encounter that perfectly fits your taste—finding a jackpot manga is all the same!

869 WHAT GOOD HABITS SHOULD A COMIC ILLUSTRATOR HAVE? Get in touch with all sorts of creators: designers, photographers, musicians, or publication editors, because they have as much to share and to inspire among each other as drawing artists do.

870 WHAT MAKES A COMIC SELL SUCCESSFULLY? Drawing with full passion and imagination.

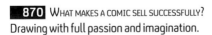

Tent

http://tent.typepad.jp

Tent is an illustrator living in Tokyo, who was born in 1983. After graduating from the Graphic Design Department of the Tama Art University in 2006, she started to work in an advertising company for a year. In 2007, she left the company and started a career as an illustrator. She names herself Tent because of the Asagiri Jam Festival in 2006. In her own words: "When I was there, I was so moved by so many people coming and enjoying vacations with their tents. I thought these happy feelings were what I wanted to incorporate in my illustrations."

Tsubasa

www7a.biglobe.ne.jp/~angeldance

Tsubasa was born in 1981 in an unspecified Japanese city. She spent her childhood surrounded by all sorts of drawing and painting tools and graduated with a degree in archeology at the University of Shimane (Japan). Despite the lack of any formal training in art, Tsubasa has become a professional cartoonist and illustrator. Her specialty is manga, but she also feels at home with illustration and video games. Since 2004, she has been running her own website, where most of her cartoons and illustrations can be found. Tsubasa is currently studying pastel drawing with a professional artist.

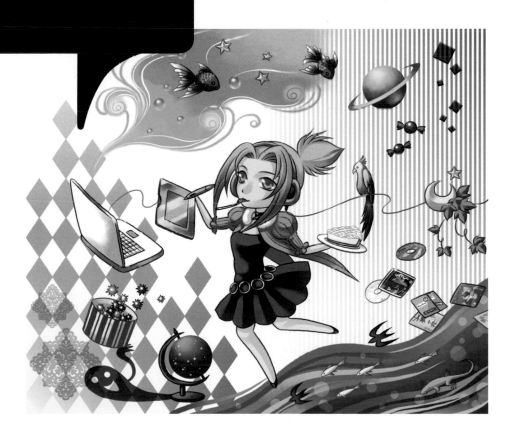

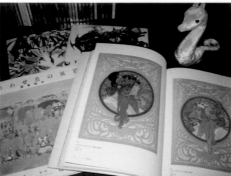

871 WHERE DO THE IDEAS FOR YOUR DRAWINGS COME FROM? HOW DO YOU DO YOUR RESEARCH? The ideas spring from everywere. Listening music, looking up in the sky... I can create a picture from just one word or from a light color casually seen. I don't do anything special, but I would like to cherish every day.

872 WHO ARE YOUR FAVORITE ILLUSTRATORS? ARE YOU TRYING TO FOLLOW IN THEIR FOOTSTEPS? I like the all illustrators who do good work. I'm especially jealous of the ones who have skills that I don't have. I would like to learn their skills and have my own style at the same time. It's hard.

873 WHAT DOES YOUR WORK DESK LOOK LIKE? WHAT CAN WE COME ACROSS? I have a bad habit of piling everything on the desk, so my desk is a mess. PC, books, CDs, letters, the plaster mold of my teeth... If you excavate my desk, you might find something unexpected.

874 WHAT IS THE FIRST THING YOU DO BEFORE SITTING DOWN TO DRAW? I determine 80 percent of the composition and the color scheme in my head, raise my spirits, put my favorite music on and prepare my pencil and papers.

875 DO YOU ALWAYS USE THE SAME TOOLS OR DO YOU CHANGE DEPENDING ON THE PIECE YOU'RE WORKING ON? The best way to express what I want is to do it differently. I always use two pieces of software for painting, but I make different use of them every time.

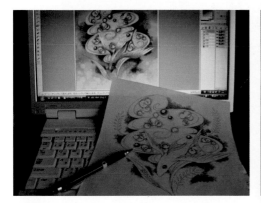

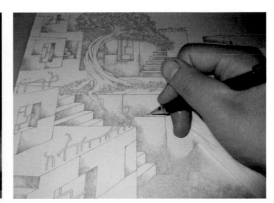

876 WHAT ARE YOUR FAVORITE TOOLS OR DRAWING PROGRAMS, AND WHY? I draw with pencil and paper and paint with photo retouching software. The pencil is the best tool for me to draw fine lines for now. The good thing about software is that it's easy to retouch pictures with it.

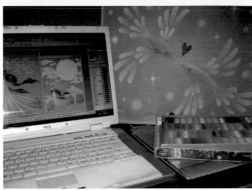

877 WHAT DO YOU LIKE ABOUT MANGA? WHAT DOES MANGA HAVE THAT EUROPEAN OR AMERICAN COMICS DON'T? Manga's possibilities are endless.

878 HOW DO YOU MAKE YOUR DRAWINGS COME TO LIFE? First and foremost, you should love your pictures and paintings with a strong passion. If you lose interest in your drawing, the pictures will die.

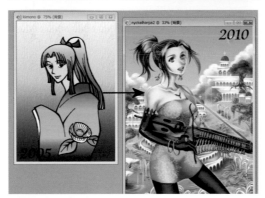

879 WHAT DIFFERENTIATES YOU FROM MANGA'S OTHER ILLUSTRATORS? Sorry, I don't know. I still have not been able to establish my own style. My illustrations will change from now on.

880 WHAT HAS CHANGED ABOUT YOUR STYLE OF DRAWING SINCE YOU BEGAN? What I want to draw is becoming wider. I used to picture only characters, but now I like to paint backgrounds, and sometimes I paint landscape paintings.

881 WHERE DO THE IDEAS FOR YOUR DRAWINGS COME FROM? HOW DO YOU DO YOUR RESEARCH? I never come up with a good idea while in my workspace. I go for a walk, play games, drink sake with my friends... An interesting idea always comes from a place least likely expected.

882 WHAT IS THE FIRST THING YOU DO BEFORE SITTING DOWN TO DRAW? I focus and imagine what I want to draw first. I don't go back to my desk unless I come up with a good image of the idea. Once I start, my hands know what to do, so I finish fairly quickly.

883 WHAT ARE YOUR FAVORITE TOOLS OR DRAWING PROGRAMS, AND WHY? I don't have any specific tools that I use. Usually, I use a regular pencil that you can get anywhere or just a pen. For coloring, I use the Mac. Recently, everyone has been using the computer, so digital illustrations and designs have become very common. If I use the computer to make everything, then it feels too digital. So I sketch everything out on paper first.

884 DO YOU PREFER THE CLASSIC GUIDELINES FROM MANGA OR EXPERIMENTING WITH NEW CHANNELS? Basic guidelines are very important, but manga can also have an experimental direction, which is a good thing. It's not always a good thing to stick to the rules, but rather go beyond that and experiment. Maybe mix up a photo and an illustration to get some interesting results.

885 HOW DO YOU MAKE YOUR DRAWINGS COME TO LIFE? With the right image in my head, I draw a number of rough sketches. Doing a lot of sketches, the right image appears.

886 HOW IMPORTANT IS PROMOTION TO YOU? HOW DO YOU PROMOTE YOUR WORK? Lately, we've been trying to expand worldwide. With each art piece we focus on quality, and being the only ones with that kind of quality is the most important to us. This way, our art can be potent knowing there's nobody else to copy our style.

887 DO YOU FEEL THE NEED TO BETTER YOURSELF WHEN IT COMES TO YOUR WORK? TO WHAT EXTENT? I would like to improve my ability to bring ideas to life as close as possible to the original vision. Having a fixed concept of what to always draw can prevent one's growth as an artist. Utilizing all types of mediums to express your art is very valuable.

888 MANGA: IS IT ART? I absolutely agree that manga is art. Back in the day, manga wasn't considered a type of art accepted by the culture. In Japan, *ukiyo-e* artist's during the Edo era drew portraits of the kabuki actors the same way that the today's manga artist draw. But if you go to an art gallery today, that same art from the Edo period is on display.

889 WHAT IS THE MOST IMPORTANT LESSON YOU HAVE LEARNED THAT YOU WOULD LIKE TO PASS ON TO OTHERS? I think it's very easy to make people feel unpleasant using art. It's very challenging to put a smile on someone's face or to touch his heart instead. In order to do that it's important to have humor. The happy childhood memories, of when I watched anime or read manga, in many cases affect my creativity to this day. Ultimately, having a good time with friends and laughing is the most important thing.

890 WHAT IS THE GREATEST ACKNOWLEDGEMENT YOU COULD HOPE TO ACHIEVE FOR YOUR WORK? This is what I chose to do. I want to keep enjoying what I do and never give up. With a goal in mind and my passion, a new opportunity is sure to come.

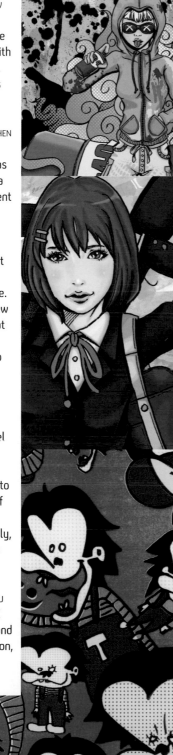

Tsukasa Tomoyose (Atoron)

www.atoron.com

Tsukasa Tomoyose along with Keiko Enobi make up Atoron. Their work has appeared in CD jackets, posters and other pop culture media. It ranges and takes inspiration from a wide variety of sources, from manga to "cute" illustration, from avant garde illustration to the latest's trends in graphic design.

Viviane

www.viviane.ch

Drawing has been the greatest passion of Viviane from the very beginning. When she was thirteen years old, she became acquainted with manga and anime and got addicted to it. She still is. She knew that drawing manga was her calling.

Today, her dream has come true by releasing her first manga, called *Gott Gauss*, which can be read online for free. Bruno Cotting, who Viviane considers "a gorgeous writer," wrote the story. Viviane never dares to write a story by herself because she thinks it's not her talent. In her own words: "Sometimes it's better to focus on your own skills instead of dissipate one's energies in too many different tasks and not doing such a good job at all".

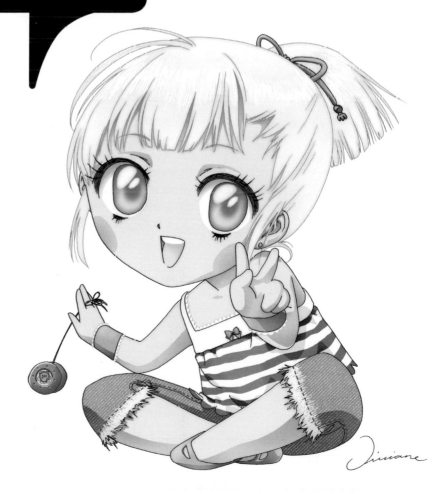

891 WHO ARE YOUR FAVORITE ILLUSTRATORS? ARE YOU TRYING TO FOLLOW IN THEIR FOOTSTEPS? There are so many wonderful manga artists out there! Besides the mangakas, directors like Steven Spielberg, Tim Burton, Jean-Pierre Jeunet or Stanley Kubrick are my great role models, due to the fact that the director's job has so many similarities with a mangaka to me.

892 WHAT IS THE FIRST THING YOU DO BEFORE SITTING DOWN TO DRAW? To hope for a good mood and a clear mind so that the drawings turn out the way I want them.^^;;

893 DO YOU ALWAYS USE THE SAME TOOLS OR DO YOU CHANGE DEPENDING ON THE PIECE YOU'RE WORKING ON? I change my tools often. It depends on what ambience the illustration is supposed to radiate.

894 DO YOU PREFER THE CLASSIC GUIDELINES FROM MANGA OR EXPERIMENTING WITH NEW CHANNELS? I love the way the original mangas look from Japan. I don't like influences from other comic styles, but that's just my personal preference.^^

895 WHAT DO YOU LIKE ABOUT MANGA? WHAT DOES MANGA HAVE THAT EUROPEAN OR AMERICAN COMICS DON'T? It's the dynamic and intriguing way of narration that grips my mind! The Japanese sense of aesthetics also coincides more with my own, so I just fell in love with the way they draw the faces and their art and design.

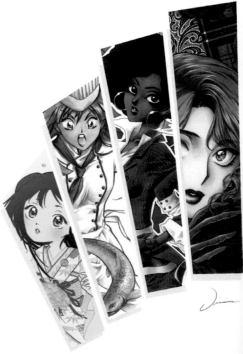

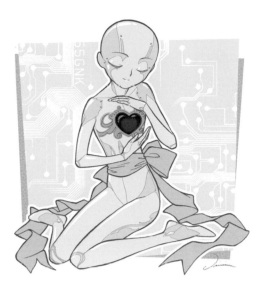

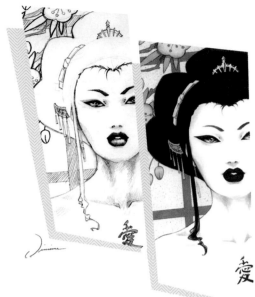

897 WHAT ADVICE WOULD YOU GIVE TO A NOVICE ILLUSTRATOR TRYING TO MAKE A NAME FOR HIMSELF? To invest a lot of time and hard work in the illustrations. Even if painting techniques and proportions are not perfect, people will sense if there has been much effort put into a drawing or if it was worked out too quickly and sloppy.

898 DO YOU FEEL THE NEED TO BETTER YOURSELF WHEN IT COMES TO YOUR WORK? TO WHAT EXTENT? I badly wish I could draw better than I do now. I'm not content with my backgrounds, positioning of light and shadow and body shapes in unusual postures or angles of view. They should look more realistic.

899 MANGA: IS IT ART? Of course it is. It creates emotions to the beholder and enables them to escape from their everyday life to a magic place. This is the case for any work in which you try to achive aesthetics and perfection.

896 HOW DO YOU MAKE YOUR DRAWINGS COME TO LIFE? The facial expression is very important. I always try to feel what mood the character is in his or her situation and then to bring it to his face. To get this feeling across even more, I also consider what pose and background enhances it.

900 WHAT GOOD HABITS SHOULD A COMIC ILLUSTRATOR HAVE? Not to fly into rage because someone used your illustration on her or his website without permission and instead figure out if this person really did you any harm and instead see it as a sort of compliment. ^_^

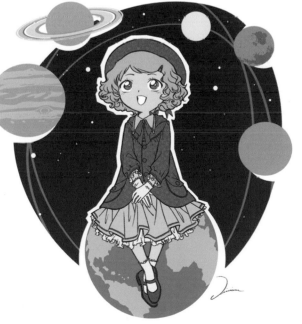

901 WHERE DO THE IDEAS FOR YOUR DRAWINGS COME FROM? HOW DO YOU DO YOUR RESEARCH? I normally work with writers, so they give me the first ideas of drawings by describing the characters in words. Then I will just draw whatever comes out from my head. If the characters need a particular outfit to fit in the story, I just google it.

902 WHO ARE YOUR FAVORITE ILLUSTRATORS? ARE YOU TRYING TO FOLLOW IN THEIR FOOTSTEPS? I like a lot of illustrators. Favorite... Hmmm... At the moment, probably Mucha and Okama. And no, I don't think I want to follow anyone's footsteps. I only try to learn some bits from their drawings, or see if I can make new things fit in my current style. This picture is me trying to get the Mucha style (right).

903 WHAT DOES YOUR WORK DESK LOOK LIKE? WHAT CAN WE COME ACROSS? I work pretty much only digitally. So my work desk doesn't have any pens or paper. The most important parts of course are the computer and Wacom tablet. I have several external hard-drives around to constantly backup my work on. Because I only work digitally, there's always a danger of getting a virus or computer failure. Then there are my cigarettes and ashtray (bad habit) and always a coffee there to keep me awake!

904 WHAT IS THE FIRST THING YOU DO BEFORE SITTING DOWN TO DRAW? Normally I drink a coffee or diet soda. I need them in the morning; otherwise I will be restless when sitting down.

905 WHAT ARE YOUR FAVORITE TOOLS OR DRAWING PROGRAMS, AND WHY? I use Manga Studio EX4 for line art and Photoshop CS2 for coloring. Manga Studio is excellent for lines because it's all bitmap, which means when it goes to print, the lines are crisp and clean. It feels and looks just like drawing on paper. I use Photoshop for colors after exporting the files from Manga Studio.

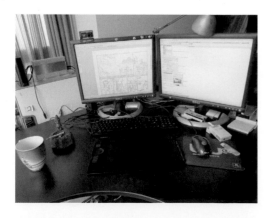

906 WHAT DO YOU LIKE ABOUT MANGA? WHAT DOES MANGA HAVE THAT EUROPEAN OR AMERICAN COMICS DON'T? Personally, I love it because it's easy to read. The most visible thing is the cute characters! And a lot of manga books are stories that typical Western comics don't do, such as very girly stuff. And the story-telling is different too. I always think if western comic were a typical 90 minute movie, manga would be more like a TV series.

907 HOW DO YOU MAKE YOUR DRAWINGS COME TO LIFE? Facial expression is the key. From the expressions, readers can feel the characters. I always find myself doing the same expression as the character while I am drawing it. And of course, the pose, the surroundings, the story telling etc. are very important too!

908 WHAT DIFFERENTIATES YOU FROM MANGA'S OTHER ILLUSTRATORS? I think everyone has their own style. My style, according to other people, is a combination of Japanese, Chinese and Western style.

909 HOW IMPORTANT IS PROMOTION TO YOU? HOW DO YOU PROMOTE YOUR WORK? I am a little bit lazy about promotions actually, although I do know it's really important. Most of the time, I will just attend conventions. There I can meet up my fellow comic friends and do a bit of promotion for my work.

910 MANGA: IS IT ART? Sure! In my eyes, there is more art in manga than some modern art! I always think art should have the "wow" factor, which normal people can understand and appreciate, and it should require some skills.

Yishan Li
www.liyishan.com

Yishan Li (born 1981) is a professional manga creator. Recently she just moved from Edimburgh to Shanghai. Her main published works include *Spirit Marked* (Yaoi Press, 2005), *Aluria Chronicles* (Yaoi Press, 2006), *Contes du Boudoir Hante vol.1–3* (Delcourt, France, 2008–2010), *CutieB* *vol.1–2* (Dargaud, France, 2008–2009), 500 Manga Creatures (HarperCollins, 2008), Manga females clip art (Andrews McMeel Publishing, 2009), Shoujo/ Shounen art studio (Random House, 2009) and The Clique (Yen Press, 2010). She was also the artist for the monthly manga series The Adventures of CG in the popular American teen magazine CosmoGirl. This year, she will have some new books out in the U.S., including a new graphic novel written by the *New York Times* best-selling author Naomi Novik called Will Supervillains be on the Final? (Del Rey).

Yiso

www.gitulgaje.com

Yiso majored in interior design. After graduation, she won a prize in a contest for *Issue* magazine. Her works were first published in a local magazine by KT. She wrote a comic book called *Remember?* in 2004, and also wrote an illustration book called *Gitulgaje* in 2005. She's drawn many pictures and covers for novels, and also drew pictures for children's books and comics. Now she's preparing for another comic book. Her hobby is traveling, and she likes taking pictures while doing so.

911 Where do the ideas for your drawings come from? How do you do your research? Mostly from my own ideas, my dreams, my daily life.

912 What does your work desk look like? What can we come across? My desk is always untidy.

913 What is the first thing you do before sitting down to draw? I drink a cup of coffee.

914 Do you always use the same tools or do you change depending on the piece you're working on? I use different tools depending on the piece.

915 What are your favorite tools or drawing programs, and why? I like Painter, because it is easy to use and it's a good way to test different techniques.

916 How do you make your drawings come to life? Emotional expression? Well, I'm not sure.

917 How important is promotion to you? How do you promote your work? I have my homepage and a blog.

918 What has changed about your style of drawing since you began? Now I like color.

919 Manga: is it art? Yes. Art has no limits.

920 What good habits should a comic illustrator have? All of them.

"I like cooking"

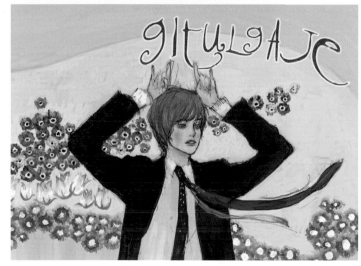

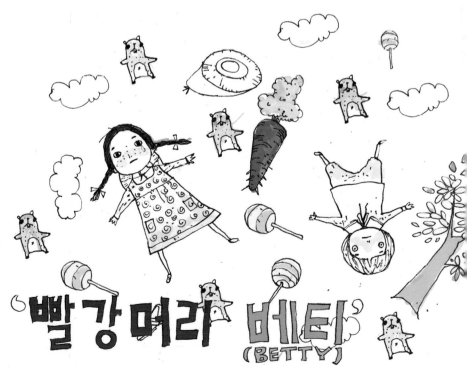

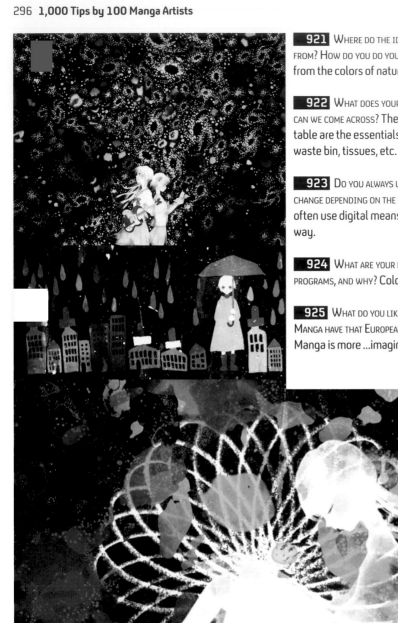

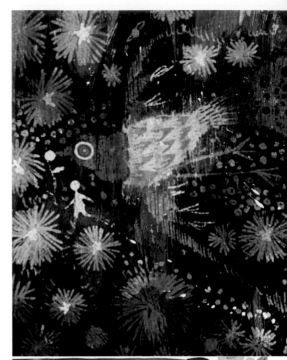

921 WHERE DO THE IDEAS FOR YOUR DRAWINGS COME FROM? HOW DO YOU DO YOUR RESEARCH? Frequently, from the colors of nature, of buildings ...

922 WHAT DOES YOUR WORK DESK LOOK LIKE? WHAT CAN WE COME ACROSS? The only things I have on the table are the essentials: ink, colors, paper, the waste bin, tissues, etc. Everything is tidy.

923 DO YOU ALWAYS USE THE SAME TOOLS OR DO YOU CHANGE DEPENDING ON THE PIECE YOU'RE WORKING ON? I often use digital means to draw. It's quite a good way.

924 WHAT ARE YOUR FAVORITE TOOLS OR DRAWING PROGRAMS, AND WHY? Colored ink. I like nice colors.

925 WHAT DO YOU LIKE ABOUT MANGA? WHAT DOES MANGA HAVE THAT EUROPEAN OR AMERICAN COMICS DON'T? Manga is more ...imaginative. And I like that.

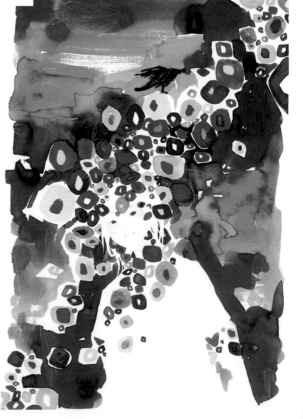

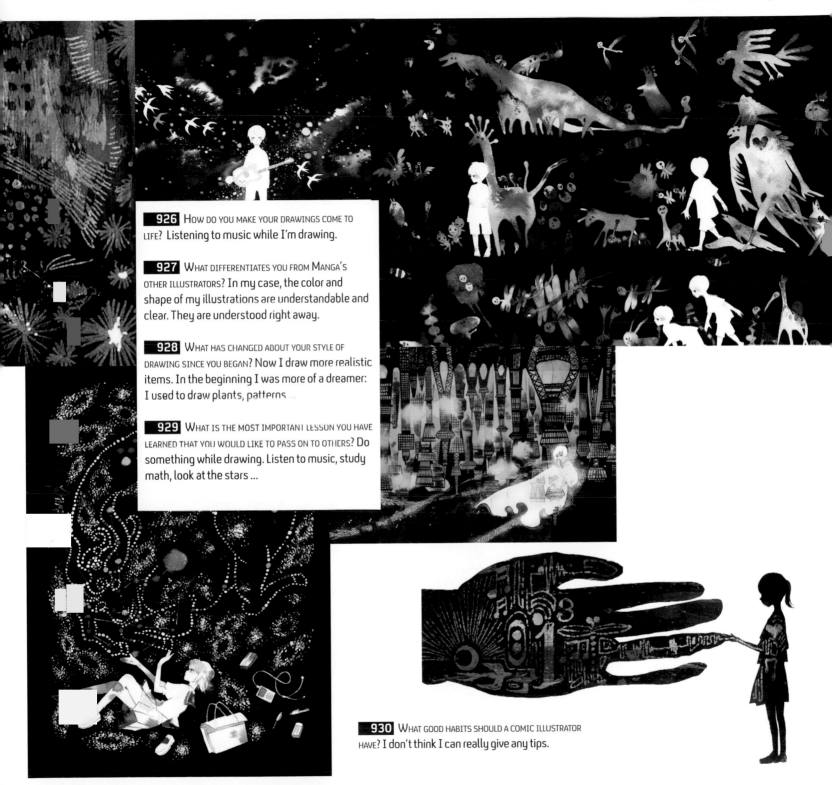

926 HOW DO YOU MAKE YOUR DRAWINGS COME TO LIFE? Listening to music while I'm drawing.

927 WHAT DIFFERENTIATES YOU FROM MANGA'S OTHER ILLUSTRATORS? In my case, the color and shape of my illustrations are understandable and clear. They are understood right away.

928 WHAT HAS CHANGED ABOUT YOUR STYLE OF DRAWING SINCE YOU BEGAN? Now I draw more realistic items. In the beginning I was more of a dreamer: I used to draw plants, patterns …

929 WHAT IS THE MOST IMPORTANT LESSON YOU HAVE LEARNED THAT YOU WOULD LIKE TO PASS ON TO OTHERS? Do something while drawing. Listen to music, study math, look at the stars …

930 WHAT GOOD HABITS SHOULD A COMIC ILLUSTRATOR HAVE? I don't think I can really give any tips.

Yoshida Yoshitsugi

http://sekitou.sub.jp

Yoshida Yoshitsugi is an illustrator. Althought her main works are book cover illustrations and CD jackets, she's also well-known because of her amazing watercolor technique. Her works have appeared in *Faust* magazine (Kodansha). She lives in Chiba prefecture, Japan, and works both with analog and digital techniques. She draws almost exclusively female characters, but they're not the center of attention in her works. This honor belongs to atmosphere and the amazing colors she works with. Notice also her unconventional shading technique: Yoshida marks depth by using darker and lighter tones.

Yu Kagei

http://kage-yu.com

Yu Kagei is a Japanese illustrator currently living and working in Yokohama, Japan. She graduated from Tama Art University, like many another Japanese artists of her generation, and was hired by a video game company, where she gained experience as a character designer. Her work as an illustrator and artist can be found in novels (such as *Ha Nobunagaki, Kireinaoshirono-* *kowaihanashi* and *Sangokushi no Onnnatachi* as well as all kinds of illustrated books). Her strength, in her own words, lies in "beautiful women and the theme of fantasy."

931 WHO ARE YOUR FAVORITE ILLUSTRATORS? ARE YOU TRYING TO FOLLOW IN THEIR FOOTSTEPS? I like Art Nouveau, classic painters, and Japanese illustrators. I am influenced by the beautiful colors and the soft images.

932 WHAT DOES YOUR WORK DESK LOOK LIKE? WHAT CAN WE COME ACROSS? Sweets and teas are always being prepared. It looks like a table rather than a desk.

933 WHAT IS THE FIRST THING YOU DO BEFORE SITTING DOWN TO DRAW? I put my hair up. This is like what the samurai does before departing to the front.

934 DO YOU ALWAYS USE THE SAME TOOLS OR DO YOU CHANGE DEPENDING ON THE PIECE YOU'RE WORKING ON? Tools are almost always the same, but I change if necessary.

935 DO YOU PREFER THE CLASSIC GUIDELINES FROM MANGA OR EXPERIMENTING WITH NEW CHANNELS? I study the classic guidelines, but new challenges are necessary.

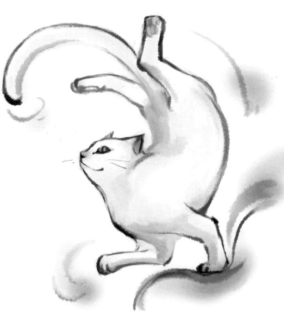

936 WHAT DIFFERENTIATES YOU FROM MANGA'S OTHER ILLUSTRATORS? I am drawing carefully to make expressions softer.

937 WHAT ADVICE WOULD YOU GIVE TO A NOVICE ILLUSTRATOR TRYING TO MAKE A NAME FOR HIMSELF? I would say let's show and spread your idea. Getting many people's agreement makes your name famous.

938 WHAT HAS CHANGED ABOUT YOUR STYLE OF DRAWING SINCE YOU BEGAN? My basic style has not changed, but I soak up trendy new styles if necessary.

939 MANGA: IS IT ART? There are no limits for manga. Yes, it is art.

940 WHAT GOOD HABITS SHOULD A COMIC ILLUSTRATOR HAVE? You should have the habit of drawing what you think. I always draw the new places and people I meet in my daily life.

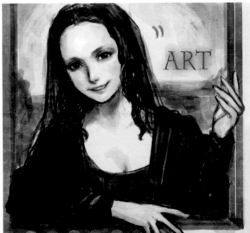

941 WHERE DO THE IDEAS FOR YOUR DRAWINGS COME FROM? HOW DO YOU DO YOUR RESEARCH? Whenever I go out, I always carry my digital camera with me to take pictures of old buildings, streets, machines (thrown away) that usually interest no one. I use them for collage or drawing a picture.

942 WHAT DOES YOUR WORK DESK LOOK LIKE? WHAT CAN WE COME ACROSS? I always try to keep my desk clean, but one can see a lot of paper, CDs and files there, so my desk looks like a very dense city like Tokyo or a city after an earthquake.

943 DO YOU ALWAYS USE THE SAME TOOLS OR DO YOU CHANGE DEPENDING ON THE PIECE YOU'RE WORKING ON? I usually use a brush pen to represent lively nuances well, but sometimes I use a pencil to show emotions of characters precisely.

944 WHAT DO YOU LIKE ABOUT MANGA? WHAT DOES MANGA HAVE THAT EUROPEAN OR AMERICAN COMICS DON'T? It is an enjoyable experience to follow a storyboard consisting of lines and images that manga can offer to readers. It is also possible for a manga artist to make manga, which is sometimes comparable to movies, with only a pen and paper.

945 HOW DO YOU MAKE YOUR DRAWINGS COME TO LIFE? When I draw a picture, I always make use of my experience or emotion that I've had before. That would be the only way for your works to come alive.

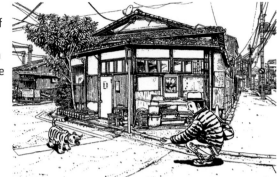

946 WHAT ADVICE WOULD YOU GIVE TO A NOVICE ILLUSTRATOR TRYING TO MAKE A NAME FOR HIMSELF? A lot of people around you may say something good or bad about your works, but it is better not to listen to their opinion too much, because you must have something original in your works to become a successful illustrator.

947 WHAT HAS CHANGED ABOUT YOUR STYLE OF DRAWING SINCE YOU BEGAN? I used to draw fantasy manga, in which a robot appears and something happens, but now I am more interested in making something ordinary with a bit of wonder. For example, I like to draw pictures in which a man takes a walk and sees something.

948 MANGA: IS IT ART? I think manga is different from art. Manga should have a good storyboard, and that is not important in art. Otherwise, it is nothing but a collection of images.

949 WHAT IS THE MOST IMPORTANT LESSON YOU HAVE LEARNED THAT YOU WOULD LIKE TO PASS ON TO OTHERS? Of course, there are good times and bad times as a manga artist, but the most important thing is to keep on making your works like you did in your childhood. If you do so, I am sure you will create a masterpiece someday.

950 WHAT IS THE GREATEST ACKNOWLEDGEMENT YOU COULD HOPE TO ACHIEVE FOR YOUR WORK? If I find my works in a village's bookstore—where I stop by chance—that would be the time I realize my work is accepted.

Yukihiro Tada

http://tadayukihiro.com

Yukihiro Tada was born in 1975 in Osaka, Japan, and was raised there, until he started to study art and comics at Kyoto Seika University. After his education at Kyoto Seika University, he moved to Tokyo to work as a freelance illustrator and cartoonist. He was nominated several times for the Choice Prize, which is organized by a popular illustration magazine, *Illustration*. He has produced cartoons and illustrations for magazines and books for kids and adults. Some of his works are *ONU* (a science-fiction manga published by Kodansha) and *GoGo 80's Girl* (a manga about an 80s girl). Currently, he lives and works in Osaka.

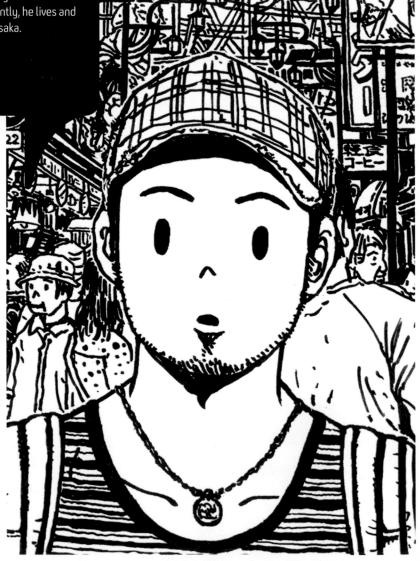

Yunico Uchiyama
www.vesicapisis.com

Yunico Uchiyama was born in Hokkaido, Japan. He has been the owner of his own studio, Vesicapisis, since 2005. He is also the founder of the silkscreen studio Artvolvox. Known for his illustrations for fashion brand Deep Sweet Easy in 2011, his works can be seen mainly in T-shirts. Strongly influenced by Hayao Miyazaki, the movies and the music of the 60s and the 70s, and especially by psychedelic art, Yunico Uchiyama was one of the twenty five artists chosen for the exhibition *Magical Girls: Art inspired by Shojo Manga*, which took place in the gallery/store Meltdown Comics of Los Angeles, in 2011.

951 WHO ARE YOUR FAVORITE ILLUSTRATORS? ARE YOU TRYING TO FOLLOW IN THEIR FOOTSTEPS? Julian House.

952 WHAT DOES YOUR WORK DESK LOOK LIKE? WHAT CAN WE COME ACROSS? It's cold... and cool.

953 WHAT ARE YOUR FAVORITE TOOLS OR DRAWING PROGRAMS, AND WHY? Holbein Acryla Gouache, Pentel Sign Pen and etcetera.

954 WHAT DO YOU LIKE ABOUT MANGA? WHAT DOES MANGA HAVE THAT EUROPEAN OR AMERICAN COMICS DON'T? When I was a kid I drew manga with such joy of freedom that I felt I could draw anything.

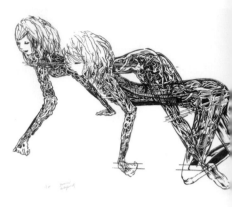

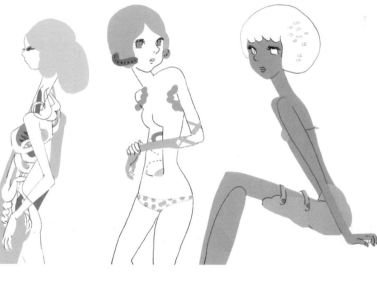

955 WHAT DIFFERENTIATES YOU FROM MANGA'S OTHER ILLUSTRATORS? This is a difficult question to answer.

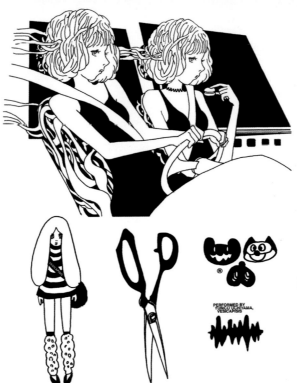

956 WHAT ADVICE WOULD YOU GIVE TO A NOVICE ILLUSTRATOR TRYING TO MAKE A NAME FOR HIMSELF? Just keep going.

957 WHAT HAS CHANGED ABOUT YOUR STYLE OF DRAWING SINCE YOU BEGAN? I am getting looser little by little.

958 WHY IS MANGA SO POPULAR IN THE WESTERN WORLD? Maybe because the eyes of the Western manga characters don't seem to have spirit in them.

959 WHAT IS THE MOST IMPORTANT LESSON YOU HAVE LEARNED THAT YOU WOULD LIKE TO PASS ON TO OTHERS? I will get lots of rest when I'm dead.

960 WHAT IS THE GREATEST ACKNOWLEDGEMENT YOU COULD HOPE TO ACHIEVE FOR YOUR WORK? That those who are infected by my work will have the energy to change the world some day.

961 WHERE DO THE IDEAS FOR YOUR DRAWINGS COME FROM? HOW DO YOU DO YOUR RESEARCH? Ideas come when I eat delicious food, and when I buy new clothes.

962 WHAT DOES YOUR WORK DESK LOOK LIKE? WHAT CAN WE COME ACROSS? There's a cellular phone, a drink, and a pen.

963 WHAT IS THE FIRST THING YOU DO BEFORE SITTING DOWN TO DRAW? I sit in the traditional Japanese form, *seiza*.

964 DO YOU ALWAYS USE THE SAME TOOLS OR DO YOU CHANGE DEPENDING ON THE PIECE YOU'RE WORKING ON? I always draw the lines with a pen, but the color depends on the situation.

965 WHAT DO YOU LIKE ABOUT MANGA? WHAT DOES MANGA HAVE THAT EUROPEAN OR AMERICAN COMICS DON'T? I like how they express the sound effects.

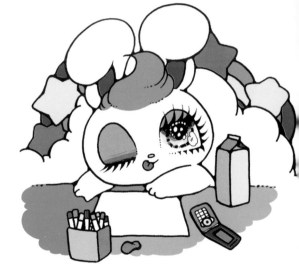

966 WHAT DIFFERENTIATES YOU FROM MANGA'S OTHER ILLUSTRATORS? How I draw the eyes.

967 WHAT HAS CHANGED ABOUT YOUR STYLE OF DRAWING SINCE YOU BEGAN? I draw eyes with a different style.

968 WHAT IS THE MOST IMPORTANT LESSON YOU HAVE LEARNED THAT YOU WOULD LIKE TO PASS ON TO OTHERS? It is important that the illustrator express something without adding words to the picture

969 WHAT GOOD HABITS SHOULD A COMIC ILLUSTRATOR HAVE? When a picture is drawn, what the person sees is important.

970 WHAT MAKES A COMIC SELL SUCCESSFULLY? Impact.

Yurie Sekiya

www.hanamizz.org

Yurie Sekiya graduated in 2010 from the Graphic Design Department of Tama Art University. After that, and while working at a company as a graphic designer, she also works as an illustrator. Her work is instantly recognizable because of her vivid (and even fluorescent) colors and the extreme cuteness of her iconic characters.

Yusaku Maeda

www.geocities.jp/ill_39/39.htm

Yusaku Maeda was born in 1978 in Kyoto, Japan, although nowadays he lives and works in Saitama. He graduated from the Department of Design at Kyoto Seika University and does not have much experience as an artist, although his peculiar lines and striking characters have started to attract the attention of the Japanese comic scene. His clients include names like Digmeout and Seirinkogeisha.

971 WHERE DO THE IDEAS FOR YOUR DRAWINGS COME FROM? HOW DO YOU DO YOUR RESEARCH? They come from doodling. I just draw unconsciously.

972 WHO ARE YOUR FAVORITE ILLUSTRATORS? ARE YOU TRYING TO FOLLOW IN THEIR FOOTSTEPS? Dick Bruna.

973 WHAT DOES YOUR WORK DESK LOOK LIKE? WHAT CAN WE COME ACROSS? See the pictures!

974 WHAT IS THE FIRST THING YOU DO BEFORE SITTING DOWN TO DRAW? I lift some weights. It allows me to concentrate on drawing with no worldly thoughts after that.

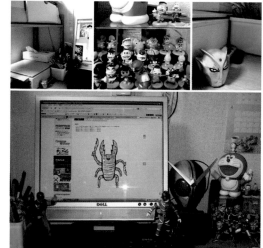

975 DO YOU ALWAYS USE THE SAME TOOLS OR DO YOU CHANGE DEPENDING ON THE PIECE YOU'RE WORKING ON? I change the tools depending on the piece I'm working on. I use to use watercolors, PC, color pencil, mechanical pencil and acryl.

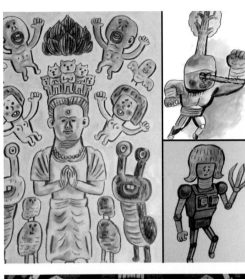

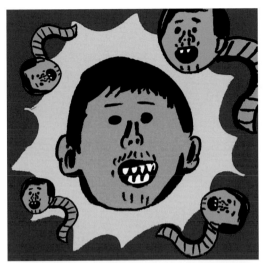

976 WHAT ARE YOUR FAVORITE TOOLS OR DRAWING PROGRAMS, AND WHY? Watercolors! With them I can nimbly draw what comes into my mind.

977 WHAT ADVICE WOULD YOU GIVE TO A NOVICE ILLUSTRATOR TRYING TO MAKE A NAME FOR HIMSELF? Have your own unique ideas and views. And entertain your boss.

978 WHAT IS THE MOST IMPORTANT LESSON YOU HAVE LEARNED THAT YOU WOULD LIKE TO PASS ON TO OTHERS? Technique is important, but keeping on drawing what you want to draw is the most important.

979 WHAT GOOD HABITS SHOULD A COMIC ILLUSTRATOR HAVE? You should collect your favorite stuff!

980 WHAT IS THE GREATEST ACKNOWLEDGEMENT YOU COULD HOPE TO ACHIEVE FOR YOUR WORK? To see my drawings printed.

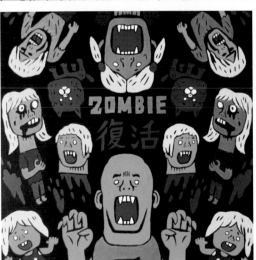

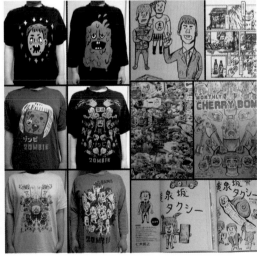

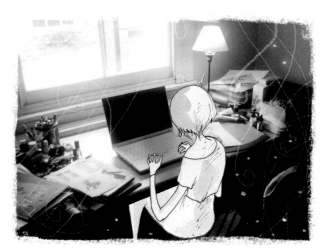

982 Where do the ideas for your drawings come from? How do you do your research? I love to get ideas and inspiration from just about everything! From people watching, collecting vintage artwork to listening to British radio stories. However, most of my ideas suddenly hit me when I'm chin-wagging with friends.

983 Who are your favorite illustrators? Are you trying to follow in their footsteps? I have so many favorites from the East (Asumiko Nakamura, Nananan Kiriko, Hayao Miyazaki and Chica Umino) to the West (Aubrey Beardsley, Kay Nielsen, Edmund Dulac and Gustav Klimt) I'm footstep following, yes.

984 What does your work desk look like? What can we come across? Lots of light and a window to stare out of (very handy). My selection of inks, pencils, pastels, art tools, two trusty laptops, nail polish (believe it!), mouse-pens, scanner, printer, jewelry, reference books and of course, green tea...

985 Do you always use the same tools or do you change depending on the piece you're working on? I usually stick to the very traditional pencil and Indian inks mixed with a digital finish. Depending on the piece and what I'm looking for I may lean more to digital tools (Illustrator, Photoshop) or just stay with the inks.

981 Do you prefer the classic guidelines from Manga or experimenting with new channels? Most of my work is structured by *yonkoma* (4-panels) but I also love the more straightforward illustration approach and believe that if experimented correctly, you can tell a perfect story by drawing outside of typical structures.

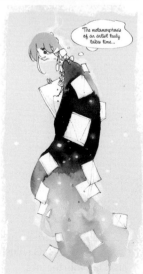

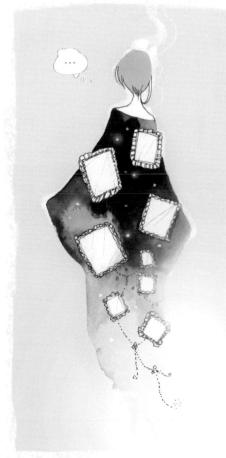

986 HOW DO YOU MAKE YOUR DRAWINGS COME TO LIFE? I always look for the quirky or the odd-ball in my work. My characters shouldn't always be "visually perfect," having lovable personalities and an alternative outlook adds color to a story! You can't overdo it, it's a balancing act.

987 WHAT ADVICE WOULD YOU GIVE TO A NOVICE ILLUSTRATOR TRYING TO MAKE A NAME FOR HIMSELF? I think the most important thing is to discover why you love illustrating and what you're looking for. Don't worry about everyone else and don't lose confidence in yourself. Find like-minded friends and support each other. And build a website!

988 WHAT HAS CHANGED ABOUT YOUR STYLE OF DRAWING SINCE YOU BEGAN? When I first started drawing I wanted to be like everyone else. After studying art on my own time, and focusing on my skills, I have now developed my own style, which isn't made up of everything I wanted ten years ago, but of everything I am now. I hope to continue to develop and grow artistically though!

989 WHAT GOOD HABITS SHOULD A COMIC ILLUSTRATOR HAVE? Patience with themselves and with others. Discipline; this includes saying "no" to meeting friends on a Friday evening because you absolutely must finish that page, to drawing the same character over and over again. Finally, good communication, to express all of the above!

990 WHAT IS THE GREATEST ACKNOWLEDGEMENT YOU COULD HOPE TO ACHIEVE FOR YOUR WORK? I feel blessed that my work has snuggled its way out there, and I have been very fortunate. I'll be more than happy though with people appreciating my work and sharing it, but I would love for my work to cross the boundary of illustration and manga, to fine art.

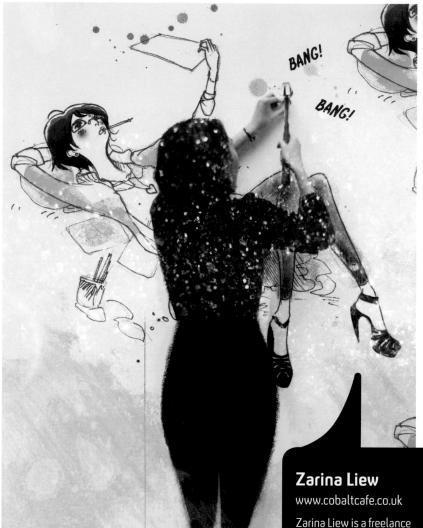

Zarina Liew

www.cobaltcafe.co.uk

Zarina Liew is a freelance fashion illustrator and award-winning manga artist based in the U.K. She works part-time in luxury fashion, and draws from her home-studio in West London. Zarina's work is inspired primarily by 1920s culture, Japanese woodblock prints to nineteenth century British illustration — all of these elements have enabled her to develop her drawing style, illustrating her love of fashion and manga art. As part of the U.K.'s alternative press scene she is also a keen self-publisher, attending expo and comic arts events as well as teaching how to draw manga professionally.

+cruz

www.wklondon.com

+cruz is a creative director at Wieden+Kennedy. Formerly of W+K Tokyo, he has spent the last 8½ years pursuing work that is culturally relevant to his Asian roots, working with clients such as Nike, Google, Honda, Aiwa, Kumon and Mori Building.

As director of W+K Tokyo Lab, he oversaw the labels entire visual output from directing music videos and DVDs to art directing and designing its packaging and online experiences. His work focuses on the intersection between art and design, moving images and digital narratives, exploring new frontiers in media hybrids. Most recently, he joined W+K's London office where he hopes to re-invent himself and help the agency explore its next evolution.

991 WHERE DO THE IDEAS FOR YOUR DRAWINGS COME FROM? HOW DO YOU DO YOUR RESEARCH? I've always had a keen interest in anthropology, history and culture and tend to travel a lot. Asian imagery inspire me: Thai folk paintings, Chinese landscapes, Japanese calligraphy and Buddhist religious paintings.

992 WHO ARE YOUR FAVORITE ILLUSTRATORS? ARE YOU TRYING TO FOLLOW IN THEIR FOOTSTEPS? My influences tend to draw more from fine art than recent commercial illustrators. I have always admired Cy Twombly, Robert Longo, Rauschenberg, Franz Kline, Josef Albers, Antoni Tapies and Francis Bacon. It's historic futurism, sampling from old, codifying forms and remixing that into something new that informs my work.

993 WHAT DOES YOUR WORK DESK LOOK LIKE? WHAT CAN WE COME ACROSS? My home is my studio and my desk is multifunctional, both a work desk and a dinner table ;-) so I keep it to a minimum. A powerbook, pens, paper, surrounded by books, artifacts and antiquities that inspire me.

994 WHAT IS THE FIRST THING YOU DO BEFORE SITTING DOWN TO DRAW? I think, write and surf online a lot. I take a walk and get lost to allow some fresh thinking to emerge as a result of experiencing a new environment.

995 DO YOU PREFER THE CLASSIC GUIDELINES FROM MANGA OR EXPERIMENTING WITH NEW CHANNELS? I don't consider myself a manga artist, but I draw upon manga culture and reinterpret that into my work.